P9-DXJ-753

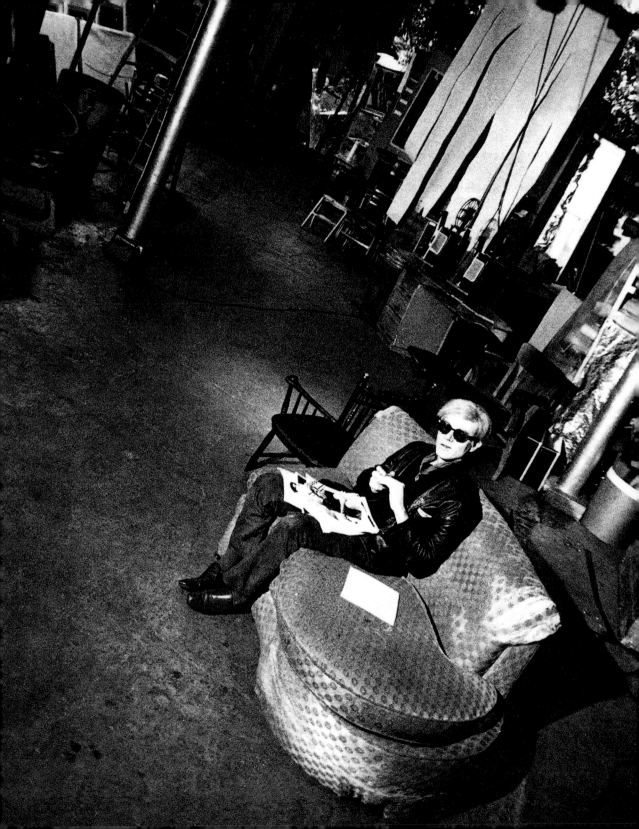

IT HURTS

New York art
from Warhol to now

Matthew Collings

Photographs by Ian MacMillan

PART ONE

PART ONE

PART TWO

PART TWO

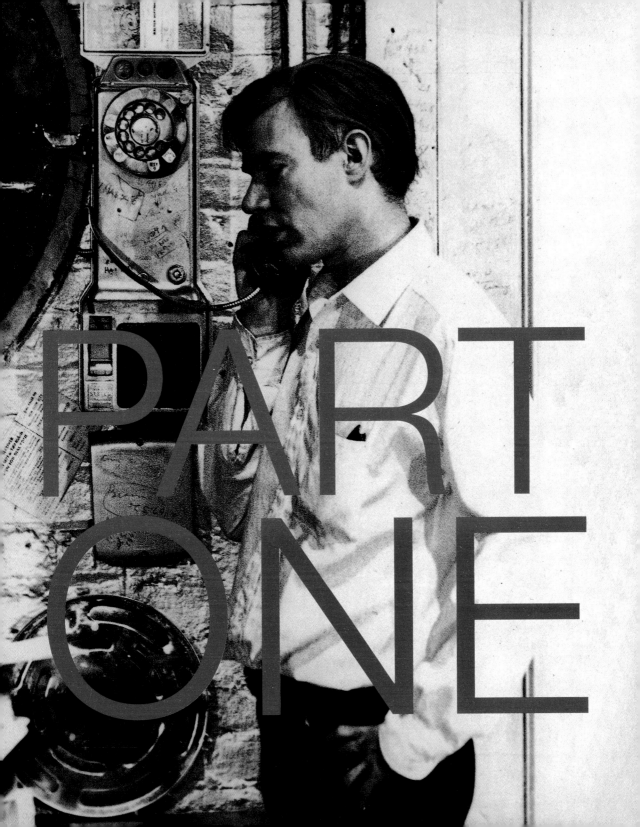

PART
ONE

Many periods

Rocky

Once I was on a day trip from New York to Philadelphia and some gallery people were taking me around. We went to the museum to see the Duchamp collection and when we came out there was some standing around and chatting and someone said this was where the training scenes in *Rocky* were shot. We all laughed and a relaxed atmosphere started up. And then someone was saying something else, or maybe there was a pause, but to keep the good atmosphere going and to acknowledge that there had been a pleasant meeting of minds earlier, I said, Wow! So this is where Rocky used to run up and down the steps! And the main gallery guy said, Uh Matthew, Rocky is a fictional character.

I told that story to Lisa Liebmann, one of the reviewers at *Artforum*, last year. She was in London for the Turner Prize award ceremony. It was just before the award announcement and special dinner. We were standing in the rotunda at the Tate Gallery, with the press photographers flashing their cameras and international art world people passing by. Hey, I really liked your review! I said, when she loomed up. Because she'd written a glowing review of a book I'd written about the London art world. She'd said that it was like Andy Warhol's style. Really pithy and to the point. Warhol's writing style is admirably clear, and I like his talking style too. Uh gee, I don't know, he would say. Or Uh wow. But I never particularly identified with him. I told her I was writing another book now about the New York art world, and the first thing in it was this story about the non-meeting of minds at the Philadelphia Museum, due to different national senses of humour, and the way you can feel at home in a foreign culture most of the time, and then someone will say something and you suddenly fall into space.

But when I finished telling her the Rocky story she looked puzzled, and so did her partner, the writer Brooks Adams. Then they looked distanced, like they were trying to remember something. And then they said they'd better be going now, to see what table they were on.

Six guys

I met Andy Warhol the year before he died. It was June 1986. I was editing an art magazine called *Artscribe*, which was based in London. Warhol was one of the few contemporary artists the publishers had heard of, and they thought an interview with him would get sales of the magazine up.

But because of the period it was, I assumed like many others that he was just a has-been and I never thought about him. I thought he just did vapid paintings of sports celebrities and endorsements of products. You would see ads in the *New Yorker* or *Esquire* with him in a blazer, endorsing a watch or a make of pen.

Of course, in the years after he died, that bad view of him as a conservative sell-out went away. More and more became known about him, all of it fascinating. Nowadays, we know there's the main critical period: the 60s, the wraparound glasses and leather jacket and T-shirt period, when he was criticising society. Followed by other periods. Nightclub period, conservative period, diamond shoes period, doing uncritical portraits of anyone who could pay period. But now they all seem endlessly complicated as periods, full of richness, none of them merely a sell-out. Even selling out seems complicated and interesting. Also being a Catholic and regular church-goer complicates his story.

So I went to the Studio, which was what he was calling his studio now, instead of the Factory, and he saw me for half an hour. He was intelligent and kind. It was obvious I didn't know anything about him except things that had been known in about 1965. I think I didn't even remember his hair wasn't real, because I never thought about him, and I wasn't bothering to be observant about what was in front of my eyes.

Er, what did you get from Basquiat being around the studio a lot? I asked lamely, not being able to think of anything else. He said the smell of grass. I had a copy of *Artscribe* with me, and it had a cover by Art & Language. I asked if he knew them. He said he hadn't heard of them. I said they were a Conceptual art group, famous in the 60s and 70s, and the line-up was always changing but there were always lots of them, maybe six.

Six guys did that? he laughed, looking at the cover image, which was a gouache about eleven inches high in the new Art & Language painting style, depicting an American bomber, because America had just bombed Gaddafi. But in fact only two guys were left now.

He said it wasn't true Brigid Polk did all his paintings. You should ask her, she was just here, he said. It was something someone reported that he'd said, and he just went along with it. How had he written his new book that had just come out, *America*? He said it was different things he'd just made up. Everybody was always making things up. They'd say they were into

healthy eating and right in front of him they'd be eating red meat and drinking red wine. A lot of the photos in *America* were taken in Paris. He didn't think anyone would be able to tell.

He was going to a launch of a new brand of biscuits after our meeting. He was going to endorse them. I asked him why he was going to do that and he said it was a photo-opportunity. I had to ask him to repeat the term and he did and he explained what it meant. It was the first time I'd heard it.

Lonesome Cowboys
An incredible film. For a long time you couldn't get hold of Warhol's films, then suddenly you could just get them from Blockbuster. I got this one out yesterday. Everyone's seen it, but maybe we forget how good it is. It's as good as Pasolini. Every frame is stunningly beautiful. The faces are amazing. The delivery of lines is perfect. It's definitely a critique of the dominant culture. The cowboys just stand around in Western scenes in cowboy clothes and say things like, We got some vittels. Get a fire goin'. Where did you get your hair done? The dialogue is roughly dubbed on, although sometimes it's mixed with dialogue that has been recorded in synch. The dubbed dialogue just overlaps the synch. There are many cuts and jumps. The cowboys are brothers in the story but the actors only half go along with the story. It's Brechtian alienation.

When you see it you think how incredible it is the way Warhol thought of everything before everybody else. But then, everything else is based on him. Like everything before was based on Picasso.

Pushy

Brechtian
When Warhol first started being a star it was naturally assumed he was completely contemptuous of high art and was an outrageous put-on artist, and it would have seemed odd and missing the point in a glaring way to find his art aesthetically exquisite. After a few years, while the mass audience went on thinking he was an amusing or annoying phoney, his art world audience began to be astounded by his Brechtian alienation techniques. And by his stripping down to structural essentials of all the art forms he used. And his use of the stripped-down forms to criticise overstuffed forms and the new Great Society as well. Then, during the 70s, he seemed not to be doing this any more, but only hanging out with Imelda Marcos and

the Rolling Stones at Studio 54 and endorsing products for advertising, and he was forgotten by the art world audience, or even hated by it.

The horror

An important thing about Warhol, which he would have noticed in Jackson Pollock, or Jasper Johns or Robert Rauschenberg as well – or any one of his important predecessors – was his way of being original and at the same time staging originality. With him, it was a massive staging, with all pretence of not staging absolutely stripped away. It was a pure staging. Like a pure colour. The previous stagers, the ones still alive anyway, were horrified. When Mark Rothko, the Existentially tortured Abstract Expressionist, bumped into Warhol on the street in Greenwich Village once, Rothko turned away with a shudder.

The Wolf Man

Then Warhol died, in February 1987, and afterwards there was a sudden rush to have some different ideas about him again. On one level, the rush was to find really complicated meanings in every stage of his art and life and pronouncements, examining every bit of them as if they were notes in a Freud case history. *Little Hans* or *The Wolf Man*, say. This was the highbrow, earnest, art-theory level. On another level, the drive was to find swooning beauty and timeless aesthetic richness in his paintings. This was the middlebrow, international culture industry, museum and art centre travelling retrospective level, with its souvenir baseball hats and jigsaw puzzles and calendars with art designs.

Old Twomblys

One of the things that came out about Warhol after he died was that he was an obsessive collector. He collected everything, and filled his house up with the collection. It became a cliché of Warhol articles and conversations. But why shouldn't he collect things? I went to the auction of his stuff at Sotheby's. His cookie jars alone sold for hundreds of thousands of dollars. A cheer went up. Why? It was the spirit of the times. It was the 80s. Rubbish selling for millions at Sotheby's. It just seemed right. I went round all the old dusty Basquiats and Twomblys and Lichtensteins laid out. And the old rubbish from flea markets and junk shops. His old four-poster bed. His old posters. His watches and American Indian artefacts and wooden Indians. The place was filled with film crews. I was with one myself, from the BBC. They were all filming the cheering as object after object was carried across the stage and sold for outrageous sums, without anyone knowing why. That morning I'd been in the house of a man who was marketing watches

with a Warhol design on them. They were rubbish too. He bought some of the cookie jars and got a big cheer. Peter Max bought the rest.

Valerie Solanas

She was in Warhol's *I, A Man* in 1968, and then later she shot him. She went up to his studio in the lift and then came in and started shooting at everyone who was there. She shot Warhol and Mario Amaya, the author of a book about Pop art, and then she came up to Fred Hughes to shoot him. Please just go, Valerie! he said. She didn't take any notice and pulled the trigger but the gun jammed so she turned and left. She was in prison and mental hospital for a surprisingly short time, and then she frightened Warhol by phoning him at his new studio when she got out. But she didn't

Valerie Solanas in Warhol's *I, A Man* 1968

try and shoot him again and she just disappeared. She ended her days in a welfare hotel, dying alone in the 80s sometime. Her book *The SCUM Manifesto* is fantastically well written with an intelligent condensed style and sharp humour. Although shooting people is bad, it's an injustice that history doesn't recall how good a writer she was.

In the run-up to the shooting, Solanas wrote letters to Warhol, some of which can be seen in the Warhol Museum in Pittsburgh. The mad anger is good. They are addressed to Daddy Warhol. Or A. Warhol, Toad. Or A. Warhol, Asshole. When she turned herself in, to a traffic cop, three hours after the shooting, she famously declared she'd shot Warhol because he had too much control over her life. She was taken to the station, but somehow there was so much media presence there, she was interviewed by the press instead of the police. In the papers, she was reported to have stated to the traffic cop, The police are looking for me. I am a flower child. But she later denied it, saying she'd never say anything so corny.

It's ironic that we think she shot Warhol because he stood for patriarchy. Because for the art world of the time, he wasn't nearly man enough. In fact, he wasn't her first choice for execution. She had decided to shoot her publisher, who was called Girodias, but he wasn't in, so she went round to the Factory instead.

One good letter from her to Warhol goes: Toad – If I had a million dollars I'd have total control of the world within 2 wks; you and your fellow toad, Girodias (two multi millionaires) working together control only bums in the

gutter, and then only with relentless, desperate, compulsive effort. Valerie Solanas.

Good Fred

As Warhol was lying on the ground writhing, Fred Hughes gave him the kiss of life, and even though it didn't make much difference to the pain, later Warhol said that always made him trust Fred. He recovered from the shooting but was always in pain and had to wear a corset. A famous photo by Richard Avedon shows the scars. Warhol was due to be on the cover of *Life*, but then he was dropped because it clashed with Robert Kennedy, who was assassinated by Sirhan Sirhan three days after the Warhol shooting.

Red morning

I was at Gilbert & George's house in London's East End recently, filming them moaning in unison on their roof, like damned souls, for a TV series about Modern art, and they said they'd commissioned Warhol to do their portrait once. They were influenced by his artificiality, so it seems right they should have bought a work from him. It was the 70s. They went to his house in New York and he gave them some take-out lunch and took their photos. Then when he was over in London later, they went round to see him at the Savoy. Fred Hughes was there. The paintings were shown to them. There wasn't just one, there was a group of several. Andy Warhol said, Why don't you buy them all? And they thought it was quite pushy of him. They thought he thought of himself as a failure at the time. It's true, from the late 60s pretty much up to his death, his credibility star was quite low, even though his popular recognition factor was high. They chose one of the paintings. It was $15,000. They gave him a cheque for part of the money and promised to give him two of their own works to make up the balance. One of the works was called *Red Morning*, now in the Nordrhein Westphalen Museum in Düsseldorf. One was called *Bollocks*.

Place of celebrity

In the art system, celebrity has a place but no one knows where it should be. It would be grotesque to give it top place but unrealistic to say it's at the bottom – a long way below integrity, say. Or known ability to read Lacan in the original French.

Before Warhol, celebrity was bad because it made you commit suicide or feel tortured. It clashed with an Existential world view and a determination to resist plastic trash. After Warhol made low pop mass dross and Existentialism compatible in a way that no one had ever thought could be

possible, except poets, celebrity became briefly bad again, because being popular was bad. That was what Conceptual artists and Minimalists thought. They went around in their US army surplus jackets and jeans and beards being against the war and against TV, and forming activist groups. What did they care what they looked like? But Warhol always thought about it and for him appearances were important. He appears to us now in our heads. His celebrity self. His smiling face, his silver foil Factory, his stripy T-shirt, his Chelsea boots. His sofa and telephone and his assistants with staple guns and stencils and magic markers and their phials of speed and packets of new syringes soon to be shared.

Up with the image of helium-filled silver pillows bobbing and clustering on the Factory ceiling, parodying Post-Minimalism, floats more celebrity Factory imagery. Factory formations of plywood boxes waiting to be silk-screened with Brillo logos, parodying Donald Judd. Silk-screened flower paintings on the floor, parodying Impressionism. Rolls of double and triple and octuplet Elvises, from when Elvis was already out and a loser. Police department photos of murderers and Mafia bosses and suicides and teenage car crash victims, lying around, waiting to be enlarged. Laughing poets passing through. Edie Sedgewick passing out. The Velvet Underground. Bob Dylan. Eternally-playing 45s, new then, retro now. Be my...be my *baby*!

Billy Name
Who snapped all these iconic historical Warhol scenes anyway? Billy Name – former famous speed freak, now old with a flowing grey beard, gesturing with long ringed fingers, and wearing a lot of other jewellery too, like New Age crystals round his neck. Knowing the Tarot and knowing Astrology. He famously disappeared, then quietly came back, with his books of photos, one in black and white, one in colour, now a celebrity himself. He photographed the Factory all the time, coming out from the little room at the back where he had his base, photographing the sights, then going back to his room. When he wasn't photographing he was doing routine boring management work with a good will, for little pay. The chores that have to be done to keep the celebrity aura radiating. All biographies of Warhol have a chapter ending with Billy Name's disappearance, and the note he left in the little room he usually sat in, and which nobody ever went in, except him. Because it's such a good journalistic punctuation point. GOODBYE ANDY I CAN'T STAND IT ANYMORE, it read, or something.

And then the room was empty except for unwashed coffee cups and a hundred years' worth of cigarette ends. And black-humoured surreal

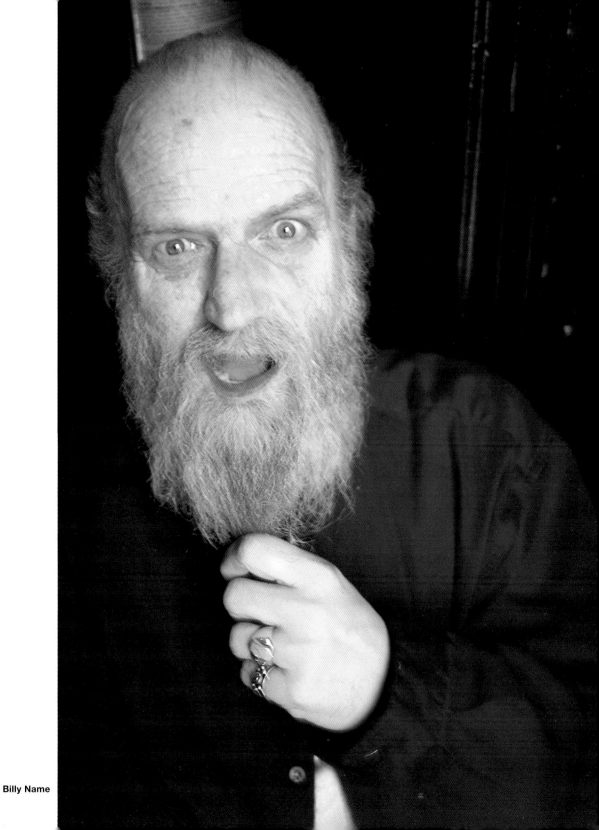

Billy Name

Rolling Stones lyrics, from the period when they were good – slightly forward in time from the heroic Factory period – reverberating backwards, landing in Billy's recently emptied smelly room. Take my arm! Take my leg! Oh baby don't you take my *head!* Inadvertently providing a good soundtrack for the first wave of Body art. Now Billy lives outside New York and does uncelebrated good works in the community with children.

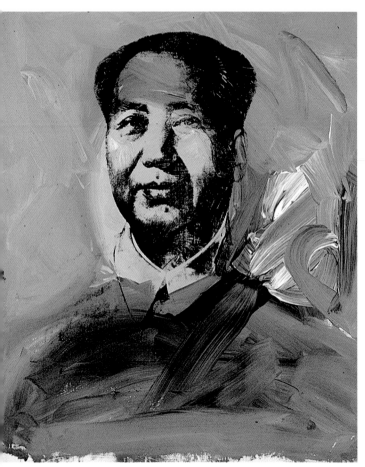

Andy Warhol *Mao* 1973

Bang! Bang! Billy heard the shots ring out one day. But it didn't sound particularly important and anyway there were plenty of people back there. Then after a while he went back there himself and there was Warhol, writhing. Shot celebrity. Shot by Valerie. He bent down and picked Warhol tenderly up in his arms, crying. But Warhol thought he was laughing and said, Don't make me laugh, Billy, it hurts too much! The old 45s reverb-ing away. Bye bye baby bye *bye*!

Welcome back, 80s art boom
One of Warhol's *Marilyn* paintings sold for $17,000,000 last week. *Orange Marilyn*. What does it mean? It suddenly gets up the prices of Warhol, so all the other Warhols the buyer had already bought quite cheap are now worth more. Good purchase, Warhol buyer!

Red
After Warhol died, all his prices went up, then they went down again. Interestingly, another Marilyn got the highest price paid for a Warhol once. It was *Red Shot Marilyn* (shot with a pistol by somebody who just came into the Factory one day and saw the stack of coloured *Marilyns* against the wall and shot it and left), which sold at auction for $3,000,000 after his death.

Helter skelter

The LA mood

New York art in the 80s was very influenced by art from Europe. Then gradually it became influenced by the art of LA. The trendy names of the late 80s and 90s were often LA artists, like Mike Kelley, Tony Oursler, Paul McCarthy, Bruce Nauman, Raymond Pettibon, Jim Shaw and Jason Fox. The LA mood is crazed, off-beat, irrational, acid-poetic, it is thought. Some of the younger LA artists share an inky adolescent comic-strip drawing style. It's exciting at first but you can get tired of it. Of the comic-strippers, Raymond Pettibon is more mysterious and literary and Post-Structuralist, and you can't understand immediately what his images and captions mean. Jim Shaw showed a lot of amateur thrift-store paintings he'd just gone out and bought, as an installation once; also he draws his dreams. Jason Fox is more like straightforward nostalgia for a 1960s *Zap Comix*, Grateful Dead graphics style.

Bouncing Balls

That was an early video work from the 60s by the West Coast artist Bruce Nauman. It showed the artist's balls bouncing in close-up, in slow motion. Another one showed him making them up with black theatrical make-up. That was *Black Balls*. *Bouncing In A Corner* showed Nauman bouncing in the corner of a room.

Bruce Nauman
Poke in the Eye/Nose/Ear 1994

These early video works were part of Post-Minimalism, with the idea of gravity suddenly being emphasised as a significant element in art. Instead of it just being taken for granted as a force that everything in the world is more or less subject to. It sounds nuts, but some of these ideas you just go along with.

Nauman made many Post-Minimal videos and other types of works, and on the whole he introduced a lot of new forms into art. Frank Stella the other day, when I was round at his studio, referred to Nauman's art as Psycho-Minimalism. He said he was an admirer. But it wasn't clear if he meant psychological or psychotic.

Nauman cast the negative space under his chair in plaster. He had all the letters of his name made into neon, each letter crazily elongated. *My Last Name Exaggerated 14 Times Vertically*, that one was called. Another similar

work was *My Name As Though It Were Written On The Surface Of The Moon*. He made a sculpture in cast wax called *Five Wax Casts Of The Knees Of Famous Artists*. Only they were really his own. Because he didn't know any famous artists at the time. He showed an iron sculpture of a human back with some rope binding it, which was called *Henry Moore Bound To Fail*. He made a lot of works that were puns or word plays. A circular neon work spelled out the circular message, *The True Artist Helps The World By Revealing Mystic Truths*. Another one flashed the words *Run From Fear, Fun From Rear*.

In the 80s he became an international art megastar. He started standing for a new Beckett-like bleakness about the human condition. He said he didn't have any answers for why people were cruel but he thought he had to make art about it. He made videos of rats in labyrinths, and clowns being tortured and laughing till they cried or howling with pain. And couples flying into psychotic rages. He made flickering neon men that flickered between being strangulated and having hard-ons. And he also made long columns of neon words that flashed up basic thoughts and conditions, suggesting that life is grim and hopeless and a living hell and all we can expect from other people is violence and sadism or to be devoured.

He made a good video recently with a human head, filmed upside-down and the right way up, yelling Feed Me, Eat Me, Anthropology! And Help Me, Hurt Me, Sociology! All in a horrible drone.

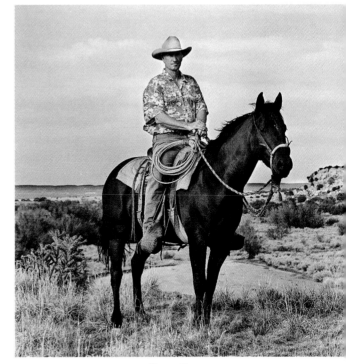

Bruce Nauman

Christian station

The other day I went out to Nauman's ranch in New Mexico. He's been living there since the 80s. It's roughly equidistant between Los Angeles, Roswell and Los Alamos. Lost wages, aliens, atom bombs. I listened to the Christian stations on the car radio. Was it a sin to be depressed? Did Prozac go with Jesus? The ranch is called Las Madres. Nauman built the house himself. He lives there like a cowboy, breeding horses, wearing a cowboy hat. He looks like a normal middle-aged Midwestern cowboy guy. It's hard to

imagine him at twenty-five in 1967 painting his balls with make-up. Or walking in the exaggerated manner he had to walk in, for the video *Walking in an Exaggerated Manner around the Perimeter of a Square*.

He offered me a glass of mescal. No thanks, I said, mindful of the long drive back to the motel in Albuquerque later, with only Jesus as my companion. What about those early works then? I asked. What were you thinking of?

He said they were tests. Testing to see if those things could be art. His daily life when he left art school in the early 60s was mostly just sitting round in an untidy studio with messes on the floor and rubbish lying around. Sitting alone, reading and imagining and staring at the neon beer sign out the window. He thought art should probably be about life, so he gradually started making all these dull grim life things into art. A photo of a mess on the floor. A photo of two messes. Neon signs. Casts of his body. Photos that dramatised figures of speech. As long as there was a clear structural logic, it would make sense, even if it was absurd. He made a video of himself covering his body in white make-up. It was called *Art Make-Up No.1: White*. The title was a play on the idea of the artist every day having to make up from scratch what art might be.

Luckily, these tests fitted with Post-Minimalism and he got recommended to Leo Castelli and then taken on there, along with Richard Serra, another West Coast artist, in 1967. Actually he hadn't done any videos yet, and it was Castelli who enabled him to get the video form going, by cleverly buying some video equipment for the Castelli stable of artists to use.

Nauman said it was true that New York was a long way from the West Coast in attitude. He personally was very impressed as a student by the simple structural logic of Warhol's early films, for example. But the underground film-making community in San Francisco – which was where he was living for a while as a student – thought they were idiotic and simplistic. Because for them technique was everything. They put every technique under the sun into their Structuralist films. Whereas Warhol hardly put anything in.

Nauman's studio today is impressively ramshackle, filled with old rubbishy clutter and coffee cups and cardboard boxes. He still just sits around in it, not working most of the time. Drinking coffee and reading books about ranching. And then at the end of the day he might get up and make something.

Yes Bruce Nauman. That was the title of a painting by Jessica Diamond once. Just the words. Everyone says yes to him.

Mike Kelley

He wouldn't give permission for any pictures of his work to be shown in this book, so it's hard to feel good about his art. He stands for transgression. But also for being quite serious. He teaches at one of the art schools in California. He's a shocker but it's not only for fun. It's thoughtful. It's about abjection. And dysfunction. It seems to fit with the modern world just right. His main forms are floppy dirty toys and bodily effluvia. He started out in the late 70s staging performances with a lot of writhing nudity and a subject matter of shitting and visceral things going on. Obviously there is a lot of humour in his work. He exhibited a collage of naked women in art performances, entitled *Why I got into Modern Art*. After performances he got on to showing drawings in black and white of effluvia and effluvia-related subjects.

In the late 80s he started showing installations of abject woolly children's toys, like teddies or rabbits. The wretched but funny creatures sat on dirty old pale blue or pink children's blankets, one in each corner, or in some other arrangement – maybe two menacing one – as if it was a ritual or a behavioural experiment. Sometimes they sat alone. Sometimes in pairs, in a sexual position. Or they were under the blankets, making pathetic lumps. Maybe it wasn't even them under there but something else. It was part of the aesthetic that you wouldn't know for sure.

It wasn't an art of formal skill but an art of selection and arrangement, and he was the master of it. He had been in some punk bands as well and that contributed to the sense of grooviness that went with his name, and still does, even though he looks quite stocky and filled out now, compared to his former wiry acid-punk self.

Another thing that makes him stick out is his ability to pinpoint with laser accuracy the weird dreadful culture of the middle class and draw significance from it. For example, the sculptures he made at art school which were from bird-cage kits. Later he became fascinated by the little wooden shelves with glasses of seeds, sometimes attractively dyed, that bourgeois homes often have nowadays, as a construction of the natural, like they used to have tasteful bowls of *pot-pourri*.

Tony Oursler

Another West Coast artist. He sometimes collaborates with Kelley. He projects films of the heads of actors reciting texts he's written, onto stuffed dolls, or plaster spheres. The

spoken or shouted or muttered words are usually schizo or horrific or disturbed in some way. The dolls lying in their little suitcases in the corner of a darkened gallery, or standing on sticks – or the disembodied heads hanging in the air – flicker and speak and emote. We find it eerie. We're all a bit possessed, we think. We hardly possess ourselves. We're just a series of selves. Just hosts waiting for ghosts to come and inhabit us. Hey, maybe they're already here and there's one writing this book right now instead of me!

He is a friendly man with dyed hair. When I was in his Lower East Village studio, which had lots of old TV sets and cardboard boxes lying around and some equipment for recording music, we were chatting about this book and how I was going to write it, and I asked what he thought Matthew Barney's art was about. As it was a genuine mystery to me. He said he didn't know either. It was a mixture of fashion and symbolism, he thought. I asked who he thought the main artist of now was, but he had a mental block at that. He said he'd just broken up with his girlfriend and she always used to advise him on these things.

Tony Oursler *Bottom* 1996

Tony Oursler

Paul McCarthy

After Mike Kelley, Paul McCarthy is the other most well-known and influential nutty menacing fucking and shitting West Coast art visionary of the 90s. He exhibited a top-class video of gnomes and elves shitting, with demented Santas urging them on. I saw it at the Whitney Biennial a couple of years ago. *Santa's Chocolate Shop*. I think I had something like what doctors call a shock. It really was amazingly disturbing, but funny too. It was an orgy of chocolate sauce and swearing, and be-smeared adult gnomes crawling around a kind of cheaply constructed wooden suburban home, like something from a TV sit-com, with their trousers down. You watched the film on various monitors while walking around the creepy wooden set, like being at the scene of a crime. And at Anthony d'Offay in London I think I once saw a good mechanical sculpture by him, with mechanical Heidis being fucked by gnarly farmers. Unless it was a dream. And recently I got hold of an excellent McCarthy video called *Painter*.

Paul McCarthy

Paul McCarthy
still from *Painter* 1995

Paul McCarthy
still from *Santa's Chocolate Shop* 1997

Painter

McCarthy himself plays the painter, in white overalls and with a big red rubber joke nose. He wears a wig of short blond curls that makes him look like a grotesque caricature of the Abstract Expressionist painter Willem de Kooning, who died recently after many years of suffering from Alzheimer's disease. As the painter in *Painter* cries out De Kooning! De Kooning! repeatedly, in a strange high demented call, like a bird, it's clear a de Kooning reference is being made. And it could be a vicious one, as this de Kooning character is obviously crazed.

But really the sense is of Abstract Expressionism generally, McCarthy said, when I was in the back garden with him at his house in Pasadena, an hour's drive from LA, with the sun shining, and the garden pool, with its somewhat Flintstones design, glinting merrily.

Or painting generally, he went on. His voice really is high and bird-like and quizzical. It seems to be cracking all the time. It's not de Kooning himself, he says, but a typical artist influenced by de Kooning. As if the painter in the video is invoking de Kooning's spirit for inspiration. He said it was just a coincidence about the wig being blond. It could have been black just as well.

In the film, there are many satirical jokes about the painter's rages being more about getting payment from his gallerist than about important Existential subjects, and about the collectors and promoters of rageful Abstract Expressionist art being quite shallow.

The painter splashes and drips and grunts disgustingly and has comic violent rages. His paints are in giant comic tubes labelled RED, or SHIT. A critic with a similar rubber nose comes in and the painter drops his trousers and the critic inserts the tip of the nose into the painter's bottom and then pulls it out. Mm, lovely, the critic says. The painter's gallerist looks on approvingly. It's pretty good satire, it really hits the spot. It's disgusting and stupid but you can't help smiling at the anarchy. It's not all broad. A lot of it is nasty. The painter stabs his hand with a knife, slicing into the huge tubular phallic rubber fingers, drawing tomato ketchup blood horribly, and then paints with the blood, gurgling and grunting with infantile pleasure. The timing is always a bit too drawn out for pure satire. So at times it's quite gruelling to watch. The dull lighting and cheap hand-made wooden stageset is a bit like the atmosphere of daytime TV, or quiz shows. And there's something of the emotionally dead atmosphere of *Henry, Portrait of a Serial Killer*. The whole set and the paintings painted with horrible materials, the dried out rotten mayonnaise and other foodstuffs, is all now in a private collection.

McCarthy quite old
Interestingly, he is quite old. He started out before everybody else in the 60s and couldn't make it in New York. He lived in Pasadena. He hated New York so much because he felt it had rejected him; he would deliberately make detours to go round it if he was travelling somewhere and there was a scheduled stop-off there. Then suddenly he became huge after a big group show of LA psycho art that included his work, in the 80s, called 'Helter Skelter'.

Crazy
That reminds me of a joke Richard Prince made into art, which went, *I was up there with Charlie Manson in prison. He said, Is it hot in here or am I crazy?*

Semen robot

Today in New York I went round the Chelsea galleries. In one gallery there was a group show. One of the works was a piece of paper on the wall with the words WORLD OF ROBOT faintly printed across the surface in small bold capitals. The label said the medium was semen. Another work in the same show was a life-size aluminium-mounted colour photo of two gay leather S&M clone guys in full chains and handcuffs gear, sitting down to dinner in the home of their Middle America parents, with a nice tablecloth and a nice kitchen in the background. In another gallery there was an exhibition of art by Chinese artists exploring identity. One set of works was photos of naked Chinese people. The people all lay on top of each other in a human pile. Another set was photos of chickens. That's the climate of art now.

Isle of Man

The next gallery was Barbara Gladstone. Ursula Andress's head was on a banner outside it. Inside was a Matthew Barney show, featuring stills from his new film, *Cremaster V*, which stars the old sex goddess from *Doctor No* as a character called The Queen of Chain. Also, there were some live pigeons in a little room, with strangely plumped-up feathers, as if they'd been pompadoured. Synchronistically, I was in another gallery later where there was a white submarine on show, by a completely different artist, with a TV monitor inside actually showing *Doctor No*.

Lovett/Codagnone *Prada* 1997

Everything in Barney's art is erotic and sexy and loaded with symbolism. Nobody understands it, or thinks it's bad that it might not be understandable. I was at a dinner in London the other night and a middle-aged collector from Sweden was saying how deeply moving she found the presence of KY jelly in his first installation.

He has a cast of imaginary characters who come and go. One of the first was called Otto Shaft, which is good because it nearly sounds like auto shaft in American, and the Christian name is all penis and testicle symbols when it's spelled out in upper case. Otto was based on a real sports hero called Jim Otto, a football player for the Oakland Raiders, who had a prosthetic

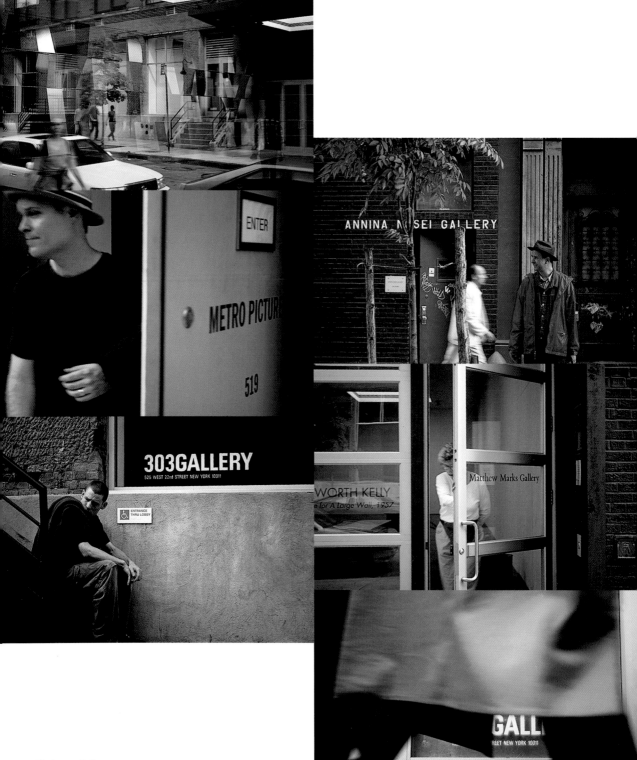

Chelsea galleries

leg or knee joint. Prostheses and the flesh-coloured strange hospital rubbery material we imagine a lot of prosthetic-type stuff is probably made from, were staple forms and materials of Barney's art at first, when it was mostly installations and object spin-offs from installations. After that, it became increasingly films. All called *Cremaster*. Cremaster is the name of the set of muscles that controls the retraction of the testicles. Doctors have heard of it but nobody else. Except now everybody has.

The general meaning is something about biology and evolution and getting on a higher plane. There's always lots of semen symbolism.

His videos are different from his high budget movies. In one video, *March of the Anal Sadistic Warrior*, an endless pageant is going on in Rotterdam, with a lot of ordinary people watching, with their children. There's a kind of float with weirdly made-up costumed people. Matthew Barney himself appears, in costume, made-up. Someone else appears. A dildo is slid into his bottom as part of the ritual. Everyone is smiling. The mood is bright but distanced from anything real. The video colours are flat, the action is slow. It's more a record of a performance than a film. At the end Helena Christensen suddenly appears. It's quite boring to sit through.

The *Cremaster* movies are filmically much more ambitious and seductive – although still quite slow – with incredibly sophisticated Hollywood-style make-up and effects and complicated action. The mood is dreamy and symbolist. Nothing is real. Everything is uncertain. Flesh is always suspicious. Openings appear in it and transparent white silicon balls, like fish eggs, come out of the fleshy slits, in an exciting disturbing way. *Cremaster V* is full of this type of excitement. Knights drowning. Japanese people with gills. Silicon dribble coming out of the mouth of Ursula Andress. Waddling, scratching,

Matthew Barney
still from *Cremaster V* 1997

pompadoured pigeons wriggling into a silicon hole. Matthew Barney climbing upside-down across the Budapest Opera House ceiling like a bug. At the end, the screen fills up with white silicon balls.

An earlier *Cremaster* was set on the Isle of Man. Obviously that's a good name. Mad masculine stuff is his theme. The film ended with a close-up of Matthew Barney's balls. Before that, there was a race round the island of different coloured race bikes going in opposite directions, and a journey

through an underground tunnel filled with white foamy matter. It was Matthew Barney struggling through the foam, made-up like a weird satyr.

Barney is sometimes criticised by gays for making a gay-seeming art and not being gay. In fact, he is married to the woman who pompadours the pigeons. I met him once in Italy. He had red hair and looked super-athletic. In real life he really had been a super athlete and it's part of his mythology. He changes his body all the time. I saw him again a few years later in London, when he was trying to get some backing for *Cremaster IV*, and he looked more ordinary.

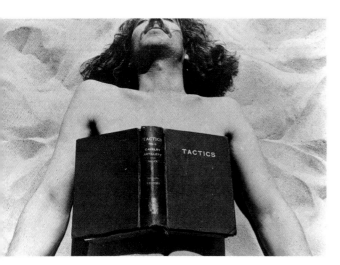

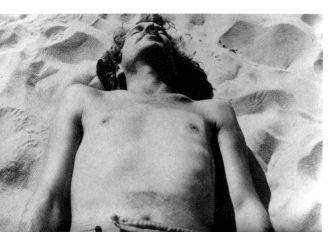

Dennis Oppenheim *Reading Position for Second Degree Burn* 1970

Then tonight I saw him again, in New York, at a party at the collector Clarissa Dalrymple's flat, for the British artist Gary Hume. He looked like a grizzled old homeless person with a baseball hat and a fisherman's beard and baggy clothes and a bent-over wasted look. But when Gary Hume asked him why he was looking like that, he said he didn't know what Gary meant.

Historic top bodies

Barney is a top artist of The Body. But Body art in the 90s is not like Body art in the 60s or 70s. Today it's about the construction of identity. But in the old days it was about encounter groups and saving the planet and stopping the war and making the personal explode into the public.

Also in the old days, Body art and Performance art were seen by very few people; videos or photos of the events would be seen by more people, only still not many. It was the beginning of the documentary aesthetic. It wasn't thought to be aesthetic, though. It was about being real. After a while, it was noticed that a special type of reality was being manufactured to fit the documentary aesthetic. So by that time, it was a mannerism. Nowadays there's a big return to this aesthetic and nobody cares if it's real or not.

Fantastic America
Dennis Oppenheim. I got his number but forgot to ring it. It's enough to remember his Conceptual art piece, *Reading Position For Second Degree Burn*, from 1970, consisting of two photos, before and after, both of his chest, the first with a book called *Tactics* lying face down on the chest, the second with the bare chest, and the red burn round the square of white flesh where *Tactics* had lain. In the 70s he made more involved things that you couldn't get. But they were still good. One thing was a metal monk with a bell in front of its head. The bell would swing back and then whack right into the metal monk's head. Whack! Gong! Fantastic. I saw it in photos and then I saw the real thing in a museum in Brussels last week.

That's another thing about 60s and 70s New York art. No one in New York bought it, it was all bought by collectors and museums in Belgium and Germany. Nevertheless, New York was where everything was at. Always remember, New Yorkers, young British art now dominates the world, even your world. But it comes from an art culture that was almost 100 per cent boring in the 60s and 70s. Whatever anyone says. Obviously not completely boring, because Conceptual art and Pop art were going on, and Francis Bacon. But somehow they were still the products of a pretty boring cultural scene. Whereas New York art of the same period was absolutely fantastic and we bow the knee to you and salute you, for your past achievements. We got all the ideas for our present achievements from you.

Acconci
For example, what about Vito Acconci's *Seedbed*? It was 1971, probably. He just lay under a triangular platform masturbating. The visitors to the gallery walked on the platform and heard him underneath grunting and fantasising about them. It was the time of Minimalism. That triangle would have made all the difference. Even if it was only an upward slope in the floor. But in the London or Paris art worlds it wouldn't have registered, because at that time neither of them had any sense of the tough

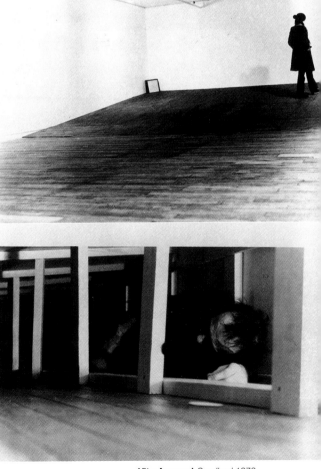

Vito Acconci *Seedbed* 1972

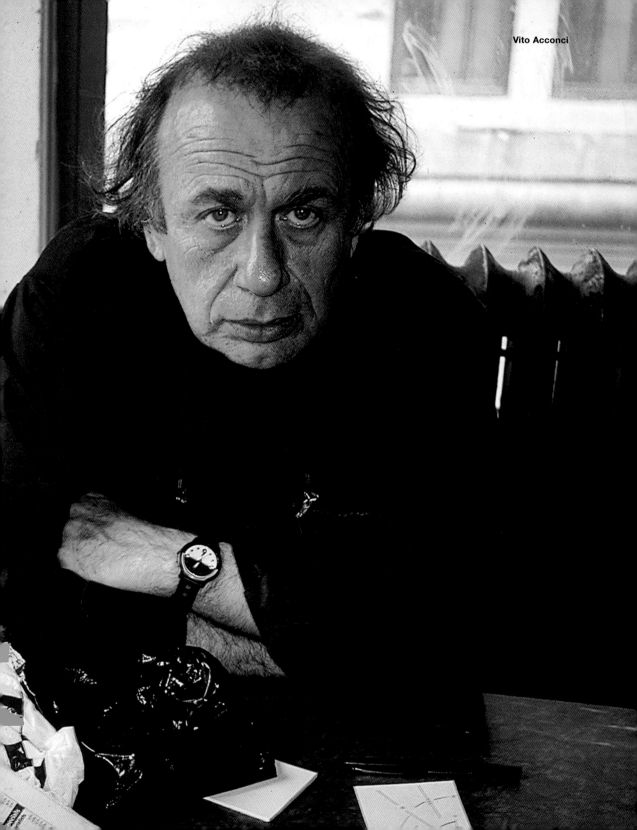

Vito Acconci

forms and thoughts that were the foundation stones of cutting-edge art culture.

Paris was worse, actually. I went there in 1976. I went to a Gilbert & George opening at Ileana Sonnabend, which was in Paris in those days. Or maybe one branch of it was. It was for their book, *Dark Shadows*. It was probably good, but I was too young to understand it. On the same trip I went to a dinner at Stanley William Hayter's *atelier*. He taught engraving techniques to Jackson Pollock. He was 70 or 80 and he had a young wife of seventeen. It was amazing. I had never seen such wealth, or been so drunk. I was very keen to get into the art world as soon as possible.

As a cultural memory, the triangular aspect of *Seedbed* is barely recalled nowadays. But somehow it's in there, and there's something special about it.

Schneemann
Another Body artist was Carolee Schneemann. *Meatjoy*, that was her performance of 1964, now a cult work. Naked bodies writhing in chicken giblets. *Interior Scroll*, that was another one. She extracts a scroll with a text on it from out of her vagina. Historians neglected her because of patriarchy. But now she's really respected, even though in her manifestos she spells history as *istory*.

Destruction in art

I can see for miles
Although worshipped by top trendies for his art of the 90s, Paul McCarthy is actually one of the original wave of Body artists of the 60s. McCarthy said when he started out as an artist in the 60s he felt it was enough just to make the kind of art that would make him feel like he fitted in the art world, or what he knew of the art world. But instead of copying Frank Stella or being influenced by him, like everyone else, he found he was copying Raphael Ortiz instead. And looking back, he realised that was a choice he made.

Ortiz was one of the artists involved in the 'Destruction in Art Symposium' in London in the 60s. The other main artist of that event was Gustav Metzger. At this symposium they destroyed a piano, and on another occasion Ortiz killed a chicken. In those days Arthur Janov's book *Primal Scream* was a

Carolee Schneemann *Interior Scroll* 1975

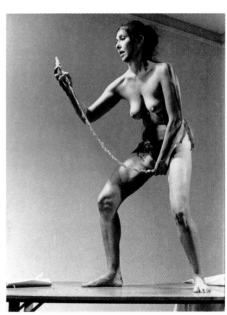

Carolee Schneemann *Meat Joy* 1964

big hit and everyone knew about primal scream therapy. John Lennon, for example. Janov's book was dedicated to Ortiz because of the chicken. And the Who were influenced by Gustav Metzger and Ortiz destroying a piano. They started smashing their instruments up on stage as part of their act.

After he left art school in Utah, McCarthy went to another art school in San Francisco, where the students were all painting. When he was there he discovered Samuel Beckett and Ionesco and Existentialism and the Theatre of the Absurd. Which was only right, San Francisco being a Beat headquarters of those days, with the famous City Lights book store, and the American Beats and European Existentialists being more or less connected on some plane or another.

Then later he moved to Pasadena, and when he was there he got more and more excited by Walt Disney. He liked Disney being about perfection and Utopia. Recently he had become quite interested in the outbreak of stories about parents suing Disney because of their children being traumatised by seeing the Disney animals without their heads on at Disney World, when the animals were on their breaks and having a beer or a sandwich.

So when you see a grizzly, mad, physically gruelling, perverted film installation piece by Paul McCarthy, like *Painter* or *Santa's Chocolate Shop* or *Captain Meat*, with gross family-size quantities of runny viscous foodstuffs

Paul McCarthy
Painting and Wall Whip 1974

like mayonnaise or chocolate sauce or ketchup sliming and sloshing everywhere and suggesting lubricants and bodily effluvia – or a kinetic sculpture with, say, some mechanical men fucking trees or fucking the ground, or a

Heidi being fucked by a gnarly old farmer, or a sex dwarf with a hairy black pelt fucking a rocking Mom holding a blond-haired cutie daughter – always remember: Disney/Beckett, Utopia/Void, Paul falling down that hill.

Ughhh!

McCarthy is very impressed by the idea that everyone's reality is now being made for them by Spielberg and by virtual reality. He said there'd been a scandal in Japan recently, where a kid cut his friend's head off and gouged out his eyes and delivered it to the doorstep of the dead friend's parents. Ughhh! I said. He said, Yeah. It turned out the kid was addicted to video games, and Japan was shocked by the notion of the kid not being able to distinguish between virtual reality and, er... Human suffering? I offered. Yeah, human suffering, he said.

East and West

On the whole, art from the West Coast is absorbed by the East and becomes part of the New York art story, or just the story of American art, which the rest of the world assumes all goes on in New York. It's chauvinism but there you are. One subtle point, though, is that shocking sights might have had a different meaning in LA than in New York at one time, because you could easily be censored or arrested in LA for something that would be overlooked in New York.

Beating heart

New York is the centre. The Museum of Modern Art there tells the story of Modern art from Cézanne to Frank Stella. It's an amazingly authoritative place. Everything looks good. It's a white box with a series of white boxes inside. That's how art should be seen, we think, because it's our conditioning. Everyone goes round with an idea of Modern art in their heads that comes from the Museum of Modern Art.

It's amazing how that works. It still works, even though we don't believe in anything any more. The beating heart of the idea is two or three inner chambers on the second floor. Although in reality the display changes slightly now and then, the feeling basically stays the same. It's a lot of coloured rectangles. A lot of squares and grids. These are what we think a really authoritative Modern art object looks like.

You come round the corner from one white box into a set of further boxes. The green square of Jasper Johns's *Green Target* hoves into view. Then other squares and rectangles loom up. A Rothko orange one. A red Newman,

Vir Heroicus Sublimus. A brown and black Pollock. Little squares of Ellsworth Kelly – cool white, green, pink and other colours. The animal squares of Francis Bacon. Dog and baboon. De Kooning's grey and orange *Woman I*. More slabs and grids of Modernism. A blue West Coast Pop slab. Ed Ruscha's *Oof*, the letters in cadmium yellow capitals. A Warhol slab, with soup cans. Another one with suicides. They're all from different times, but it's basically a 60s space, with all the 60s Pop affluence and entertainment associations. A mad, mad, square, grid and slab, Modern art world.

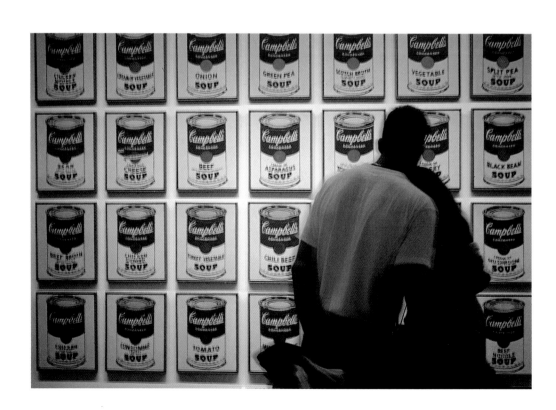

Museum of Modern Art

No one else laughing

Please help me

Going round the SoHo galleries today in the rain, with Ian MacMillan, the photographer for this book, I saw Willem Dafoe letting himself into a door on Wooster Street. I remembered that was where I first saw the Wooster Group, which he used to be in, and I was introduced to him after the show. They were doing Thornton Wilder's *Our Town* in blackface. I laughed so hard, I couldn't believe how outrageous they were being, with really offensive Alabama accents and grinning faces and rolling eyes and flapping big white hands and white lips. But then through my tears I noticed no one else was laughing. And actually, although the Wooster Group was always the height of cool, that was one of the few performances by them that wasn't received very well.

Then, at American Fine Art, Ian bought a Jack Pierson drawing for $2,000. It was called *Please Help Me*. It was just the letters that spell that plea, but slightly scrambled. He could have bought one that said Enola, Live, Evil, Alone, with the letters going round the edges of the paper and all spelling the same thing backwards and forwards. Jack Pierson takes romantic nouveau-Beatnik, on the road photos of America and Americans, as well as making word drawings, and word assemblages using thrown-away bits of shop signage. The words usually suggest a vulnerable mood, not an ironic emotionally distanced one.

Jack Pierson *Solitude* 1995

Exit

After that, we found ourselves in Yoko Ono's new installation of wooden coffins, with real trees growing out of them, and little clusters of creepy mushrooms. It was called *Ex It*. In another space uptown, Yoko had a show of her old Fluxus work called *En Trance*. The front of the gallery was open

Jack Pierson

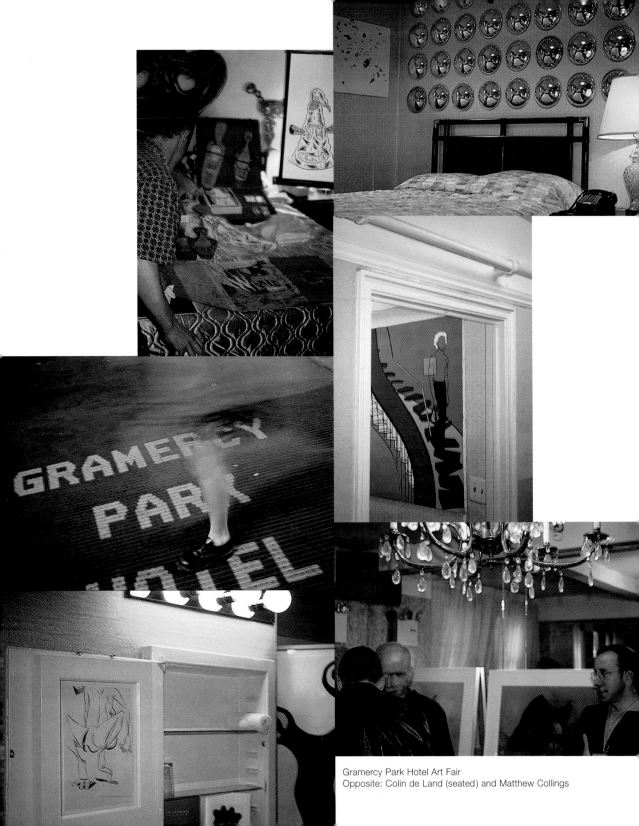

Gramercy Park Hotel Art Fair
Opposite: Colin de Land (seated) and Matthew Collings

to the rain. In the back of the gallery, there was a skylight open to the rain as well. It came dripping in, the sound mixing with the installation soundtrack of recorded bird tweets.

Zen thought sorts out world

In the 80s, Yoko was asked if she didn't think the art world wasn't a bit terrible now, compared to the 60s, what with all the money. But she said it was a good balance of money now. In the 60s the weapons industry had all the money, she said. Now it was the art industry as well.

Control sights more, please

Then we were at the Gramercy Art Fair. All art fairs are frightening. There's no control over the sights. At first the anarchy is fun but you soon get depressed. You want someone to control it more. Here, it wasn't even fun at first. It was grim and unaesthetic right away. It was a bad crass atmosphere. Also, it was a horror-film atmosphere. Because of the hotel. With its dark corridors and green exit signs and the creepy clients and desperate dealers and the desperate art in the bathrooms and on the beds. It was like the last scenes of *The Shining*, with Shelley Duvall going round the corridors in a panic, catching glimpses of horrible sights in the rooms. I'm free-associating the labyrinth scene at the end as well. If that's a free association. To be really free maybe it would have to be an association from a different film.

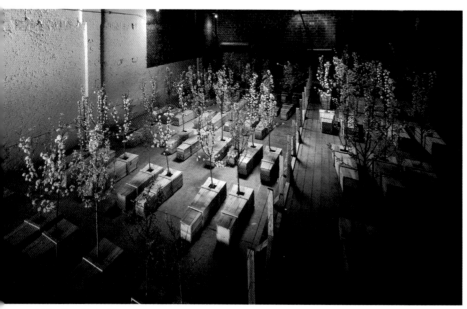

Yoko Ono *Ex It* 1997

But anyway without the snow. Because it was hot in here, with the cold rain on the clients' coats turning to steam.

We went through the labyrinth. Finally we came to a room with a heavy-set man smoking a cigar. Next to him was a bed with nine framed photos of swimming pools on it from the 60s or 70s by Ed Ruscha. They looked good. The first thing at the fair that did. Can I take your picture? Ian asked. No, actually, the big guy said. Then I looked down and there was an opposite guy, a tiny guy, dark-eyed, hunched on a chair there, also smoking, looking like Hubert Huncke, the Beatnik. It was Colin de Land, the dealer. He reached out a pale hand and said Hello! and What are you doing now? because he hadn't seen me for some years. I said Hi! and he introduced the other guy. It was Patrick Painter, the LA dealer. I said I was working on a six-part TV series about Modern art, from Picasso to now. Then Painter said he really admired Picasso. He had five periods, he said. Ed only had two and he's a genius. De Land laughed dryly and said, I didn't know you were a Pablo fan. Sure, said Painter. He's about weeping not seeing, I know, and Duchamp's about seeing not weeping. It came out in a flow, like a comedy routine. Or as if weeping and seeing in Modern art, and Picasso's five periods, and Ruscha's two, really were well-known ideas.

You never knew what he would do

The 80s
What happened? A lot of movements in a speeded-up stream. They all re-did movements of the heroic past. It was Reaganism, so there was a lot of money. All the stars got some. At first the main movement was painting, then it was dry but gleaming ironic Neo-Conceptual objects. Also, there was photo-text art that critiqued. It was historically conscious and uptight. Painting was historically careless and loose. It didn't care. Ha ha, it said. Critique art said, Watch out, dominant culture, we've got your number! And that goes for you painters too! Collectors went crazy for everything and they were deeply moved by everything. They loved painting and they loved being critiqued and they loved voting for Reagan. Greed is good! they laughed. (Then in the 90s they said, Tibet is good! And greed too!)

Neo-Expressionism
No one knew what to call all the painting that was coming out at the beginning of the 80s. Gradually it got called Neo-Expressionism. Almost any painting could be called it. It was virtually meaningless as a label but it

seemed to fit. In a way it was Neo-Pop as much as Neo-Expressionism. That was a label for a while too, but it didn't catch on. Neo-Expressionism was a kind of sudden awareness that the freedoms won in the 60s and 70s could now mean the freedom to do art that had seemed impossible in the 60s or 70s. Expressionism. Why not?

The new painting was a huge retching after a tight congestion. All the 60s and 70s isms had congested together into a dry grey shape. Pop, Minimalism, Conceptualism and their offshoots. All now in a stiff glob. Neo-Expressionism uncongested them, so they could never fit together like that again, even after Neo-Expressionism was driven away by Neo-Geo.

From about 1981 to about 1985, there was an East Village scene. There was the Fun Gallery, Civilian Warfare, P.P.O.W. and other wackily named galleries, all just smallish spaces that you had to walk over winos and prostitutes and punk drug addicts to get into. Or so the legend goes. Madonna might be in there, and Jim Jarmusch and Jean-Michel Basquiat. So it was worth going. The art was nutty paintings, including a lot of graffiti art.

Plates

Neo-Expressionism lasted until the mid 80s. It started in the late 70s and became popular in the early 80s. It covers a lot of different types of art. Downtown funky art and uptown ritzy art. But if the grey box is the icon of Minimalism, then maybe a Schnabel plate painting is the icon of Neo-Expressionism. One rises up before me, now. The plates are stuck with Bondo, a car body filler, on a wooden surface that juts out and sinks back, like a section of a room. A lot of the plates are smashed, some are whole. Their separate decorative patterns and edgings connect up pleasingly across the surface and are integrated as well with the clumsy vigorous punky formations of the paintwork. Deliberately deadened, unlovely paint in a wax medium moves across the whole plates and the shards of plates. It's a glut of paint, with an imagery that is glutted and flowing at the same time. Miasmic erupted pre-Modern art hallucination figures. Done in an ugly way. Saints and zombies, writhing torsos, classical pillars, shadows, horizons, branches, veins, all out of scale. Why not? It certainly could be nonsense, but in fact it's not a structure that doesn't connect at all to 60s and 70s art structures. Weird materials, process, the body, Minimalism, the object, architecture, kitsch, black humour. All the 60s and 70s concerns. All now jutting and receding in a new way.

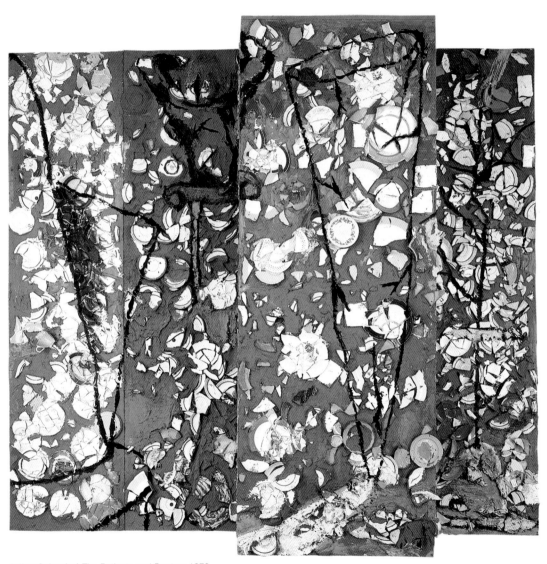

Julian Schnabel *The Patients and Doctors* 1978

As soon as Schnabel was famous for plates, he started doing other things. You never knew what he would do. It was all the materials under the sun, and all the meanings. Poetic, sensitive, banal, blunt, everything. You could easily think it wasn't really meanings but only materials. At least the materials were interesting, though. Antlers and stuff.

Look at those breasts
The day after I met Warhol in 1986 it was airless and steaming and I took the hot train to Bridgehampton to meet Schnabel. He met me in a white Merc, wearing black RayBans. We went to his house and saw his paintings in the tennis court and his sculptures lying around in the garden, in the tall grass. We had Pimms and lasagne and salad he picked himself from the sculpture garden. He smoked a big cigar and painted a whole velvet painting. He held up a little fetish object he'd made from fibreglass and copied it onto the black velvet. He used spray paint and oil paint. Pass the Mars Yellow No.2, he would say to the assistant. I feel like an old matador with the sun going down! he said, when it was finished. I smoked my cigar too, glad to be here with the old matador.

I'm eating a meatloaf sandwich and it's so good I can't stop! he said on the phone a few days later, when I was back in London.

Then another time I was at his studio in New York to do some filming. He put on his red pyjamas and got out his brushes and poured white paint on some prepared canvases and smoothed out the white blobs with old record covers. He smoothed out a square, with Miles Davis's *Sketches of Spain*. He was listening to Chet Baker. It was Captain Beefheart earlier, Don Van Vliet. His children asked if I knew Don, because of course they did. We filmed inside the dining room. There was a real suit of armour in there. He had furniture made of pony hide. In his bedroom was a TV and a Max Beckmann. And somewhere else there was his 1981 *Portrait of God*, showing the influence of Yves Klein in its use of blue. And a real Steinway piano. He could really play it too. His parents and brother came round. You look nice, Dad! he said. When did you get here? About two, they said. You look beautiful, Mom! He showed her off to the camera. Look at those breasts, man! he laughed.

Abroad
A lot of Schnabel's imagery came from European art, both Modern and pre-Modern. Until Neo-Expressionism, New York was up and Europe was down. Then Europe was up in a big way. European art was really admired

and nobody thought any more it was just something you had to get over. European artists were amazing stars. They came over to New York and bought buildings and stayed on and became New Yorkers. Everybody wanted to copy them and generally copy European art, and pretended they'd always liked it. Then Europe gradually died down again, but it was never back down to its old nowhere position.

Movement with balls

Rise of new movement
Neo-Geo just whacked right in, as if overnight. New York art was all paintings one minute, then all ironic shiny Neo-Conceptual objects the next. There were paintings, but now they were paintings of ironic stripes or ironic squares. Once I had to phone up Charles Saatchi in London and ask him what the new trend was. It was about February 1986. I was at the publishers of *Artscribe*'s flat in Park Avenue. They wanted to see if I was really connected. So I took a chance and dialled his office, and I was put through, and he did in fact kindly tell me what the new movement was. It was East Village galleries showing installations of basketballs floating in tanks of water. At least that's what I thought he said. Of course, he would have said exactly what was happening. But to me it was all new and hard to take in. I got the image of a big room-sized tank, and many basketballs. It seemed very 70s. When you first hear about something in art, you can easily get everything mixed up. I got the names of the artists and the dealers mixed up. But some of the artists were dealers as well, so it wasn't surprising. The first Jeff Koons I saw was a slide, sent to *Artscribe*, showing one ball floating in a museum vitrine-sized tank. That was the Koons look. It was the everyday made to seem like Minimal art. Ordinary things presented in a particular way so they seemed like unreal hyper-things. He put new hoovers in Plexiglas cases, with neon lighting illuminating the previously disregarded but actually, it turned out, stunningly lovely, uncanny, sexual, plastic and metal commodities. And he cast an aqualung in bronze.

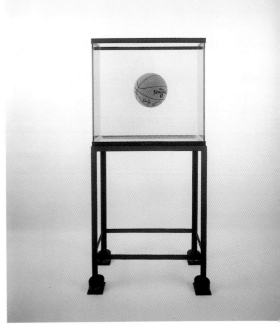

Jeff Koons
One Ball Total Equilibrium Tank 1985

How many millions?
Everything about Koons was unusual. He worked as a commodities broker, making millions apparently. When I first met him, I asked if he didn't think

that was weird for an artist, but he said no he didn't. I could make maybe two or three million dollars a year, he said. But I could never be up there in the 100 million a year bracket!

At one time he sold membership subscriptions at the Museum of Modern Art, in the foyer. He was a typical embarrassing salesman, only magnified. He would wear three ties at once, and make people notice him. The Museum never had so many subscriptions as when he was working there.

He took off in a big way with his basketballs, then his silver bunny, then his giant kitschy objects. Including a giant kitschy Michael Jackson with a white face, holding the chimp, Bubbles, also with a white face. Then he hooked up with Cicciolina and made big sculptures of them both in erotic entanglements, and wall-size colour photos, which he called paintings, of more sex between them. He showed everything, in a super-realist style, but with absurd butterflies and kitschy props as well. Even the mud that smeared their bodies seemed like the clean mud from film sets. He said he wanted to embrace banality and he wanted his audience to do that too.

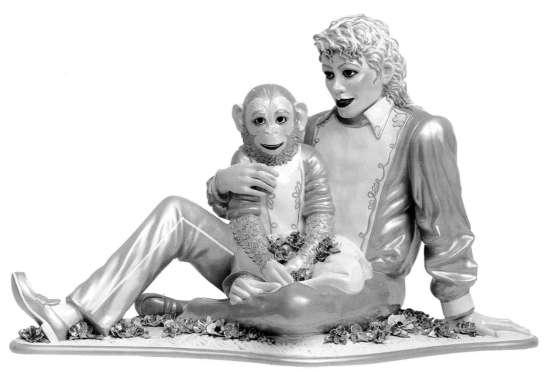

Jeff Koons *Michael Jackson and Bubbles* 1988

And they did. Only he wasn't banal. He was super-talented. He made really striking objects with good colours. He said the first ones were readymades. Like Duchamp. Then he said he was making his own.

But in each case somebody else was making them. Craftsmen, assistants, photographers. It's just that the first things he exhibited already existed, and he was just re-presenting them. The next ones didn't already exist. Or they already existed in fragments and he was putting them together. But you could say that's more or less what any artist does when they make something. Also, Donald Judd had everything made by a factory. So it all made sense.

Right into the 90s he ruled the art world, the new Andy Warhol, but always about to fall. In fact, rather than falling, he just seemed to drift away. All you heard about him was his war with Cicciolina over custody of their son, and the depressing stories – for those of us who are parents – of the son going back and forth between them, between New York and Italy. Then suddenly you heard about him again. He was making a big comeback. A huge comeback. At the Guggenheim. But it never seemed to happen. Then the idea was it would happen in 2000. Will we still want it? We don't know.

A popular idea is that he is intellectual and ironic. In fact, his art can be both but he is neither. He frowns and tries to keep up in certain conversations. Uh Matthew, who is Ruskin? he once asked. And he famously talks in Malapropisms, stitching sentences together out of bits that don't fit, hoping for the best. You can't imagine him relaxing in front of the fire with the *New York Review of Books*. But the fact is he's not unintelligent. He's super-intelligent. He just rises above normal intellectuals, leaving them down below, smoking their pipes.

Sixty thousand different flowers make up Koons's giant *Puppy*, a puppy as big as a house. The flowers all have a different life. Some strive and thrust, some are more retiring. It's a chaos and a system. Everyone likes *Puppy*. It's big because it's archetypal. It's a society puppy and an inner-self puppy and a God puppy.

Krens confusion

Thomas Krens is the famous director of the Guggenheim Museum, a new type of art museum director. It's the only type that will make art museums survive. That's the message, the idea that he is the sign of. But is it the sign of the devil? He's understood to be like the head of a big global corporation.

Not an aesthete or a scholar. He's always on the look-out for new global partners so that new Guggenheims can open all over the world. Container-loads of new art fill up the new Guggenheims. Nobody in the host countries has to think about what the art means or if it's good or not. One opened in Bilbao recently. He tried to get new Guggenheims to open in Massachusetts and in Austria but they both fell through. But the globalisation principle is operating all the time. One expansion project fails, another, or two, succeeds. There's a new Guggenheim in Berlin now, in partnership with Deutsche Bank. Hugo Boss is another partner. The new partners bring in money for renovations, new shows and new expansions. That's why it's global. It goes round and round.

Krens caused a scandal by getting the Guggenheim to buy a vast amount of Minimal art from the Count Panza di Biumo collection, and to partly pay for it by selling old Modern art masterpieces from the Guggenheim's permanent collection, by Kandinsky among others. It was de-acquisitioning. The scandal was confusing, though. It was a scandal about crassness. But was it Minimalism that was crass or globalism?

Also, Krens opened a downtown New York Guggenheim, on Broadway, which was a good idea since before that there'd only been the one Guggenheim, all the way uptown. In the Broadway Guggenheim there's a fantastic shop full of plastic rubbish you can buy. And that's good too because the uptown Guggenheim only had a small shop full of rubbish, which you could easily miss. Whereas with the downtown one the shop is enormous and facing onto the street and you can't even get into the rest of the museum without going through it. And Donald Judd with his exactitude, and Kandinsky with his love of the spiritual, both would have really loved that.

On the other hand, I've seen some good shows there.

Need for discipline

The culture of art

You can't just say anything you like. You have to join in the official discourse. There are discourses for everything. But with art the discourse is incredibly tortured and unreal, and you have to get to know it over many years. At first you can't believe the phoneyness and unreality. It's like a bad film, set in the art world. It's so extreme, you feel sure everybody must be joking, and that suddenly they're going to admit it. (For mad people, of course, that's what everyday life is like.) But they never do, and actually their laughter at the occasional joke you might make about the discourse and the need to maintain it more or less 100 per cent at all times, however absurd it gets – just to give your aching mind some relief – is always uneasy, and you learn not to make them after a while. You go along with it even though there's a permanent uneasy feeling and you know you're playing a role.

Innovations in art often seem to be about calling the bluff of the discourse. The new often seems satirical almost. The discourse reels, then adapts. The new seems solemn.

The best barometer of the grotesqueness of the changes in discourse is collectors. Because there's something about their nature that makes the buckling and straining of the changes the discourse is going through show more clearly. They're like a parallel universe to actual art, but one where everything is a little out of joint. In art, the moves make sense, the system makes sense. But when collectors say how moved they are by the new moves, it all becomes absurd. They go from being deeply moved by abstract stripes to finding stripes beneath contempt and being deeply moved by video instead.

Torqued

It means twisted with force. At the DIA Centre in Chelsea at the weekend, after the robot semen and torture queens and Chinese chickens, I saw Richard Serra's new permanent installation there, *Torqued Ellipses*. It's fantastic, no one could dislike it. I went at the weekend because it's part of the New York weekend leisure experience in the 90s to do something like that. They were rusted metal plates about 20 feet high, twisted round in curves, making high-walled enclosures.

I looked at the catalogue afterwards, and it said the plates weighed 40 tons each. Two of the *Ellipses* have two plates each, and one has five plates. The one with five is an enclosure within another enclosure. That's 200 tons of enclosures. You walk round a narrow corridor space to arrive at a narrow opening that leads into the inner enclosure. Once inside, you feel awed by all the weight and rust, and on the way you feel uncomfortable with the sense of something heavy maybe about to fall and no exit nearby. A serious heavy deathly doomy ancient awe experience. Our favourite.

Richard Serra *Torqued Ellipses* 1997

Everyone knows a Serra fell on someone once and killed them in the 70s. And in the 80s another one fell on someone else and they were badly injured. It adds to the seriousness. Obviously if a Richard Prince psychiatrist joke on a piece of paper fell on you, it wouldn't make any difference.

Poetic dream of Minimalism
It was the ancient past. 1966. Grey squares in an architectural space. The space activated by magic beams. Specific objects. They keep mystery out by keeping meaning in. By not having any meaning. The non-meanings are the magic beams that activate the negative space round the grey squares. Then Post-Minimal grey shapes deactivate the geometric non-meanings and activate quirky human meanings. Then bouncing human bodies and gravity activate further-removed magic meanings that still emanate from the deactivated but slightly radioactive original geometric specific objects. The specific objects – now glowing with an eerie opalescent light – send out new mystery beams, activating strange performances and videos and earthworks. Discourse steams up from the nutty objects and rolls in a cloud out to the year 2000, sending down mystery rain. In a cell, on a laptop, incense burning, head shaved, copy of Walter Benjamin on a lectern, someone is chanting the mystery words and tapping them onto the screen. It's a body experience. And a gaze experience. And a spectacle. It's a weekend gaze and body spectacle experience.

Blanks at the weekend
At the weekend normal people go to the DIA Centre and see something blank. Some string, say. There are big white spaces. There are pretentious books in the bookshop in the lobby. There is ostentatious wealth. Some

Robert Morris *Untitled (Slab)*

people in black will come in sometimes and talk pretentiously and you can overhear them. So that's OK then, the normal people think, wheeling their prams.

Drive

It was reality again and I was at a party in a loft. There were a lot of moustaches, white T-shirts, work boots and overalls. Todd Haynes was in charge of the music. It was all Glam Rock selections because he was currently editing *The Velvet Goldmine*, his 70s Glam Rock film. Suzi Quatro came on. *Devil Gate Drive*. Ha ha, some lesbians were saying. This is the music we liked when we were twelve! Michael Stipe came in, in a patchwork denim jacket *c*. Bob Marley 1970s, playfully clashing with blue mascara and blue nail varnish, drinking a beer, talking on his mobile. Some gay guys were laughing and talking. Chuck Nanney, an artist, was saying he'd been in a group show at a warehouse gallery in London. He showed pictures of supermodels torn from magazines, with moustaches drawn on. Then Anthony Viti was talking about Gary Glitter being arrested. He said he'd heard he took his hard drive in to be repaired and the repair man spotted kiddie porn on it, and reported it. And then Gary Glitter was arrested and now his scenes in *Spiceworld* had been cut. Of course, no one knows if

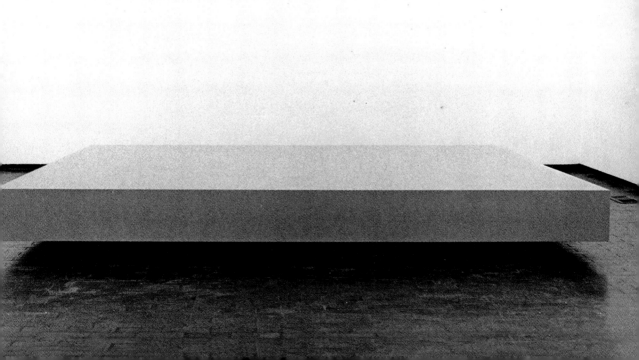

he is guilty. Then Viti, who paints lyrical abstract canvases in browns and yellows, like 1950s Abstract Expressionism, only not with oil paints alone but with his shit and piss and sperm as well, which he keeps in the fridge in plastic containers, was enthusing about Serra's *Torqued Ellipses*. He said they made him think of men coming round corners flashing, or many men all flashing, like a ballet of flashers. Because the high rusty walls made him free-associate a darkened gay sex club. I was thinking if this had been a more highbrow party the association might have been more about Jungian labyrinths.

Excellent
The great critic David Sylvester is an admirer of the new Serras, and I was recently on a television discussion programme with him in London when he attempted to eulogise them. But unfortunately as he was gathering steam the artist Tracy Emin, who was also on the discussion panel, which was being transmitted live to give a sense of breathlessness to the occasion, stole his thunder by announcing in a frankly drunken way that she was going home now to phone her mum.

Bye everybody, she slurred, terrifyingly, for a live TV situation. And then she staggered out of the lighted space of discourse and into the chaotic darkness. I've had a really brilliant night out – fuckin' excellent! she called from the void of non-discourse, to the dozen or so critics in their chairs, and to the half-million or so TV viewers. This is a parable of how you can never control the discourse.

What you see

The important interview
Amongst the most important interviews that make up New York art mythology is the one someone did for the radio with Donald Judd and Frank Stella in the early 60s. What you see is what you get, was what Frank Stella said. It became a credo of Minimalism. Or what you see is what you see. Nobody can ever remember it exactly. But they always quote it however they like, to make the point that there weren't any mystical meanings in what he did, which was a big difference between him and the Abstract Expressionists. The idea was it wouldn't do any good to look for more, because what you saw – which would very likely be a big slab-like canvas with two and a half inch wide stripes painted in metallic paint – was what you got. Or saw.

Frank Stella

Frank Stella kept going and going with this straightforward approach, even though the straightforward look became more and more exploded and tangly and it was as if he was going to test straightforwardness to its absolute furthest limits before he would ever give up and try and do something where what you saw or got wasn't only what you saw.

Aborigines less good
Along the testing way, he did geometric shapes in bright colours with a line of white canvas separating the colours. These paintings of the 1960s, with their arbitrary bright colours and absurdly simple patterns and huge scale, now seem almost camp with their intense 1960s period resonance. I saw one in a museum in Sydney the other day and it was amazing. I really wanted to like the Aborigine paintings that were there too, more. But the ancient elegant dream-time symbolism and tasteful oatmeal colours of the Aborigine artists, good as they are, just didn't come anywhere near the sheer camp joy and hilarity of this 1960s boringly titled *Protractor* series Stella.

Frank Stella *Lomb* 1994

When these *Protractor* paintings first came out, they were considered the most challenging art around and full of austerity and seriousness, and they famously made Michael Fried, their main critical champion, literally cry with emotion when he was explaining them in his famous lectures, using slides.

Stella became famous straight away, with black stripe paintings, and went on being successful and talked about and fashionable for about 20 years, which is an amazing success-run for a New York artist. Maybe no one has quite beaten that record. Bruce Nauman, you could say. But really Nauman had two separate runs. A medium one in the late 60s and a mega one in the 80s and 90s. But Stella's was mega from start to stop. The stop was quite sudden, in about the early 80s. Suddenly nobody cared any more.

But he went on as if nothing had changed, producing furiously. New batches of variations on his theme, every year. Like someone whirling around in the middle of a dance with everyone clapping. And then still whirling when everyone else has left.

Stella's studio now

His studio in New York is an amazing sight, with fantastically vulgar but compelling eye-boggling illusionisms everywhere. The colours are high and mad. There are Bridget Riley-type *moiré* effects, taken to a maddening extreme. And shocking tasteless colours. You can't help being drawn into them. Even though you're immediately repelled right back out again. He doesn't seem to care what anyone thinks. He just goes for vigorous vulgarity in a weird high energy but completely emotionally flat way.

Everything is swirling and rolling and jutting and exploding visually and it's hard at first to see the difference between an actual collage, with a surface of different pieces of marked and patterned paper stuck down, and a physically flat but optically exploding surface. They both look like they're physically exploding.

He goes round the large studio, generously explaining the sights. He says he generated one sequence of shapes from first of all smoking a cigar into a box and getting some photographs taken of the smoke, and then having the photos made into computer plans, and then having the plans made into big cut-out shapes with computer lines on them.

It's just cigar smoke and it isn't particularly interesting. He doesn't seem all that interested himself. Kind of willing to put on a show of interest, but

emotionally distanced at the same time.

I want to ask him if he feels stranded with his art nowadays, what with nobody talking about him, even though he's a giant from the past who still produces a lot and can get a million dollars for a public art commission. So I jump in and ask him about how he compares the present with the past. Obviously there are big gaps in his understanding of the present because of being someone essentially from the past. But still he certainly pays attention to now and he roughly knows who the present stars are.

His problem with the way art is understood now, he says, is that it's about the spectators racking their brains, finding significance in tiny details. In the old Abstract Expressionist days it was all there spread out before you and looking beautiful. Like a Franz Kline. That's the artist he mentions.

He doesn't want to think about all the signifieds and signifiers, although if you mapped it out for him, he says, he could probably get it OK as an idea. To illustrate his point, he waves his finger over some bits and pieces on a table and starts a would-be hilarious interpretation of them as Post-Structuralist signifiers. The signifying Coca-Cola can, and roll of film, and old teaspoon and so on.

He liked Peter Halley writing about him, and he even likes Peter Halley's paintings, but he doesn't particularly like what Halley wrote because he doesn't care to hear about Baudrillard's philosophy.

He always thought Andy Warhol had his own touch, and that everything Warhol did he wanted to be clever, and he can appreciate that. But a lot of it was boring. For example, he thought his Brillo boxes were boring because those things are boring in real life. But he thought his cow wallpaper and silver pillows when they were shown together were good.

He says he was there with Emile de Antonio, the film-maker, when Warhol had his two paintings of a Coke bottle out, or a telephone, one semi-painterly and one straight, without painterly drips. And it was him and Emile together, not just Emile, who said to go with the straight look and stop dripping.

But I thought it was Ivan Karp in that story. Maybe it was everybody. Those days were the days that formed the art world I was brought up on and it's interesting to hear about them from the horse's mouth.

Clement Greenberg was such a slimy person, he says, when I ask him if he found it hard when the great critic didn't support him. He didn't find it hard. He came from a generation of art that Greenberg found too good to be true. He couldn't believe there was anything lasting or substantial to it. But Greenberg never took so strongly against him as he did to Rauschenberg and Johns, he says. He just ignored him.

He says Greenberg was slimy because everyone had to suck up to him and praise his awful watercolours. It was sycophancy. But he stumbles over the word and he's not sure if it's sycophancy or synchophancy. What slip could he be making? I wonder, on a signifier alert.

He says when he first got going as a painter it was as if all art was either painting or sculpture. Then suddenly, in the middle of the 1960s sometime, it became more or less only sculpture. And all the things that go with sculpture, like Performance art. And it's been like that ever since. He remembers everyone thinking it was the end of the world when some scatter art by Barry Le Va was on the cover of Artforum. That was during the editorship of Phil Leider, which apparently was a good period, because of there being mainly only painting and sculpture during it.

But then it was always being the end of the world. It was the end of the world when Nancy Graves had a camel on the cover, and it was the end of the world when a Manet was on the cover. I suppose because Nancy Graves was too narrative and Manet was just art history.

Lynda Benglis end of world

I know another time it was the end of the world. It was when Lynda Benglis had a double-page ad in *Artforum* with a photo of herself nude with a dildo in the 1970s, and it was a bit confusing whether it was radical or regressive. It was part of the drive to expose the hidden male-power nature of Minimalism. Nowadays, of course, there wouldn't be any confusion about nudity and dildos and whether it was feminism or sexism, because no one would care. But in those days it was a controversy and some of the *Artforum* staff resigned or went on strike or went off to start *October* or something.

Forgot about arrest

I forgot to ask Stella about the stable of racehorses he runs and what it's like being a millionaire, and about when he had a phase of buying Ferraris and other fast expensive cars and speeding in them and the time he was arrested for that.

The advisor

What Jeffrey Deitch said

I first met the art writer, exhibition curator, gallery director and art advisor Jeffrey Deitch in 1986. He was in his mid-thirties. At college he was the only one who took business studies and art history, he liked to say. He got Candy Darling, the Warhol superstar transsexual, to come and give a lecture. Then he worked at the John Weber Gallery in the 70s. They showed Minimal art and Conceptual art. Then in the 80s he was working as the art advisor at Citibank.

What do you think an art advisor would be doing at Citibank? I don't know. I remember in the 80s art advisors were everywhere. I never thought about what they did because it didn't seem very interesting. I went to see him then at Citibank because Charles Saatchi said he was someone who knew what the new movement was.

When I got there, I said there didn't seem to be much happening in New York art, and German art was better. On the contrary, he said, there was a new movement with a whole new look. It was Neo-Geo. It re-did Minimalism and Conceptualism in a shiny Pop-like brainwashed way. And that was only the second time I'd heard about these artists.

So after that, I sometimes found myself asking him what the even newer movements were. Although after Neo-Geo nothing so dominating ever came up again. That was probably the last really big new art movement there was. And I think I didn't see him for a few years anyway.

Mood of correctness

The last time I saw him was just recently. He took me for dinner near the Gramercy Park Hotel at a Greek restaurant. The conversation was about the new movements. Or semi-new. Like the political correctness of the early 90s. Was political correctness a movement exactly? It almost was in a narrow style sense. But mainly it was an attitude that could take quite different forms. Bad Girl art was part of it. The most popular Bad Girl was Sue Williams. Her paintings were rough, with abrasive imagery of sodomy and assault and black eyes. And sentences, written with a brush, of imagined dialogue, which growled at patriarchy.

Another side of political correctness was Lorna Simpson, who showed smoothly beautiful photo-text works, which were cool but with a solemn

Jeffrey Deitch

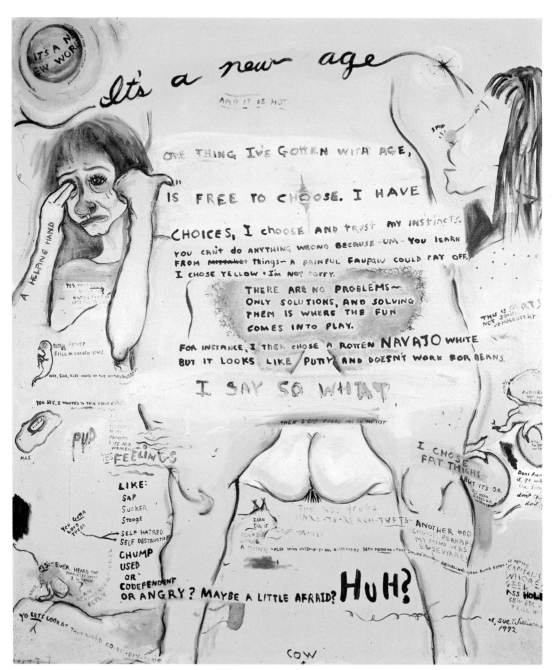

Sue Williams *The Yellow Painting* 1992

Mariko Mori *Mirror of Water* 1998

atmosphere, with an imagery of elegantly dressed beautiful black bodies, with their faces turned away because identity is problematic, inscribed with soporific free-floating abstract thought phrases and words. These words were from the quasi-religious swirl of identity/gender/race theory mantras of the late 80s, hanging on into the 90s. The theory mantras of that time were the equivalent of the Zen or Buddhist or generalised Eastern religion mantras of the 60s; in that they were a buzz or a hum sensed everywhere in the air. Like the scent of patchouli oil that was omnipresent in the 60s. The combination of words and imagery in Simpson's elegant works offers a tragically dignified and sheenfully elegant deconstruction of identity and gender, I was thinking. Phew, the red wine was making my head spin.

Globalism

I asked Deitch what the new movement today was, and he said it was Globalism. But I already knew about that. It was art from Brazil and China. Artists making installations about identity, and mixing techniques. Scrambling high and low, West and East, folk art and sophisticated art.

He said Globalism was right, because New York was very cosmopolitan. His favourite Globalist is Mariko Mori, who he shows in his gallery. She's a female Japanese Warhol or Gilbert & George or Jeff Koons. Costumed,

outrageous, theatrical, never out of character. Her art is a crossover from high to low. But only the very highest of low. She is very interested in Pop culture communications techniques. She makes giant photos of herself in fantasy hallucination science fiction scenarios. The photos are elaborate and expensive with high-production values. Composites of various staged set-ups, often from different parts of the world.

Another one he likes is a Russian artist who pretended to be a dog. And a woman from Pakistan. But these were all artists showing at his gallery, Deitch Projects. So I couldn't take it as an absolute certainty that they were the lead artists of now.

Sell the dog
How do you market the art of the one who lived as a dog? I asked. He said it was essentially unmarketable but still there was some debris, like the tray they slid his food in on every day, which might acquire a market value. He said, After all, what was there to market after Joseph Beuys's performance where he lived with a coyote?

Joseph Beuys's performance
It swam into my mind now. Black and white with crudely dubbed dialogue and old 70s haircuts and sideburns. It was called *I Like America and America Likes Me*. You can see it on video. I saw it recently at the Hamburger Kunstverein, which is in Berlin, confusingly. It's a huge gallery, where they have a permanent collection of vast numbers of Twomblys, Warhols and Rauschenbergs, in a big space. They all look fantastic and you can really see how those artists emptied the Abstract Expressionist gesture of its macho associations of rage and tragedy. And there are more big spaces full of a mish-mash of art magazine art, the usual Gerhard Richters and so on. Richter is quite good, but it will be a while before we don't feel we've had a bit too much of him.

Joseph Beuys still from *I Like America and America Likes Me* 1974

On this video, you see Joseph Beuys arriving at the airport for his first trip to New York. It's the 70s. He looks the same as always but everyone else looks like extras from *The French Connection*. Beuys gets into a waiting ambulance and is covered over with symbolic felt, by a slave or gallerist, to shield off the dangerous vibes of America. The ambulance drives off from JFK, and on the way into town – lights flashing and siren blaring – it's

stopped by the police. The policeman gets out of the police car and questions the ambulance driver. Not Beuys, of course, because he's wrapped up in the back on a stretcher, because of the angry spirit of America. The policeman is real, but apparently they couldn't persuade him to be wired for sound, because his dialogue sounds like a very bad added-on amateur actor's voice. Who gave you permission to drive that ambulance with the siren sounding, almost causing accidents? the added-on cop voice stiltedly asks. Then the Beuys ambulance arrives at the gallery. Maybe it's the John Weber Gallery with Jeffrey in the back, doing the accounts. And Beuys is bundled into the gallery space and there's a coyote in there and some straw and they're both locked in. And that's it for a few days or weeks. Beuys sits under a blanket and holds a magic walking stick, and the coyote, which has the spirit of America in it – wild and new, sometimes bad, sometimes good – paces about. Then it's the end of the performance and Beuys goes back to Germany. It's a classic.

There goes the neighbourhood
Jeffrey Deitch made so much money he used to live in Trump Tower. Before that, he lived at the Gramercy Park Hotel. But then he had to move because there was an old woman who lived there too, on the same corridor, who was dying. And she used to leave her door open and he would see her naked on the bed on his way to his room in the evening.

Yoko
Then a month later I was in another restaurant with Deitch, and Yoko came in, smiling, with some smiling muscular bodyguards and a woman holding a baby. Jeffrey jumped up and said Hi! because she was having a show with him in a month's time. It was *Ex It*, which I was talking about earlier, jumping ahead in time. And she said Hi!, too. And then, pointing to the baby in the woman's arms, she said, This is my baby! So that was interesting. How did she have that baby?

Then they all sat down on their table and we were on ours, Jeffrey, me and Ian MacMillan, with his camera. But he was afraid to take her photo. And we went on having our orange juice and scrambled eggs and talking about art and Ken Noland and his daughter, the artist Cady Noland, and what Frank Stella said about Andy Warhol having his own unique touch. But we couldn't help glancing over and looking at the Yoko table and wondering about the baby. Yoko had blondish or henna-ish highlights, and muscular arms from working out.

Is Yoko a good artist? No one can tell. She's too legendary. She was one of the Fluxus artists. They made ephemeral art and films and weird music. The films were collected up and archived by Jonas Mekas. He's a legendary film-maker and archivist. His film style is a kind of documentary realism. The shots are wobbly and the films don't last long.

Fluxus. Conceptual art. They overlap a lot. Fluxus was more silly, Conceptual art more dry. Fluxus started sooner and was overseen by a single main figure, George Maciunas. Conceptual art was much more diverse in form, even though by definition all the forms were very dematerialised compared to the forms of all previous art movements. And there were lots of main figures. Both Fluxus and Conceptual art were part of the drive toward egalitarianism in art, away from élitism. Democracy was the thing, élitism was out. But hardly anyone could get it. Only an élite few.

Not dysfunctional at all

Koons and Schnabel, the metas
When you meet Jeff Koons and Julian Schnabel, they are extreme meta-versions of a real self. You could say they were stagey in the way they present themselves. But it's not like they're somebody else behind that presented self.

They're both so egomaniacal they could seem psychotic, except they are not ill but actually fantastically capable and functioning in the real world. They each have a huge army of assistants and a magnificent empire and a load of paradigm-shattering artworks that they've invented, so psychotic isn't the word.

But you feel it's close, when they do that amazing oblivious behaviour that meta-artist stars do. Just riffing and busking and extemporising and jamming on a self theme. Like super-content children. Instead of the usual negotiating of egos and giving and taking and even the occasional silence that we expect in adult social interaction.

Charming
Of the two, Schnabel is the most charming and realistic-seeming. He is famously physically big. He has a sexy look and a devilish beard and golden highlights in his hair, which is either expertly dyed, or lightened from trips to sunny San Sebastian in Spain where he lives for part of each year. He

has the feel of a film set about him, and of course he does make movies now. In his studio the other day, there were some of the eccentric anachronistic portraits he has been showing lately. They're portraits of real people but in an approximation of a seventeenth-century Spanish mannerist style, and in historical costume. Then this look is interrupted by big incongruous pours of white. Some of them look good, some just weird.

Looming elsewhere in his cavernous studio/living space – where I have been several times over the years, for various reasons, and now again on this particular day – are gigantic dark bronze sculptures, assemblages of vaguely familiar shapes, like sections of interior architecture from old buildings. One is a giant cruciform, with the letters IDIOTA painted on it, in white.

Julian Schnabel
Portrait of Rene Ricard 1997

He explains the narrative of a film he's getting off the ground. It starts with a very poetic image, a baby in a wood. It's a film about a poet who had sex with a thousand men. It's a true story. There's a scene where the poet is in prison and his protector there, a murderer, strikes another man and for his punishment he's folded into a cement drawer for a month. This very man, who became a poet in prison, I think, maybe inspired by the main poet, came to stay at Schnabel's house with his family. They were a bit worried at first because he hadn't stopped being a murderer just because he was a poet. He was both, says Schnabel, with a serious look. You can't help being drawn into it all.

He says he thinks the London scene now is quite good but it's all ideas. There was one thing he liked in my book about it, apart from the descriptions of him and his influence on the young London artists, as an early role model. And that was Marc Quinn's *Self*, the artist's head cast in his own frozen blood in a refrigeration unit. He was pretty shocked by the reaction from London film critics to his film *Basquiat*. He said reviews there were much worse than anywhere else.

The gods
Schnabel is only in touch with the gods nowadays. He directs top Hollywood actors. *Idiota* and another iron or patinated bronze sculpture on a similar huge scale are both waiting to be picked up by Elton John, who bought them recently. He shows me a painting he completed on a day when he

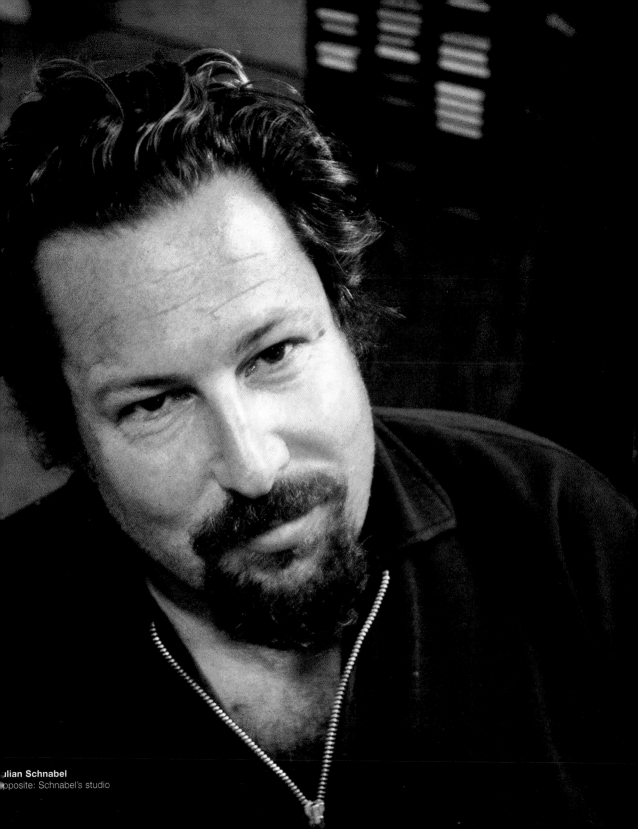

Julian Schnabel
Opposite: Schnabel's studio

was depressed and feeling bleak because Versace had just been murdered. His wife is a fashion model in Spanish *Vogue* and she's in the film *High Art* about trendy doomed lesbian photographers.

Glaring

With Jeff Koons the gaps in the construct are famously glaring, the Frankensteinian seams more jarring. But Koons has something like the same child-contented appeal as Schnabel, and is charming too, in a weird way, with his open expression and his pleasant cartoon-like face, part classic American handsome, part *Mad* magazine.

Like Schnabel he falls naturally into interview mode straight away. A bit less naturally actually because he is naturally unnatural. Since I see them both within a day of each other in their studios, I notice they both quite quickly start talking about the sex and sexuality in their work in an abstract way, and they both talk about faith. Like they're poets. Which they are. They're both full of ideas. As a poet, Schnabel is epic and transcendental and sentimental and imagistic and cinematic. Koons is more abstract transcendental.

Koons's studio is full of expensive children's toys and brightly coloured huge sculptures and paintings about childhood, with kiddie imagery. It's a big monstrous children's party. Nobody could say this wasn't a fantastic experience. To be toured round his endlessly chambered studio work-shop, with his paintings and sculptures that go on and on, never getting finished, all shown to me and explained. His dozens of assistants are sanding and scraping and wearing their dust masks. Or mixing up their paints on their palettes and putting little dabs onto enormous flat colour areas – parts of enormous flat bright Neo-Pop paintings – with tiny sable brushes.

Why aren't you photographing our leader? the assistants asked Ian MacMillan – he told me later – with a naughty edge to their enquiry, as he snapped them. The one with the carmine-tipped sable brush asked what date this book was coming out. When he was told the answer he gave a mock-bitter laugh and said he'd still be painting this red then. In fact, they're all sincere fans of the leader.

Meanwhile in another mighty chamber, Koons is explaining to me that the sculptures are all made in editions of four because it's more objective to do that. He has embraced the objective realm. He shouldn't do one sculpture in red, just because it's the most popular colour, he intones. He should do another one that's more purple and green because someone might like that.

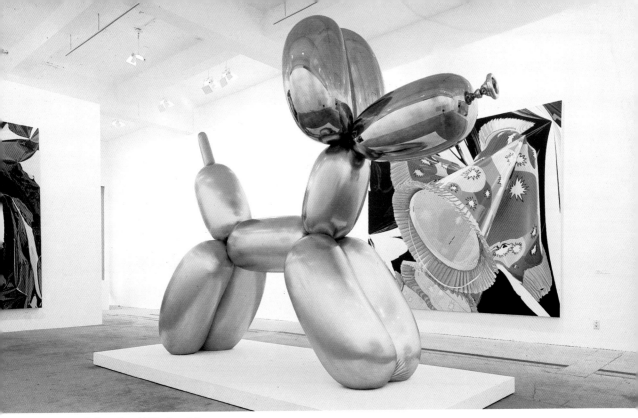

Jeff Koons *Balloon Dog* 1995–8 work in progress

The paintings have very interesting complicated spaces but basically they're paint-by-numbers and Koons says that's to be more objective too. Because, he explains, in a kind of much-rehearsed but simultaneously awkward way, if I had an area of white, and below an area of black, and one was grading into another, and I said, Matthew, where does the black begin and the white end? Everyone would have a different answer!

Your inside is out and your outside is in
Now it's near the end of our visit and Koons is saying a giant sculpture of a mountain of Play-Doh is a Freudian sculpture. That might be because it's like a pile of faeces that it would be nice to play with in a regressive fantasy world. Or because it's made up of 24 separate but interlinking organic shapes in a way that might suggest an integrated personality. Even though that would be more Jungian, I suppose. Or it might be because the inside is outside and the outside is in. That would be more Beatles.

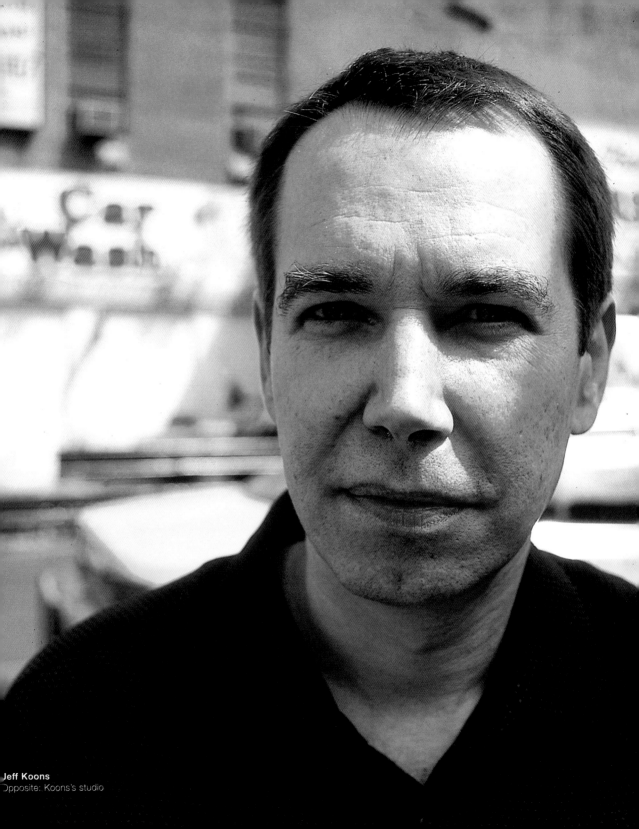

Computer golf

We hate you

The 80s had a lot of good art but it was a cruel era, or so we think today. We quite rightly don't wish any harm to come to the main stars of the decade but at the same time we hate them.

The burning crack addicts

Paul Taylor was an art writer from Australia who settled in New York and died of AIDS in the early 90s. He was the last writer to interview Andy Warhol. I was impressed by his candour once when he said he didn't think there was anything wrong with yuppies, that their values were reasonable. It was obvious he'd really been thinking about it and he kind of thought it was true. Maybe he already knew he had AIDS at this stage and he was genuinely testing out ideas, however objectionable, because there was no reason to pretend any more.

Another time, I was at a dinner given by a new gallerist. She was showing some photos by someone or other. They were interchangeable international photoworks of the late 80s, with asinine ironic Conceptual art titles. I think it was 1988. Anyway, the gallerist's husband's phone rang and he said he had to go out for a while because one of his buildings was on fire. And when he came back everyone enquired if everything was OK and if anyone was hurt. He said no one was. Only some crack addicts burned to death maybe, he laughed. And Paul Taylor looked a bit disconcerted and said some of his friends were crack addicts, and the humanity of his comment registered for a moment, but then of course I forgot about it.

The Mirror Phase

In the 80s, there was a good artist – Aimee Rankin – who really thought she could remember the Mirror Phase. She wrote about the experience and it was published in a book put out by the DIA Foundation, together with a lot of other essays in the mumbling high priestly style of the highbrow theorist critics. The Mirror Phase is a notion in Lacan. Children acquire language when they see a reflection of themselves in the mirror. It's nuts, I know, but that's the idea. Anyway, Aimee Rankin lived in Brooklyn and I went out there and there was a smell of incense there, and there were candles and devil objects and voodoo gear and stuff. She had changed her name. I forget what to. I had a headache and she gave me a magic potion for it, and it really did get better. She was great. I was there to make a

short BBC film about the influence of theory on the art world. She said it was true it had been a big influence on her in the past but she was a witch now.

Eric Fischl

David Salle is one of the main artists of the 80s, standing for figurative/abstract free-floating signifier art. But he was soon caught up by Eric Fischl, who was not so free-floating, but still hard to pin down. He painted roughly straightforward narratives instead of fragmented ones. Still slightly twisted, though. He painted scenes of suburban sexuality. Nudity on the beach, in the bedroom, in the pool, in the garden. One painting that became emblematic was called *Bad Boy*. It showed the bad boy reaching into a symbolic open purse in his mother's bedroom, with the symbolic mother lying naked on the bed. It's a hot afternoon maybe, because light streams into the room through the Venetian blinds and casts dramatic noirish filmic stripes over the naked mum. Beside the sexy purse is a bowl of phallic fruit. The paint-handling is cursory and loose, as if only the amount of realism that was really needed to make the scene was felt to be necessary. This might not sound much of a point, but actually it was the second main thing about Fischl, after the psychodrama subject matter. Or maybe the main thing along with the scenes. His way of making the paint itself seem as if it had a surly attitude.

Laurie Anderson

Partner of Lou. A big performance artist of the late 70s, with her star supernova-ing and then going out sometime in the early 80s. But probably due for a comeback soon. Her big work was *United States* and her big record was *Oh Superman*. *United States* was a spectacular lengthy performance, with the spiky-haired, big-suited Anderson singing and talking and playing a transparent electric violin that glowed, and her teeth sometimes spookily glowing too. She made good use of an electric voice-changer, making her voice suddenly deepen, like an effect from *The Exorcist*. The theme was identity, plus mistrust for parents, country and state. She thought there were nuclear missiles in the silos you see from the air all over the American West. She quoted William Burroughs: *Language is a virus from outer space*. And she told a good story about being in Paris, where she saw mothers pushing their prams out into the road before crossing, as if to test the traffic.

Laurie Anderson *Big Science*

Francesco Clemente

A very good Italian artist who settled in New York in the early 80s. He was absolutely the centre of art for a while, with charmingly weightless images

of bodies and faces and water flowing in and out of bodily orifices and out into the sea and down from the clouds in an eternal cosmic cycle, and bloody finger stumps and Indian religious imagery with sacred cows and archetypal terrifying earth mothers and Kali the Destroyers from Jung, using Grace Jones as a model. Then he was less the centre. He was always modelling for Comme des Garçons. He plays a psychiatrist in *Good Will Hunting* and his drawings are used in *Great Expectations*, starring Ethan Hawke as an artist of the 90s. They look good, as did Rainer Fetting's paintings in *To Live and Die in LA*, and Miró's and Schnabel's in *Wall Street*, and Schnabel's in *Basquiat*.

From the 80s through to now there has been a steady stream of Hollywood movies set in the art world or featuring contemporary art. Usually the art world is a place of evil in these films but sometimes it's a place of higher values. Some of them are: *9½ Weeks*, *Legal Eagles*, *Beverly Hills Cop II*, *Wall Street*, *An Unmarried Woman*, *Great Expectations*, *New York Stories*, *Slaves of New York*, *After Hours*, *To Live and Die in LA*. All of these are unwatchable rubbish except *To Live and Die in LA*, which is very good.

Clemente went quite fast from being a strange outsider to a popular exotic. At a gallery opening in *Great Expectations* someone says, Is Clemente here? as a sign of the producers' alertness to the well-known names of contemporary art. If they'd said Is Donald Judd here? it wouldn't even have registered as an anachronism, which is a mark of Clemente's rare success in crossing high and low.

Join the army
Schnabel's film *Basquiat*, which came out in the 90s, but is obviously about the 80s, is the only art movie ever made, pretty much, where the art looks quite convincing, even though it wasn't painted by Basquiat but by Schnabel.

The bad thing about the film is that some of the characters seem to have underdeveloped personalities and are listless, as if they didn't eat enough corn flakes, and you find yourself wanting to make them join the army. You have to wait till Dennis Hopper and David Bowie appear for anyone to say anything funny, which is a long time. Whereas Basquiat couldn't have painted like he did if he wasn't very intelligent and with a sense of humour.

Basquiat brilliant
Basquiat was an incredibly good artist. So good it's hard to take it all in. He just went at art in amazing leaps and bounds. He got the idea of

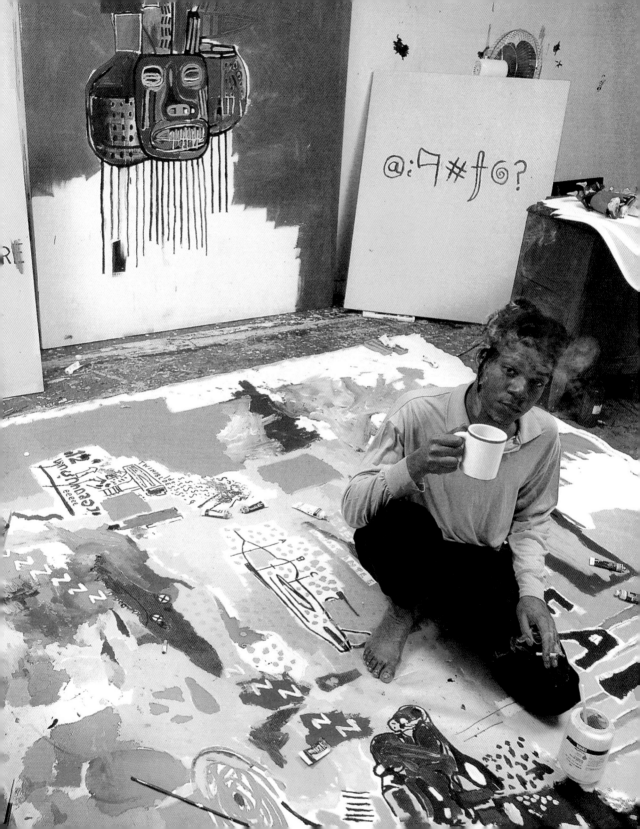

Abstract Expressionism and the idea of Pop and put them together effortlessly so they made a new idea. Then he died aged twenty-seven. Not everyone agrees about his greatness. Robert Hughes puts him down, saying he's slight and the Eddie Murphy of painting. Obviously it's wrong to be racist, but anyway it's wrong because he's not the Eddie Murphy but the Dubuffet, Cy Twombly, Rauschenberg, Picasso and de Kooning of painting, all at once, only black. Black faces loom out of his paintings. As good as the Mediterranean faces in Picasso's.

Dennis Hopper

He played Bruno Bishofsburger in the Basquiat film. He never met Basquiat, but he bought a painting by him from Tony Shafrazi for $17,000 just before Basquiat died, and then after he died he was offered a million for it. But it's still up on his wall. It's a big painting, with a lot of writing and drawing and abstract gestural marks and an African face staring out, with a mad eye made from a white blob with a black X on it. Hopper points out a little black silhouette of a movie camera amongst the graffiti.

Amazingly, I'm here in his house in LA, talking to him. The river flows down to the sea. Wherever that river flows, that's where I want to be. That's *The Ballad of Easy Rider* by The Byrds. The Easy Rider's faithful *campadre*'s computer-driven golf machine is here. It's great. He can change the terrain on it in a flash, as if it's a movie special morphing effect, and every time he gets the ball in the hole, the machine applauds. He's just come from the gym. He laughs and says he doesn't know why he bothers. But in fact he's amazingly handsome and a good ad for oldness. His Andy Warhol silk-screen of Mao Tse Tung has some bullet holes in it which he did himself. It was in a different life, he laughs – when I was a bed-wetter! He is referring to his years of alcoholism, now long past. About the *Mao* he says, I fired a warning shot and then I let him have it right between the eyes.

He says he only noticed the movie camera in his Basquiat after he'd had the painting for a while. I ask him what he thinks about Basquiat's uncertain status – *vis à vis* that Robert Hughes quote. And he says he thinks his status is always the same. Always high. He shows me some photos he's been doing, of the surfaces of walls in Peru or somewhere. They're all good. Prints of all his old black and white photos are stacked up. Portraits of Ed Ruscha and stuff.

Ed Ruscha

Basquiat studious

Basquiat was obviously studious. In their energy and amazing formal coherence and impact and structure, his paintings would fit in any museum showing the heroic Moderns. But also they're full of interesting learning and information and weird poetry. He writes CPRKR at the top of a black space for Charlie Parker, and Charles the First at the bottom for the same thing, and it's the best concrete poetry you ever saw. Unless you've seen Ed Ruscha's art, because he's a good poet too.

Ed Ruscha

A leading West Coast artist who never goes out of style, even though he's sixty now and he's been going since about 1963. Books. Photos. Works on paper. Paintings. He did them all. He's uniquely American, even more than Warhol. Maybe he's even more American because he's not traumatised

Ed Ruscha 26 *Gasoline Stations* 1964

or an outsider and nothing much has happened to him. His art is fundamentally normal. It's not deep and it's not shallow. It's sublime on its own terms. On other terms it might seem a bit thin. But it could never be on other terms, because it could only be what it is. *ARTISTS WHO DO BOOKS. ARTISTS WHO MAKE 'PIECES'. A BLVD CALLED SUNSET. HOLLYWOOD IS A VERB. JAPAN IS AMERICA*. These are some of his works on paper. Just the words, with the backgrounds filled in with light washes of pastel or watercolour, or dark blocks of ink. In the past, the backgrounds were often odd materials, like gunpowder or spinach. *Honey I twisted through more damn traffic today*. That was another work. *Brave men run in my family*. That was another one. He still uses a masking and filling-in technique from the dark ages, without assistants or computers.

He was at the Anthony d'Offay Gallery in London yesterday for a photo session. Where did you get the line for *Brave men*? I asked him. He said it's from Bob Hope. Lana Turner asks Bob Hope, Are you afraid? And Bob says, Afraid! Brave men run in my family! He said he just wrote down the line in *Honey I twisted* one day. He couldn't remember where he'd heard it. They were all just things in the air. He said he'd seen a young British art exhibit at the Hayward Gallery last year and he thought it was Hot. When it was time to take photographs of him, he said, Let's Boogie!

Crescendo of obscurity

Murdered and tortured

Coming out of the Museum of Modern Art, I see a middle-aged man on the corner of Fifth Avenue, bald, with silver gaffer tape strapped round his head, like a diagram of a space helmet, or a sign for a force high above to home in on. He holds a card that says, Help me I am being murdered and tortured. It's quite rare to see insane or homeless people on the street in New York nowadays, in the late 90s, whereas in the 80s they were a natural part of the experience of going round the art galleries. It was Modern art Babylon then. Restaurants and openings and enormous studio lofts and outrageous homeless people.

Murdered for real

Once in the 80s I was at the bar in the Chelsea Hotel, or one near it – maybe they don't have a bar – with Tom Lawson, the art writer, and Susan Morgan, another writer. I was staying at the hotel because I'd heard of it and it was the only one I could think of. So I just got the cab to go there when I got off the plane. Unfortunately it wasn't really a cab, but one of those fake limos the airport police warn you not to get in, and the fare was $100. Then I checked into the Chelsea and it was really seedy, just like its reputation. Only in reality, as opposed to myth, seedy isn't what you really want your hotel to be. Plus there really were artworks in the lobby, by artists who'd paid for their rooms with art. Only the art was all dreadful and it was just gathering dust. So the whole thing was depressing. And that was my first trip. Except for an earlier one, in 1980, which I don't usually count, because nothing happened. I went to a Ken Noland opening at André Emmerich. It wasn't so much that something happened there, as that it was rather grim. The art was dead, and the press view people were zombies, and the whole uptown gallery scene seemed like a cliché, and you could really sympathise with terrorists and with Valerie Solanas.

Anyway, I was at the bar at the Chelsea, or in the restaurant next to the Chelsea maybe, five years later – with the TV sets not working in the hotel and the plumbing making a noise at nights and the other people staying there being really boorish – and Lawson and Morgan were filling me in on recent art world gossip. An uptown dealer and an employee from the gallery were out partying one night with a Norwegian student and they all had sex, and then the two dealers took the Norwegian to the woods and tortured him and murdered him for fun and left his body in the undergrowth. But

then it was found by backpackers and somehow the gallery guys were arrested and charged and eventually the dealer was freed but the employee went to prison. How unpleasant, I thought. And it all seemed to fit with the grim reality of the art world, even if it was a bit more exaggerated than the real reality. And nowadays you still see that dealer's name in ads in the art magazines.

Dealers of the 80s

They were all incredible stars. Mary Boone was the best. Everyone wanted to be as good as her. She lives in a gold and marble palace and she's always sun-tanned. Then it was Larry Gagosian. He frightened everybody with his willingness not to bother to pretend he was a gentleman. It's great that he really does own a house called Toad Hall. The model for the gentleman dealer was Leo Castelli. He's very old. He discovered Jasper Johns. There has to be a gentleman to contrast with everyone else, to make the mythic system work. He's definitely got the job.

Annina Nosei. She had Basquiat down in her basement churning out his works. Collectors came round and bought them and she sent him round to the cash machine with her assistant, so he could get paper bags full of thousands of dollars. For his packets and piles and lumps and wraps of drugs. (Although of course she wasn't ordering him to buy that stuff.) And his hamburgers and expensive coffee-table books of Cy Twombly and Leonardo da Vinci and bottles of champagne and Dean & Deluca groceries and dinners at Mr Chow and the Armani suits he always painted in. The year before, he'd been living in a cardboard box. It's true and a myth at the same time. It's a myth that's run out. We don't know what to do with it. And we don't know what to do with the truth either. But it's the thing Annina Nosei is still most famous for. Even though there's a lot of other interesting things about her. One interesting thing is that Manzoni once signed her as a work of art for life, and gave her a certificate of authenticity, which she still has. Is it patronising to say Basquiat was a slave in the basement? Is it blind to say he wasn't? We don't know how slavery works in the modern age.

Jay Gorney. He was a new one. He showed Tim Rollins and K.O.S., Kids of Survival. Everybody liked them. Then they didn't. And he showed Barbara Bloom. Same thing. Barbara Gladstone. She cleverly showed Matthew Barney. But maybe that was the 90s. He was the next big star after Jeff Koons. No one can sum up what it is he does. Meyer Vaisman. Peter Nagy. They cleverly combined gallery-running with being artists. International

Mary Boone

With Monument. That was one of the galleries they ran. Nature Morte. That was another one, I think. Then Peter Nagy went to India and ran another gallery there. Tony Shafrazi. He showed graffiti art. French kids loved it. They came over and hired cars and went driving around the Bronx, pointing at the poverty and laughing. The East Village. That's where a lot of new galleries started up in the early 80s. Closed. That's what most of them were by 1985. NoHo. That's the area above SoHo where a lot of new galleries opened and then closed when the art boom ended in 1990. Chelsea. That's where all the old galleries are moving now and the new galleries opening up.

The 80s receptionist
The receptionist's boyfriend used to work at the Whitney Museum, packing or hanging. One day she received a call from the biggest dealer. Would she consider a position at the gallery? Yeah! she said, as she was only working as a secretary or an assistant manager or something, somewhere.

Eventually there were two phone interviews with the dealer, really rigorous, each lasting an hour. Every detail of the receptionist's life was gone over. It turned out the dealer even had the receptionist's birth chart done. (Later, after she left the gallery, she learned the dealer asked someone applying for the same position what *her* birth date was, and when the dealer heard it was such and such a date in 1966, say, she said, That's good, because I've had a lot of trouble from people born in 1965.)

Then there was an interview in person and at last it seemed the job was in the bag. But the receptionist still didn't know what the job was. When she asked what position the dealer was interviewing her for and the dealer said receptionist, she laughed.

But then she started work anyway. She arrived at the biggest gallery absolutely on the dot of opening time on the first day. The dealer asked if she'd had trouble finding the place. Because obviously you had to get there long before the dot.

The dealer communicated with the receptionist by sign language through a glass partition. All callers had to wait. The dealer would signal with one finger held up, or two, or three, how many minutes the caller should wait. The receptionist had to memorise the phone numbers of the people likely to call – the biggest collectors, the biggest artists, the biggest museum directors, the biggest journalists, the other biggest dealers. The biggest dealer would test her. Give me ten Ss, she would say.

The calls had to be colour-coded in a special book. Maybe a certain colour for the biggest collector, another colour for the biggest artist, another for the biggest journalist. Other colours for the nature of the call – a big hello, a big wish to purchase, a big wish to have dinner.

She had to always be ready with a memory of the various numbers of whoever was calling – their mobile, their country home number, their Swiss or Mauritius or whatever home, their office. So she could ask the caller, Should the dealer phone you back on (repeating the number by heart, even if it was a long mobile number or a complicated foreign number), or on (repeating off by heart two or three other numbers)? So the caller could feel good about himself, or herself.

The big collectors ran publishing empires or advertising companies or owned Gap or (put in your own biggest thing).

The dealer said she was the most verbose person she'd ever had working at the gallery because she would say to the dealer, Call from (the name of the biggest collector or artist or whoever). Instead of just saying the name on its own.

The artists would sometimes come by in their suits. If they weren't already signed up, the dealer would seduce them with millions and new cars. If they had been signed up, but had moved on, everybody in the gallery always had to laugh when their name came up. What losers they were! How their careers were going down now!

Just before a new show went up, the dealer would go around and hug all the employees and cry and say how glad she was they were on the team. But sometimes there would be a mistake. For example, the receptionist once made the mistake of asking a caller to hold while she took another call, because no one could call for more than three rings without being answered. The call-waiting turned out to be only a wrong number, and the receptionist should have known that's all it was going to be. And she should not have made the caller whom she asked to wait feel bad about himself.

When something like this happened, then the sound of banshee screaming could be heard through the glass partition and through the whole space of the gallery and maybe even down to the corner deli, from where the dealer would arrange for lunch to be sent each day for the receptionist, so she would never leave her desk.

Every evening before going home everyone had to sponge their desks.

The receptionist was driven home each evening. There were other perks. Like holidays in Europe after a certain period of employment had passed. And occasional fabulous gifts. Like a lovely item of clothing the dealer didn't want any more.

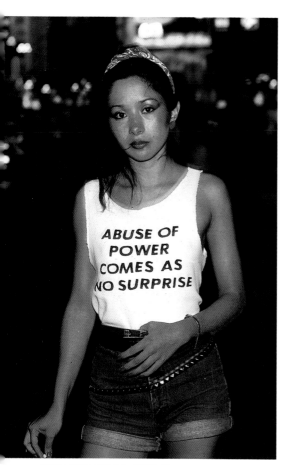

Jenny Holzer *Truisms* 1977–9

The receptionist should never leave. She knew the colour-coding system and the big callers' numbers and the secret rituals of the dealer's big dealings. There was nothing in writing, though, in case anyone sued. So it was a verbal agreement that everybody worked to. They worked for a certain number of years on a verbal agreement. Then the verbal agreement would be renewed.

But in fact the receptionist left anyway, like a lot of the receptionists left, quite suddenly, in this case after only two months, shocked silly.

Jenny Holzer

Not to be confused with Baby Jane Holzer, Warhol's first superstar. She showed aphorisms in the 80s on the LED system at Times Square, and in huge flashing neon environments in different colours at the Guggenheim Museum and the Venice Biennale, and set in cast bronze plaques and carved marble ones. When she started out, they were on posters in phone boxes and on T-shirts.

In their tone and sense, they drifted in and out of being very sharp and being quite dim-hippie. But they always had a definite look and a high recognition aspect. *Abuse of power comes as no surprise* is the most famous one. The idea was that, in responding to them, your own unconscious ideological beliefs would be exposed. Were you for the evil master narrative or against it? Maybe it was ruling you without you even knowing it!

Sherrie Levine

She took photos of Walker Evans's photos and presented them as her own art. It was Appropriation. She was one of the main figures of Appropriation in the 80s. She presented a quote from Roland Barthes, about the death

of the author, as her own statement, with the words 'author' and 'text' changed to 'artist' and 'picture'. She copied Egon Schiele's sexy watercolours and called them hers. After she was established as an Appropriationist she changed tack and did paintings on wood or lead, with stripes, or silk-screened Krazy Kat cartoons, or assembled vitrines with glass objects in them that recalled the bachelor malic moulds in Marcel Duchamp's *Large Glass*. She became more and more obscure. Nobody could keep up. It was something to do with masterpieces and women and Appropriation, but you couldn't tell immediately how it all worked, and gradually nobody mentioned her any more. Although she could suddenly come back again at any moment.

Barbara Bloom

Reached a crescendo of obscurity straight away in about 1987, but somehow there was an audience ready for it and it lasted several years. Her best-known work was an installation of old-fashioned-looking busts and portraits, from some imaginary Neo-classical past, but all based on her own features. It was about identity and culture, almost certainly.

Barbara Kruger

A top artist of arresting slogans. *I shop therefore I am*. And *Your gaze hits the side of my face*. And *Your body is a battle field*. These were some of her lines, which now almost seem to stand for the 80s as much as Koons's basketballs or Schnabel's plates.

She started out as an artist in the early 70s, but it wasn't quite right so she got into book design and advertising, and then gradually got her art going again. And then suddenly came up with absolutely immediately noticeable slogans that were about who has the power and how identity is constructed and how the body is just a series of discontinuous gestures and how patriarchy subjugates the woman not by hitting her with a big stick but by making her feel she just naturally has to play a slave role, even though it isn't natural.

Sherry Levine
After Walker Evans 1981

She used a bold, plain typeface, white out of black, a very 80s look, and ran the slogans, which she made up herself, across appropriated old photographic images of various things. The images seemed to fit, and the conjunction of imagery and slogan was often very startling, like the slogan

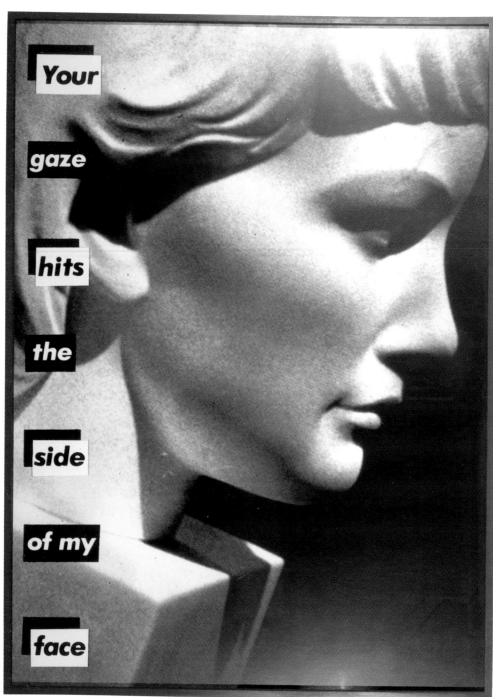

Barbara Kruger *Untitled (Your gaze hits the side of my face)* 1981

We have received orders not to move, over an image of a woman in a chair, slumped over, with giant pins sticking out of her. Perhaps it was an ad for painkillers originally. Other images included a shadowy man in an old-fashioned hat, gesturing for silence, finger at his closed lips, and a little boy in a T-shirt trying to flex a manly muscle.

These images came from old annuals, where there weren't any copyright regulations. Her art went beyond the gallery. It was presented all over the world as public art on billboards. In the galleries, it was buyable painting-type photo-objects, framed in a trademark red frame.

It was largely through Kruger's art that the discourse of power suddenly took off as something that everyone suddenly felt they ought to know about. Even though, after a while, it either sank in so successfully that it seemed too obvious, or else it seemed no more credible or absolutely true an explanation for the world than the Bible or alien abductions or Rosicrucianism. And basically there was a backlash against it and against her art.

At first, the international art world went crazy for her. She was taken on by Mary Boone, and stood for a whole sea change in art. Hunky men out,

Barbara Bloom *The Reign of Narcissism* 1989

sassy women in. Women, theory, the personal being the political. All in. In the past the personal had exploded into the public but it was never all that popular or commercially successful. With Kruger, the personal being the political was a big hit, and it started to be an idea that everyone knew about and was fascinated by, until it ran out in the 90s sometime.

But she went on having shows, even though the reviews started to become lukewarm or hostile. The single lines of type spread to vast environmental rants on the walls and floors of the gallery, about who has the power, the streaming texts overdriven with 90s-style swearing.

Importance of reading

Art magazines guide
Here they are. Always read them and keep your old copies.

October. Highbrow. No ads. Many quotes from Bataille and Walter Benjamin. Footnotes say things like: *See of course, Benjamin*. Because of course Benjamin would just naturally be on anyone's mind at all hours of the day.

Art in America. Middlebrow. Reviews all boring. Articles worse. Homogenised *Time* magazine style. Always must read it, though, to check who's up. Book reviews at front of mag often more imaginative.

Artforum. High and middle. Many articles not about art. Reviews at front of review section more lively than those at back. Lively ones from New York. Others from rest of world. Articles about art often very clever. In the past, great notions of art frequently appeared first in *Artforum*. Sometimes an *Art in America*-style article on painting is slotted in. No one knows why. Square format mag. Most enjoyable of all the magazines as an aesthetic object. Every few years a new reviewer who is always right emerges. At the moment it's Jan Avkigos. Always read her.

ARTnews. Lowbrow. Vast circulation. Magnificently vapid articles without any Benjamin quotes, about who are the richest collectors, or where are all the SoHo galleries now moving to, or personality profiles of star artists. Always amusing for absent-minded browsing.

Flash Art. Mixture of all others. Comes from Italy. Powerful in the 80s. Very threatening to trendy hegemony of *Artforum*, without even bothering to

weed out typographical errors or have a good design. But nowadays only on a level of power with all other art magazines. Main threat in the 80s came from being willing to have articles that transparently mapped out new trends, indicating clearly who the main artists were and what they did and what their rhetoric was, so you could really memorise them easily. Other mags somehow unable or unwilling to do this. Either too inept or unhip or ill-informed or too high-minded.

Importance of magazines

An artist doesn't really exist unless they're having exhibitions in a gallery. And an exhibition never happened unless it's been covered by an art magazine. Ad space is taken out in the magazines to advertise the shows. And to keep the general communication system going. The system is based on the idea that the magazines will cover the shows. It's not a direct financial relationship, where reviews are actually paid for. But it is nearly. On the other hand, it's a system that seems to work quite well.

Separateness of art

Even the magazines in which they keep the intellectual level deliberately low wouldn't be much fun for anyone not in some way professionally connected to the art world. The art world is cut off from the rest of the world, so art magazines are cut off too. They're impossibly inward-looking and precious, fearful of breaking the codes or rules of the discourse, whatever the discourse happens to be. Whether it's a discourse with entropy as a buzzword, or commodity or Benjamin or cruciformality.

And even where there are outbreaks of outside-world awareness, as there sometimes are in *Artforum*, with reviewers' discourse in the 90s somewhat jarringly emulating youthful street-speak for a few paragraphs, it's still in the context of an intricate, complicated closed-off system of values and ideas, which no outsider could possibly get. Art is separate. No one knows how it happened or if it will stop one day.

My favourite art critic

Greenberg's greatness

Clement Greenberg wrote very clearly and brilliantly about art. His writing had a number of phases. It is all worth reading, but the first phase, from the late 30s to the early 50s, is the best. After that it's not so interesting, initially because he had said all he had to say; and eventually because even though he thought of some more things to say, it was too late because he'd been knocked out by Pop. Nevertheless, he should be anybody's favourite American art critic, as nobody else ever came close to his very clear, bold, high-minded style. But instead he is rather hated. Anyway, here he is now in this book, not for the first time. And he'll be back a lot, later on, too.

Jules Olitski with **Clement Greenberg** and **Kenneth Noland**

Plaster

The last time I saw him was just before he died in 1994. He had a plaster on his head and he looked the worse for wear. It was in the Pace Gallery. He said, There's a lot of good paintings here! And there were. Rothkos and stuff. He was tiny and shaky.

In charge

For a long time Greenberg was in charge of Modernism and what it meant to be good. If he said you were bad you really were. He said if you were in or out, worthy or rubbish. That's why we must always think about him, even though after a while he wasn't taken seriously any more. Because Modernism ended and it didn't matter who thought they were in charge of it.

Those who had been the servers of the leader thought it was just the immoral ignorant philistine tasteless market calling the shots now. But those who had been outsiders thought the change was good and it wasn't just the market.

Greenberg basically said you could tell if an artwork was good just by looking at it. You could tell by your trained eye. It didn't matter what the ideas were. The forms were enough. In fact, they were the main thing. The only thing. That's why his idea of art was called formalism. Formalism is bad, we think. But we don't know for sure. It might turn out to be good.

Formalism as a kind of historical style is abstract colour-field paintings and abstract sculptures of the 60s and 70s. There was a formalism earlier but we hardly ever think about it. It was Russian Constructivism and designs for teapots and stuff.

Formalism back

Today there's a return of 60s formalism. It looks fantastic. But we don't know why. It would be alarming if we thought the reason was that we had a secret craving for authoritarian criticism to come back. So it must be something else.

I went to an exhibition of formalism recently. It was some old Ken Nolands and Olitskis and Caros, at the André Emmerich Gallery. That's where these artists all used to exhibit. Maybe not Paul Feeley, who was also in this show. He taught at Bennington College, in Vermont, where all the Greenberg artists taught, and where Greenberg himself was a constant presence – advising the artists and lecturing the students. And sleeping with them, according to a racy recent biography by Florence Rubenfeld.

I don't know where Feeley used to exhibit. He was a relatively minor Greenbergian formalist, who appears in a few anthologies of 60s art but who died in the 60s and was forgotten. Until his layouts were ironically appropriated in the 80s by Philip Taaffe, the Neo-Geo painter.

Everything in the show looked fantastic, as it was intended it should. The paintings and sculptures looked slightly unreal, like objects in a space ship, beamed up. On the reception desk there was an amusing reprint of an article in *Vogue* from the 60s, about Bennington. It was full of anachronistic references to the glamour and sexiness of the young women who studied there, and evocations of the swinging lifestyle of the artists, and their sexy cars.

Kenneth Noland

It must have been a hell of a life for him after about 1968 when absolutely everything that happened in art was against him and everything that was written was against him too. What did it mean when he stained paint straight into the raw canvas and eschewed gesture and cubistic space and subject matter and narrative? It meant nothing, everyone said. He did targets, chevrons and stripes. History will tell, he hoped. But his target paintings in this show are already good, whatever history says.

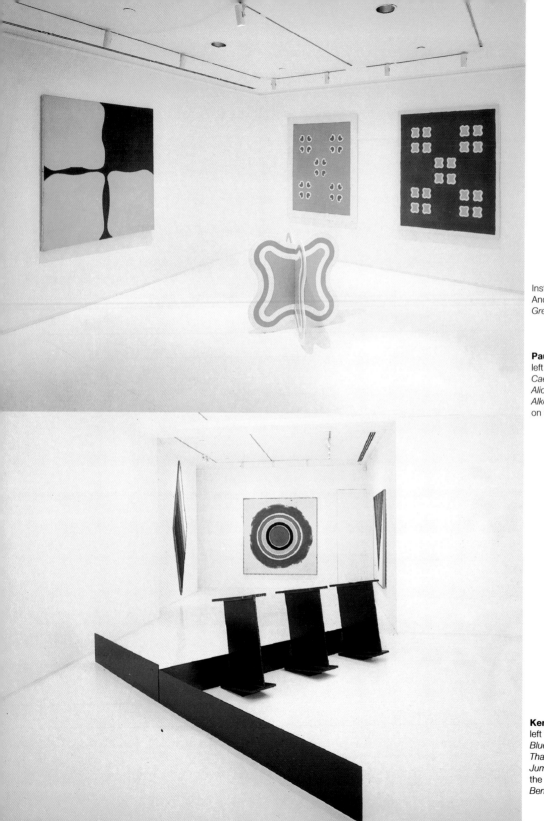

Installation at
Andre Emmerich, 1997
Green Mountain Boys

Paul Feeley
left to right:
Caesarea 1962
Alioth 1964
Alkes 1964 and
on the floor *Enif* 1965

Ken Noland
left to right:
Blue Plus Eight 1964
That 1959
Jump 1966 and on
the floor **Anthony Caro**
Bennington 1964

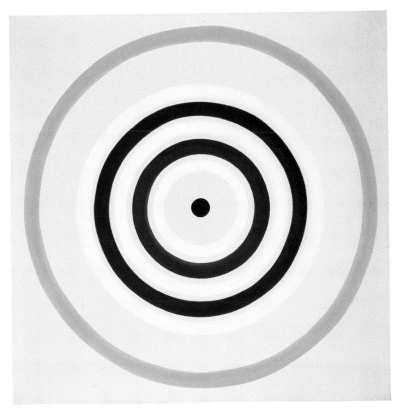

Ken Noland *Spring Cool* 1962

I saw another target by him in the Ludwig Museum in Germany the other day, called *Amusement Blues*. It was in the permanent collection there of abstract paintings coloured blue. A blue Barnett Newman, a blue Brice Marden, a Pollock with blue in it, an Ellsworth Kelly with blue and yellow. Only the blue Noland could survive the curatorial crassness.

Stop all movements!
Greenberg was against all the art movements of the 60s onwards. Except the one he named himself, Post-Painterly Abstraction, and the sculptural version of this style. I'm not sure if he had a name for that. But his broad term for both of them was advanced art. It just spoke for itself, he thought. Its quality was what made it advanced.

Clever, cry, crop

Greenberg stands for a model of art critic that certainly no longer exists. He was respected and feared for quite a long period. Money somehow came to him. Although not all that much. Less than his enemies say. He seemed really to be in charge. He went to artists' studios and made them cry. He made them crop their paintings.

At first he said advanced art was Jackson Pollock. Then not Pollock but Barnett Newman, Clyfford Still and Mark Rothko. Then not them but Morris Louis, Helen Frankenthaler, Jules Olitski, Kenneth Noland and Anthony Caro.

The paintings were about colour, because that was the only direction painting had left to go, he said. After it had rid itself of everything that was unnecessary for quality. And the sculptures were about not being solid and lumpy, like sculpture is. But being open. And maybe having some colour as well. Although no colour was OK too.

Helen Frankenthaler

She stained first. *Mountains and Sea*. That was her stain breakthrough. In the 50s. A beautiful painting. Stained canvases were really supported by Greenberg. They had more flatness.

Nowadays there is a big push to spotlight women artists of the past who may have been overlooked because of patriarchy. But with Frankenthaler, the opposite is the case. Because of the even bigger push to forget about Greenberg, she is hardly ever talked about, and gets less and less famous all the time.

For Greenberg, Frankenthaler is the bridge between Pollock and all the international abstract blob and stain and stripe and spray paintings of the 60s and 70s.

What was it, this stripy, blobby, stain-y, spray-y stream of international successful art? What was its compelling power? It was kind of the art of the highbrow end of the Martini set, before the point where the Martini set met the intellectual set. It was the radicalism of the canvas weave. The radicalism of flatness and Cubism. And things looking just right in a flash. If you were tuned-in enough to get it. Looking Modern but seeming to be connected to a *crème de la crème* of art history and culture and learning as well. Up-to-date but also up there with Beethoven and Mahler and Ming vases.

But then from about 1972 onwards, although it went on being made, stained and stripy art suddenly seemed like it was only connected to lounges and corporate lobbies and airports and Martinis. And not to radicalism.

We don't know why the cold wind blew on stripy paintings. It just did.

Rocky II

Greenberg was amazingly ready to punch anyone who crossed him. He had an affair with Frankenthaler for a while in the 1950s. They were both clever and attractive, so it made sense, everyone thought. One day, when he was at a party, he heard Frankenthaler was having an affair with someone else. So he punched the man who told him. Then he walked across the room to where Frankenthaler was standing with the man he'd been told she was having an affair with, and slapped her. Then he tried to punch the man, but the man punched Greenberg instead and knocked him to the floor. Then Larry Rivers, the proto-Pop painter, who reports this story in his autobiography *What Did I Do?*, helped Greenberg up. But soon after that, Greenberg said Rivers's paintings were no good, and so they were always enemies.

In the war he punched Max Ernst and gave him a black eye. That man has a sense of honour, Hannah Arendt said, coming out on Greenberg's side. There's no flies on Arendt, Greenberg said.

Morris Louis

He poured. He used acrylic. All the Greenberg painters did. His paintings look fantastic. And they have really dignified titles like classical Greek words, or like the names of space satellites. *Delta Nu* or *Ambi I* or *Gamma Gamma*. After Louis died of cancer in 1962 at the tragically early age of forty-nine, Greenberg had the job of deciding where his paintings should be cropped, because they'd all been painted with the canvases unstretched. Someone had to do it and he probably was the best choice, but it somehow counted against him later. It was seen as his arrogance. He got some free Louises as payment, one a year. And of course he sold them. And that was seen as his money-grubbing. Unfairly, I would say. But then Louis's widow went off him anyway, as everyone went off him sooner or later, it seems, because of his arrogance usually, and the supply dried up.

Jules Olitski *Green* 1962

Jules Olitski

Olitski's paintings look fantastic too, like Louis's. Only more wildly varied in their thickness of paint surface. From really thin to really thick. Also, they range more in type of colour. From brilliant saturated high greens and oranges and reds and so on, to more muted plums and browns and pinks, to extremely muted, like cream or clay or coffee or toffee. They're pure pleasure. You could say it's hard to consider seriously the magisterial greatness of paintings with titles like *Green Scrozzle* or *Instant Loveland*. Or *Blue Bonza*. But that would be wrong. Those titles don't mean a thing. And anyway, they're good.

Olitski was Greenberg's favourite in the critic's last years. He said he was the greatest living painter. It used to be Kenneth Noland and Olitski, but then it was only Olitski. Olitski lays it on heavy! Greenberg exclaimed once, in a kind of delirium, when I was interviewing him for TV. He lays it on thick, he said. Damn. Thick. Thick. So heavy was good for Greenberg by then, the early 90s.

Olitski market comeback unsuccessful

In fact, this was the time there was an effort by an international group of dealers to get Olitski back into the big time art market, which he'd long since fallen out of. And the new paintings by him they were pushing actually were amazingly thick. Three or four inches in parts, with Olitski putting on the paint with his fingers. Not with a brush, but wearing a big mitt to do it. And he applied light sprays of opalescent colour, to bring out the roiling surface.

Olitski's excellence

Two days ago I was on a boat in New Hampshire with a silver lake all around me and the sound of loons calling and the breeze blowing and a dark forest looming up ahead. It was Bear Island. Home of Olitski. Interestingly, Olitski isn't his real name. It's something else, beginning with D. His father was executed in Russia in a pogrom, and his mother brought him out to New York as a child. She answered an ad to be married and the husband turned out to be a nightmare stepfather who abused him mentally and physically. He was told that he was an idiot and retarded and he believed he was. He never spoke. The only thing that kept him going was the fantasy of killing the stepfather when he was older. He grew up and joined the army, to get power for the murder. But when he thought he had enough power, he couldn't go through with it, and felt pity for the stepfather instead; and he even took his name, even though he hated it.

He came out of the army and started being an artist. But he was too socially inept to get into the art world. He lived in a little room that had rats. He was starving. He thought he was going mad. He felt suicidal. Then his luck changed. Because of something to do with the G.I. Bill he was able to get a job at an art school as a teacher. He found he could talk. He had a salary. No one thought he was retarded. He kept expecting them to notice but they never did. After a while, he even got in to the art world. He was painting thick surfaces, influenced by Dubuffet, only abstract. Because of his shyness he pretended his paintings were by somebody else. He said he was only the agent. It was a complicated story but in the end he got a show and after a while he stopped pretending not to be the author of his own work, and he met Greenberg, and that was the beginning of his rise.

Er, Jules, I say to him now, in his studio, with his new paintings all around us. You know there used to be this kind of intellectual framework around your art that Clement Greenberg kind of started up? And then suddenly it

Jules Olitski *Rapture Veil* 1993

wasn't there any more? And nobody believed in it? And for about 30 years you've been this forgotten artist? Well, how do you feel about that?

That's when he told the grim early life story. He said he'd had so much rejection before the rise, that when the fall came he found he was emotionally equipped to deal with it. And anyway he wasn't completely forgotten, he said.

I tell him I met Greenberg a few times and I ask him about the new book by Florence Rubenfeld, who says that Greenberg, who was a famous heavy drinker, took heroin and cocaine and smoked pot as well. He says he can't believe that, because Greenberg was too mean to pay for drugs. Although, if you laid them out for him, and paid for them yourself, he says, he probably would take them, because he wouldn't care what anyone thought and he would take anything.

What about all that wife-swapping? I ask, not referring to Kristina Olitski, of course, who he's only been married to since the 70s, and who used to design all Janis Joplin's outfits in the 60s, and who is sitting here now with us. But to the wives and girlfriends of the 60s, when Greenberg and his *confrères* were all having nutty therapy from a group of psycho-analysts,

and they all stayed in a therapy residence in New York and there was a practice of changing partners and of therapists sleeping with their patients. Yes, it's true, he says. Although the book exaggerates it. He was involved in that therapy himself but eventually he went off it. But he is absolutely respectful of Greenberg and tender about him.

Olitski says he never really knew what flatness in painting was. The only time he really theorised, he says, he was wrong. He wrote an essay about the Edge. He said drawing was a matter of the edge of the painting. But it was all nonsense and he didn't believe it. What he really believed was that drawing was everywhere, in every fleck and spatter and gloop and drip of the painting. But then the Edge became a buzzword and everyone was obsessed with it.

He rationalises his universe. He thinks culture is very bad now. He used to think there was high and low in culture. There was a low point and nothing could get lower than that. But now he sees that low attracts low and makes more low. And now culture is all low. He can't understand why excellence is out and why élitism is bad. Elitism is necessary, he says. You don't find a heart surgeon in the Yellow Pages! he exclaims triumphantly.

Night falls. Out come the paints. Plastic tubs of acrylic. He knives a few gloops of the stuff on the surface of a white canvas laid on a table. Then he squirts liquid paint from plastic containers around and over the gloops. Then he pours on thick transparent medium from different pots, each lot tinted slightly differently, from various warms to various cools. Then he puts on a plastic glove and moves the goo around with his plastic-gloved hand. And then out comes a big hairy-backed glove that house-painters use for some textured house-painting technique or other, and he does more gloop-moving with this glove. Then he gets out an industrial blower and switches it on and there's a roar and he blows one corner of the gloop surface, making it pucker and move. Then he picks up some artist's brushes, and paints in some squiggles of colour here and there. Then he picks up one side of the canvas and lets the whole painting-gloop slide down the sloping surface a bit and then he arrests the slide. Then he stands back and looks at it all and says, That's it.

The next morning I go into the studio early and have a look at the painting and it looks good. It's the worst kind of art anyone could be making now, but it looks good anyway, even though there's no framework to make sense of it any more. Around the studio are more paintings on the walls. The one

Jules Olitski *Irkutsk Passage* 1997

he did last night is abstract, but the ones on the walls are almost all figurative. They have sailing boats and sunsets and nude women. He certainly is making his own intellectual framework nowadays. There are operatic skies of yellow, purple, blue. Lots of suns – orange suns, green ones, silver ones. The naked women are like Chagall. Generalised woman-shapes, in the water, on the rocks. Like mermaids. One even has wings and is flying in the sky. There are outrageous touches, like little puffy white smudges to denote cloudy edges. The kind of thing amateurs do. But it's all mixed up with sophisticated painterly abstraction. It's the new Olitski framework working itself out. What are we doing? the mermaids call. Where are we going?

Then it was later on and I was at a warehouse that had 50 years of Olitski's art stored in it. His whole back catalogue, it seemed. Racks and racks of paintings. You could slide out a rack and there'd be four or five paintings on one side and two huge ones on the other. And there were hundreds of these racks. The warehouse was on the side of a highway, half an hour's drive from Bear Island. It was run by Olitski's daughter Lauren. She works there every day, maintaining things, negotiating the odd sale. It looks like nothing from outside. Inside, besides the rack system, it's a gleaming environment. Part office, part 60s pad, with paintings beautifully installed on the walls, and classy sofas and glass tables and catalogues, and bowls of fruit and vases of flowers. You could sit on the sofa and soak up all the opulent, decadent, theory-less, stoked-up, anti-Duchampian pleasure-painting sights. From the outside, it was just an immensely long shabby old metal structure. But inside, it was Olitski World, waiting for élitism to come back.

Avant-garde and kitsch

That was the title of the famous article Greenberg wrote at the end of the 30s. Kitsch was the opposite of avant-garde, and we would all soon be swamped by it because of capitalism. Avant-garde art, flatness, Vlaminck, Cubist collage, Léger. Noble stuff like this was our only hope. Kitsch was things like bad poems and Tin Pan Alley. I learned later that Greenberg quite liked that music.

Greenberg's thoughts

Hot

In the early 90s I sometimes went round to Greenberg's idiosyncratically non-air-conditioned Central Park apartment to interview him for TV. He would come to the door in his shirt sleeves looking really hot and let me in and be gracious and friendly, asking if I wanted a drink, a big one like the one he was having maybe. There were Anthony Caro table-top sculptures around the place, and African sculptures and Kenneth Nolands and a general wall-lining of pastel or bright or cappuccino-coloured lyrical abstract paintings. When I asked him once which one he liked best, he said he didn't really see any of them any more. There was a big squarish Friedel Dzubas in dark colours, and a big horizontal striped Noland, and a vertical diamond-shaped one, and a vertical yellow-cream swirly Walter Darby Bannard. He was impressed once when I correctly identified some of them. There was even a work on paper by Jackson Pollock. In the bedroom, there was a

sandy-coloured lyrical abstract, about three or four feet wide, by Greenberg himself.

I would introduce him to the TV crew and the director. He was gracious but would sometimes confuse them by either mumbling or being suddenly very direct. You don't have to be so polite! he exclaimed to one director who was calling him Sir in an exaggerated British way, which I was finding quite irritating myself. So that was good. You know, you're very pretty! he suddenly exclaimed to the female production assistant once. Which of course was bad.

I'm having all my top teeth out in the morning, he said another time, when I phoned to remind him I was coming in the afternoon with a film crew to interview him about Willem de Kooning. But I'll be fine, he said, not very reassuringly.

Monet, Manet
I'm known as the most hated art critic in America! You've heard that haven't you? Sure you have! Well, so what? So what? That was him again. I was there to interview him about general topics, having interviewed him the day before about Monet. I must remember to say Monet, not Manet, he had said. Monet, not Manet!

Bad Bill
Yeah, Bill was by way of bein' a genius as a draughtsman, Greenberg drawled later that day, speaking of de Kooning. Ice in the whiskey glass clinking, unfiltered Camels blazing, sweat gathering. His TV interview style was incredibly natural, no different from his talking style, without any concessions to TV timing or the TV need for no mumbling. You either heard it or not, and he certainly wasn't going to finish a sentence when leaving it up in the air would do just as well. When I tried saying, Well spell it out, what was Harold Rosenberg saying Action painting stood for? He said, Hell no, I'm not here to educate anyone.

He said de Kooning had a bad character. He only thought how to be the greatest artist of the twentieth century. All his good paintings were in the 40s. Maybe there was some good blue in one painting in a recent retrospective. But that was often Greenberg's style. To isolate a very small thing and take it seriously, to emphasise how bad the rest was. It was probably an empty mannerism by now. The husk of something that had been real once.

That stinky de Kooning! he exclaimed later, gesturing violently with his elbow to show how de Kooning hit him in the Cedar Bar one night. It was a fight because de Kooning knew he was saying he was no good. I'm not afraid of you! de Kooning yelled, as the other drinkers dragged him off Greenberg. I've had all your women! Greenberg is supposed to have yelled back. But like a lot of art myths this one turns out to be only partly true, as Greenberg later recalled. He said he only liked one of de Kooning's women and that was de Kooning's wife, Elaine de Kooning.

Up and down
He said he never read the art magazines any more, because they only showed who was up and who was down. Take Ken Noland's daughter, he said. Cady. She's up. Now you know Cady, she happens to be beautiful. But aside from that, she does this arrangement art that's supposed to be conceptual. But God, her brother's a far better artist. And nobody's heard of him. Now *he's* a sculptor!

Moore is less
He said Henry Moore's sculptures were only turds.

Anthony Caro
He liked Caro. But even here he was watchful for the good and the bad and for opportunities for punishment for lapses in quality. He said, I saw that Caro show six or seven years ago. There was only one good sculpture there. And everything sold. Except that one!

Evil Modernists
Today I was reading Thomas Crow's new art book, *The Rise of the Sixties*. He calls the Greenberg artists the Modernists, and he describes a sinister struggle for world domination by the Modernists. Which wasn't just the artists but the other critics who agreed with Greenberg, as well as all the institutions that followed his lead and bought a lot of Nolands and Olitskis. The institutions on the side of the Modernists included many university art faculties. The bad Modernists would have won if the good Post-Modernists hadn't noticed it was universities who produced the government advisors who influenced American foreign policy in the 60s and caused the Vietnam war. They put two and two together and worked out it was stain paintings that were causing the war to go on.

Where Greenberg might have been wrong
Greenberg stands for clarity and intelligence and tough-mindedness and sincerity and sensitivity. But also, sadly, for drunkenness, cruelty, violent language, being a bully, being oblivious. What we notice nowadays, if we bother to think about him at all, is that there's no real connection between his main first idea – that culture had to be saved, which is a good idea – and then saying the particular American artists he liked were its only possible saviours. He might have felt it was true, but it wasn't necessarily. That was just him going out on a limb. And in the end no one else liked them and he went on stubbornly liking them, at least when he wasn't denouncing them, and that was his downfall. Maybe the drink too.

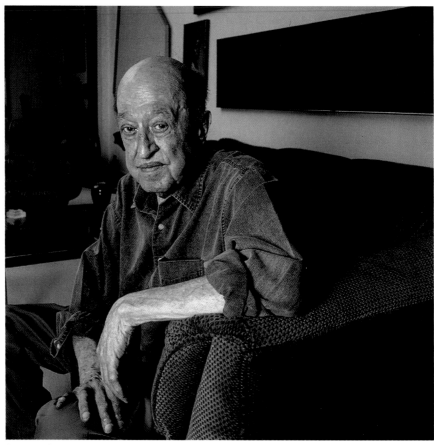

Clement Greenberg

Sex will never die

Pop art

This movement is so well known it's not worth going over it again. All its myths have lasted, with hardly any changes. When you see it in all the German and Swiss museums today, some of it looks a bit tawdry but it's still pretty good. The only thing we worry about is whether it was sexist or not. It was representations of modern life, with no emotional engagement. We want emotions back again in the 90s, but in those days, the 60s, it was all irony and flatness. That's how they could have outrageous sexism in art.

When Pop started

It started in Britain in the 50s but in New York it was about 1961. It was emphatic images of the consumer society and the mass media. Cars, sexy women, sexy men, sexy film stars; words as objects, objects as signs, signs as signs; ice creams, cakes, spaghetti, comic strips, toasters, hoovers, light bulbs, aeroplanes, ironies, lipstick. The images were as much abstract as they were figurative. It was a new kind of figurative. Hard, big, humorous, popular.

The main Pop artists

The first main one was Roy Lichtenstein and his early nervous Pop painting, *Look Mickey I've hooked a big one!* Then after a while the main Pop artists were Warhol, Lichtenstein, James Rosenquist, Claes Oldenburg, Robert Indiana, Tom Wesselman, Jim Dine. Before they became Popists, they all tried things that looked like the painterly expressive dripping art of the 1950s followers of the Abstract Expressionists. And then in a kind of desperation they painted or made things that, before, would have felt a long way below art, but which now suddenly seemed the right thing. So the first feeling of relief about Pop was that art could be made direct from the artist's own inspiration and not from following followers. Also, of course, it could be made from the low rubbish of brute life, and not just from the high-up things.

Sexism and sex

Pop had a lot of ironic sex. Much of it seems cruel today. Actually sex is back in art in the late 90s, but its perspective isn't so narrow as with Pop. In fact, one of the things about sex in art today is that the perspective is often ambiguous. But then, how unambiguous was it with Pop? It's hard to recreate the mindset of those days, and get how the jokes worked.

PART
TWO

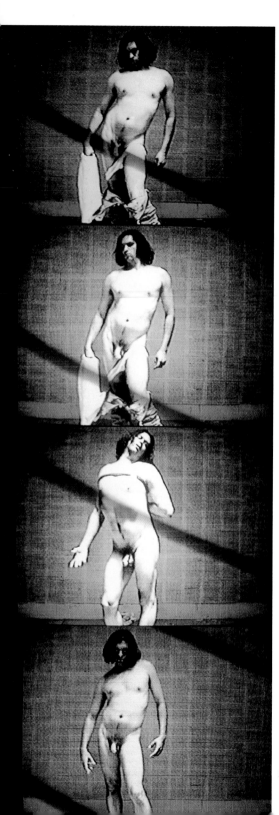

Be stupid and rude

Sean not lame
In the early 90s Sean Landers stood for the new mood in art after Neo-Geo. It was the slacker stupid grunge mood. It was a relief at first, like all new art moods. New art always looks satirical and anarchic, even when it's Minimalism. But this was far from Minimalism. He exhibited stream of consciousness diary ventings on yellow legal paper, as well as videos showing himself standing around with his trousers down, posing like Italian mannerist paintings of the sixteenth century, or naked, whipping himself. It made sense when you read his writings and learned he was a Catholic. He made crude clay heads of his grandparents, and stuck them on poles and stood them in front of his flagellating video, with huge canvases covered with his intimate confessional writings nearby.

His stupidity was brilliantly staged and his act honed to perfection. His writings are clever and witty and pointed, although at first they seem meandering and juvenile. They are sometimes rude about art's sacred cows, like Barbara Kruger, who he calls a hypocrite, and On Kawara, the famous Conceptual artist, who has been carefully painting the date every day since about 1966, about whom Landers writes: On Kawara, big deal, fat man in sandals.

I went to Landers's studio when it was on Houston Street, a few years ago. He seemed to share it with his brother and with the painter John Currin. He thought he'd come to the end of writings-paintings and he was trying out paintings-paintings. The paintings were pictures of New England types in three-cornered hats in landscapes. They were amazingly lame but he had made lameness his thing. It was a virtue now. Like ventings. There are ventings and ventings. And lameness and lameness. And he was the master of both. It was like Ken Noland making colour his area. You couldn't say, Hey that's only lame! It would be like complaining to Noland his concentric circles were only coloured.

Sean Landers stills from *Italian High Renisance and Baroque Sculpture* 1993

Then later

Then later Landers showed his paintings-paintings at Andrea Rosen. This time they were different scenes. Pictures of robots and bunnies having picnics. Nudes chasing each other. But nobody wanted them. So he got them all back and painted writings over them. So they were writings-paintings.

I went to his studio again the other day. This time it was in the meat district. There was a new writings-painting up, and some paintings-paintings waiting to have writings painted over them. One paintings-painting was a picture of a country bumpkin with a hat shaped like a penis, smelling a flower with a nipple in it.

Return of sex

Sean Landers *A Midnight Modern Conversation (Ignoring Hallucinations)* 1996

Sex painting

The late 90s have seen a rise of painting about sex. It is by artists in their early 30s. Both men and women. The main stars are Rita Ackermann, Lisa Yuskavage, John Currin, Cecily Brown.

Sean Landers also produced some sex paintings, but the sex is stupider and funnier with him than with the others. For example, his figure portraits that have pneumatic female breasts instead of faces. Or his paintings of Hogarthian drunks in period costume passed out at a table with breasts floating in the air above them. What connects the other sex painters, and separates them from him, is their emphasis on paint-handling, and the content of the painting being as much in the handling as in the imagery.

Elizabeth Peyton is sometimes associated with this group but what separates her is that, with her, sex is sweetly romanticised, and there isn't any actual sex being depicted, just depictions of sexy people, who are poetic and sensitive as well as sexy. With the others, and as we have seen they are not all men, there is outrageous nudity and frequent leering, throbbing explicit sexuality.

John Currin

He paints in a broad, painterly, realist style. A kind of realism that is not believable, or meant to be believable, in itself but which conjures up memories and associations of painterly realism. Not a particular realist painter, like Courbet, say. But a lot of realist painters, like George Bellows, say. Or other medium stars of the vague past whose dates we don't bother remembering but whose paintings are quite sympathetic because of their broad, vigorous handling.

Anyway, with this realism – which is only a suggested or referred-to realism essentially, but which has a lot of real realism pleasures about it, if you like that kind of thing at all, which, let's face it, many of us do – he paints women with enormous tits, vast. And weird thin men with goatee beards and polo neck shirts and odd over-sized medallions, who look like swinging intellectuals of an embarrassing type. Maybe they're art critics. He gets their clothing

Sean Landers

John Currin

styles from menswear catalogues. He says they're all self-conscious and straining and artificial, whereas their adoring busty women companions are all natural. The sex in the pictures is perverse and obvious at the same time. For example, a painting called *The Enormous Bust* shows a bust so enormous and so rounded and realistic and high-lighted and believably touchable that it looks unpleasant and frightening, but is sexy at the same time. But also it's a painting about different languages: rounded, flat, painterly, illustrational.

Currin is an amazingly Irish-looking man. He looks almost like a cartoon of an Irishman. His studio space is next door to Landers's. They're both from Irish families and are both good look-ing and it's hard not to objectify them, even if you're not gay. Both of them should be in the movies, and it's lucky for art that they are not. Unless you object to the dumb sexism of their paintings. Which would be wrong because it isn't dumb. How did sexism come back? No one knows. There was a big attempt to get rid of it, but it failed. Or else it was redefined to let these paintings in. Probably that.

Lisa Yuskavage

She paints grotesquely shaped sex-object women, or grotesquely endowed sex-object children, like sex nightmares, in lurid colours like turquoise and lemon. It's the revenge of the repressed sex object. And the revenge of the fat sex object. The figures just stand there, splayed, sad, tiny-headed, big-bottomed, super-throbbing. Aesthetically they verge on the horrible but there's definitely something there. She painted one picture that the title identifies as a likeness of herself looking like her shrink. Another picture shows an anxious chubby male face looming out of a black void. *The Feminist's Husband*.

top picture: **John Currin** *Entertaining Mr Acker Bilk* 1995
bottom picture: **Lisa Yuskavage** *Surrender* 1998

Cecily Brown

I go to her studio. Her friend is there. They smoke fags. They're charming. She's David Sylvester's daughter. She went to the Slade School of Art in London and now lives in New York. Her paintings are orgiastic streams of sexy imagery. Fields of image fragments, like throbbing organic exploding jigsaw puzzles. But with sweet colour. Mint or chocolate or bloody red or light yellow. Like food colouring or tinting or make-up. The writhing sex going on in the paintings is energetic and endless and everywhere, as if every day is a party for this painter, and every moment a tearful screaming climax.

Maybe their entertainment value is connected to the rise of sex and shocks in installation art and videos and sculptures and Neo-Conceptual art of the 90s, and our general tolerance of excess, and our expectation to be appalled all the time by things we see in art. Which proves how decadent we are.

Lisa Yuskavage

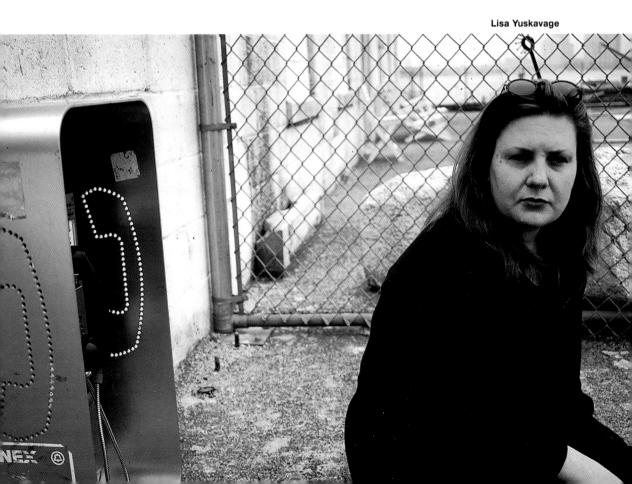

Cecily Brown

Even when we sometimes long for a bit of geometric rigour and purity and grey Minimalism back again, it's only for the associations, not the real thing. We don't even know what the real thing would be any more. Of course, the real thing was never real anyway. What was it then? We don't know. It just became an empty mannerism for everything to be grey and geometric or laid out in grids. But what did it mean before it was a mannerism? It's impossible to tell any more. We think it's all lovely and elegant anyway, whether it was real or mannerist. So once you get to that realisation, you realise there's no real reason not to just paint sex in whatever colour you like.

Everyone likes Brown's art because they think it's a relief to have art without ideas back. But in fact it's not against ideas to make art that's about sex, because in art sex is an idea too.

Cecily Brown *The Pyjama Game* 1998

I saw a lot of sketchbooks lying around her space, with drawings of outrageous fucking and fellatio and sodomy scenes, copied from different sources. Comic strips, nineteenth-century illustrations, old engravings, old paintings. These images were running through her paintings, but more flowing.

The pleasure of her painting is more in the confidence to make all this orgiastic adolescent stuff work, one way or another, than in any revelation of an amazing technique. So in that sense, it's quite conceptual.

Rita Ackermann

She is a recent arrival in New York, from Budapest. She lives uptown near a fantastic tangle of subway bridges and a busy noisy intersection. She looks like a drawing, with perfect features but everything slightly askew. Like a Chagall or Modigliani. Her paintings have multiple perspectives, with overlapping imagery, faces and bodies, usually her own. And free-floating abstract painterly blobs and patches. You see one face or body through another face or body. This overlaid transparent drawing with a brush is like Schnabel and Salle from the early 80s. She's twenty-nine now, they're about forty-five. Their paintings seemed to cleverly break but at the same time acknowledge the rules of painting as they stood at that time. Making a law-maker like Greenberg seem hopelessly doctrinaire and old hat, and themselves seem full of cheekiness and life and energy. But hers are all innocence. They just use the new rules Salle and Schnabel established as if they were natural laws. In fact, she's never heard of Greenberg. And when I ask her about Salle,

she says, I'll have to look into that – I've heard of him but I don't know what he does.

She shows at the same gallery that shows Sean Landers and John Currin. She says they have different interests from her. Different aesthetics. Different culture. 70s culture. Disco culture maybe. She's more 80s. They're more 70s.

So that's interesting. They define themselves in terms of what decade they ironically enjoy reliving.

Language

It's more relaxing to hang out with older artists, Rita says. She says she loves Dan Graham, the 60s Post-Minimalist and Conceptual artist. She says he's always complaining no one likes him and he's unsuccessful, even though he's the most important artist of his generation. Of course, her aesthetic, by contrast, is romantic, she says. Yeah. Pretty romantic. Psychedelic. Very eclectic. Actually, I *am* very conceptual. How I *choose* a style. It does come naturally. I'm painting from my guts but I still have a conceptual control.

It's a whole new language but you can kind of understand it.

Guitar and amp

There was a guitar and an amp in Rita's studio and a cassette playing. It was apocalyptic distorted guitar sounds and drums, which her husband had something to do with recording. She used to be called just Rita but now it's the full name. In the early 90s she was famous for graphic paintings of nubile pubescent girls with almond eyes and blond hair. They looked like her, but in grungy modern-life situations. A syringe hanging out of her arm, or puking. Or putting on lipstick in a mirror. Or having a bandage round her head with a patch of red blood. Or kissing another Rita. Or all those things in one painting.

Rita Ackerman *Smell the Flower From Below* 1998

Rita Ackerman *Get a Job* 1993

Rita Ackermann

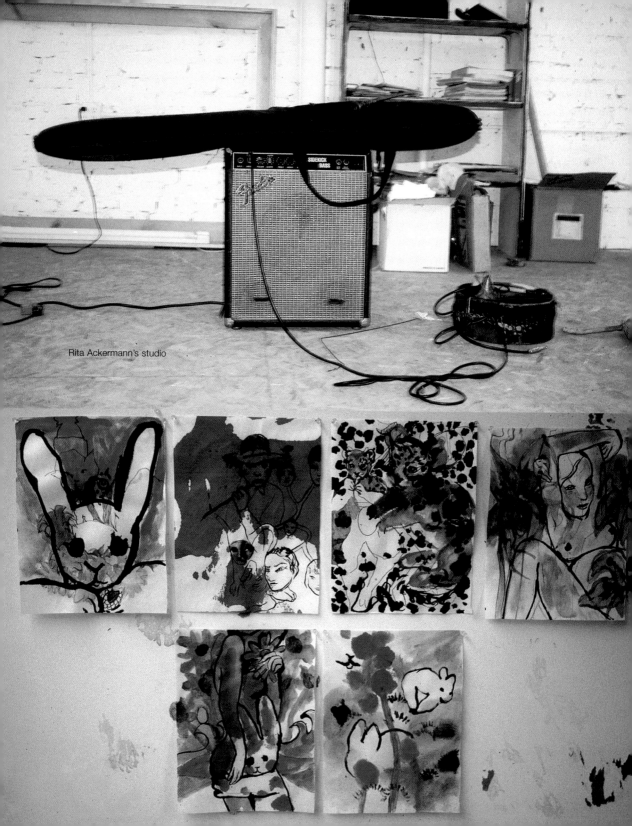

Rita Ackermann's studio

That was her early graphic style. Then after that her style got more painterly and full. Not just linear, but atmospheric, with swathes of paint and painterly drips and runs. And she started painting not on large sheets of paper in acrylic and ink but on expensive primed linen, with different types of paints. Before, you could say they were like 60s graphics illustrating a 90s grunge *mise en scène*. Now she is more timeless. But only timeless if, say, the album cover graphics of the Beatles' *Rubber Soul* are considered the beginning of time.

Bleed and run

On Rita's studio wall, now, there are little watercolours. A few of them all jumbled together, about A4 size. The colours are bleeding and running. It's odd how adolescent the mood is. After all, twenty-nine is pretty old. But the painting is sophisticated. Confident, dense and believable.

It's a definite look. You couldn't imitate it. You would never think of it in the first place. You'd think it would be too corny. When it came out in the early 90s, it must have seemed this was the new thing. The twisted Pop sensibility. But it was too exuberant and the collectors and magazines and museums found they wanted something a bit more hair-shirt, more political, more atoning for the excesses of the 80s. Maybe now is its time.

Elizabeth Peyton

She paints rock stars and celebrities who are already quite effeminate, in a way that makes them more effeminate, like 1890s dandies. Her pictures are small and the oil painting technique is like watercolour, with the colour transparent and the bright white of the gesso ground shining through. They're about childish or adolescent sexuality, innocent and decadent at the same time. Her use of oil paint takes away the medium's traditional robustness. And she works small, not big. She takes the position of a fan. Her subjects are worship-objects. So she's a natural inheritor of the Warhol legacy. Only she also takes shock and impact out of the equation. Warhol's paintings had a lot of shock and impact, hers deliberately don't. They're shocking because they're not. They're sweet instead.

Her studio is a tiny dark room near the Bowery. I go round there and a Pulp CD is playing. There are drawings and

Elizabeth Peyton
Jarvis and Liam Smoking 1997

watercolours of effeminate boys on the wall. Hair glossy, lips rosy, bodies slight, clothes silky and velvety. And a lot of pictures of boy stars cut from magazines. There are little squirts of oil paint on a palette. There are photos of David Hockney from the 70s, from the film *A Bigger Splash*, with Hockney at thirty really looking like he should be in Pulp, with his Peter Pan shirt collar.

Outside the sweet studio is a dingy corridor. It's all greys out there. Then I come out into the street and the klaxons are calling. In fact, it's just one klaxon, the wailing siren on a vet's motorised wheelchair, as he hurtles past, just missing a poor dirty teenager passed out on the dirty pavement, curled in a foetal position, wearing a black T-shirt with a white slogan that reads: Sticks and stones may break my bones but whips and chains excite me.

After these lashes from the whip of grimness, it's a month later and honey is pouring again, because I'm driving in the Hamptons, on my way to Elizabeth Peyton's rented summer studio, with the glinting ocean and the green overhanging branches and the blue sky and the shining white cemeteries and the white wooden houses with American flags outside, all flashing by. The gulls swoop, the cicadas chirp, the butterflies flit. The jellyfish are in the sea. The lobster salads are in the classy restaurants. Elizabeth is on the Internet, ordering up CDs.

In her studio, there are half-finished paintings of Leonardo DiCaprio, and of some celebrity footballers. Rinaldo after his World Cup 98 panic attack. George Best before his downfall. And there are more photos of David Hockney. She says she paints Hockney and collects photos of him because he did everything at once: made a great image for himself, with his blond hair and gold lamé suit; made great art; stood for a humanist idea of beauty. She says she tried to get in touch with him several times but he wasn't interested.

She says she paints beauty because everyone is fascinated by it. Leonardo DiCaprio was in the news recently because a young Chinese woman athlete, who'd been injured and was

Elizabeth Peyton
Opposite: Elizabeth
Peyton's studio

facing paralysis for life, said the only thing that would cheer her up would be to see him in her hospital room. So he visited her. There's just something life-affirming about beauties, Liz says. I hold up her painting of Rinaldo next to the news photo of him on the wall, and it's obvious she's made him into an effeminate Nijinsky faun. But she says she didn't know she was doing it, it's just the way the paint goes on.

Alex Katz

Although he doesn't do sex, Alex Katz is a big influence on all these young painters. He likes them and they like him. He developed his style in the 60s. It's cool and bland. It's supposed to radiate spiritual shallowness. If shallowness can radiate. But actually it's dramatic. Only it's a drama of light and movement in tension with an iconic sign-like quality. Not an emotional drama of people crying and fighting, like at the theatre.

Alex Katz *Summer Triptych* 1985

He makes fast impressionistic oil sketches – reflections, flowers, sailing boats, people, his wife. He just stands in front of them and sketches them. He was standing on Houston Street the other day, sketching some red flowers that the local community had planted. Then he works up more and more fast sketches, editing out, adding in, changing the tone, generalising, putting in details. Then he does the enormous finished paintings. But they're fast too. He mixes up the colours and loads up the brushes and lays the canvases out and then holds the little sketch in front of him and whacks the image down on the heavy white oil primer surface, hoping it's all going to work. Because if it doesn't he has to start again, he can't re-do anything.

He discovered early on he could work quickly. He comes from a working-class background and it was confusing when he found he could paint so fast. It didn't seem enough like work. But he can only do a few pictures a year. He says he's a machine that can only be used for a short time.

He lives part of the year in Maine. I went to see him in his house there. It's like the Taj Mahal. A wonder of the world on an equal level. Just the natural beauty of the place. You get to it by flying to Bangor and then driving. The pine trees rush by. You see the shining sea. Birds flying about. You get to the house. Alex Katz is there in his white shorts, and Ada Katz in her sun-glasses, just like in his paintings, only not fourteen feet tall. They're friendly and funny. Drinks and chips and dips appear, and friends and family.

Alex Katz

Everyone sits around outside the studio. There's a lake that goes on forever. Green stuff on the lake, orange pine needles on the ground, light flooding down from the brilliant sky on the elegant untroubled well-groomed Katz crowd, their bodies making dramatic shapes against the dark trees.

C, U, N and T

David Salle

He was incredibly influential and exciting in the early 80s and was seen as a main figure of Neo-Expressionism. He was the most Neo-Pop of the Neo-Expressionists. His paintings were narrative but without definite stories. They were randomly narrative. They worked by association. By making unlikely connections between different types of image signs. The signs were from a huge variety of visual sources. He took them from art history and from magazines and books and photos. And from his own photos of naked women, which were often outrageously deliberately provocative. He would paint a light bulb over a crotch and it would seem sinister and cruel and objectifying. But when people, artists, critics, were provoked by this, he just acted as if he thought they were idiots and they shouldn't tell him what to do.

His painting style was sparse to begin with, then it became more and more lush. It always seemed bitter, ironic, angry. But you couldn't tell what he was angry with. He once exhibited four paintings together in a show, with a capital letter on each one. C, U, N and T. One of the paintings had a portrait of Spencer Tracy on it.

A piece of cake

I go to see Salle for a photo session. He is sun-tanned and wearing white clothes and nautical white shoes. He has a very classic straight nose and a weird feminine haircut. There is an even light throughout the large white space. It is a sympathetic painterly studio with a messy look. Your studio looks very painterly, I say. He replies, Well, it's a painter's studio. There's a reason. Well, it's nice to see that painting at such a vulnerable stage, I venture. Pointing to a big typical Salle on the wall with a lot of broad bold brush-stroking and disparate imagery and marks, and some canvases kind of awkwardly stuck in. Maybe waiting

David Salle *King Kong* 1983

David Salle

to be stuck in more smoothly. Well, actually that's finished, he says. Wow! I say. That's a sensitive one! And it is.

On the table he's sitting at in the middle of the room, there's a jumble of things. A plastic geometric calibrating instrument. Some collage materials. Cut-up watercolours and magazine pictures. He says he's working on a possible mural. Against the wall, some small painted canvases are leaning, with broad matter-of-fact renderings of simple objects. A piece of cake, for example. I ask if they're all destined to be inserts in larger works.

He says, Well no. Not really. Maybe not.

Salle on Greenberg
Did he ever meet the great critic? He says he did and he seemed mad. He says he thinks he was pathetic really. It was clear he had an eye but all the theories were just bunk. It didn't follow that Pollock was a good painter and therefore painting's task was to strip itself down to its essence.

All the critics of *Partisan Review*, the critical periodical that Greenberg first published his theorising articles in, in the 30s, were incredibly aggressive, he says. Because they came from a situation of adversity. Marxist intellectuals of the 30s. He says Greenberg was a classic case of radicalism changing to conservatism. And, he says, it's a real puzzle to understand why Americans wanted something like that.

Triangle Workshop
I ask Salle if he's heard of the Triangle Workshop and he hasn't. I only know about it myself because I remember it was spoken of in the early 80s in London. English Greenbergian artists used to save up and go out to America for a few weeks to go on courses there.

It was in an out of the way place. Greenberg and Caro would be there, and Michael Fried, the main Greenberg-influenced writer. They'd be standing around, with hands held up to the sides of their eyes, to do mental cropping of the artworks they were scrutinising. Greenberg would use salty language and frighten everybody with his shocking comments. He'd say something shocking about Jews or women or the Irish to Caro, for example. Challenging Caro to add his own shocking thought. But Caro would demur, saying, Well, that's the kind of language you use Clem, not me. But everybody put up with Greenberg's bad behaviour because of the higher cause. Which was to do some damn good quality art. While everybody else not at the

Triangle Workshop was trying to be trendy and perverse.

It sounds like the teaching was really mono-directional, I say to Salle. I say that I suppose at Cal Arts in LA – where Salle famously studied in the early 70s – there were lots of things that could be done and lots of ways of thinking a thing could be good. But he says actually there were only two or three. A teaching situation isn't necessarily a bad place for authoritarianism and dogma, he says. But a museum certainly is. And that's where Greenberg's bad influence is most apparent today, he says. Not at the Museum of Modern Art, but in the regional museums. It's all Greenberg out there. The provincial museums and the ones in Canada are dominated by his taste.

He asks which younger artists we're photographing. He says the only young one that really captures his imagination is John Currin. There's something right there in the painting, he says. It isn't theoretical or conceptual. He says the real legacy of Greenbergianism isn't a painting style but Conceptual art and theoretical art. He says Joseph Kosuth, the Conceptual artist, is the real legacy.

Not fatuous
In his studio, I remembered another time I'd met Salle, ten years ago, when I was working on a BBC film about the Cologne art scene and he happened to be putting up a show at the Michael Werner Gallery there. I interviewed him about Michael Werner and he outrageously over-praised the famous dealer's taste and powers of perception. So I assumed he must be incredibly phoney. But then when I thought about it I realised it was only right he should be polite on TV about his dealer, and rather than empty he was being professional.

But the time I first saw him was a few years before that, when he was first famous. He was giving a slide lecture at St Martins School of Art in London. He arrived wearing sunglasses and kept them on through the talk even though it was dark in the room. At that time, he was always being in Tom Lawson's articles in *Flash Art*. Lawson came from Scotland and settled in New York and became a briefly influential critic. In his articles, he said painting was suddenly becoming the radical new form after the years of Conceptualism. But it was only by being radically against the things painting had previously stood for. That is, the things it had stood for in the 70s, which were purity and quality and aestheticism. Now painting was expressing the real/unreal, new mediated world we all lived in. And Salle was one of the best at doing this.

After a while Salle stood out from most of the other new rebel painters and became a giant star. The main thing he was associated with was being successful. He used to be always mentioned in connection with Schnabel. They were friends but then fell out. David Salle doesn't have an idea in his fucking head! Schnabel suddenly exclaimed, when I was interviewing him for an article, in 1986. But that was obviously wrong and just Schnabel getting carried away with his own *joie de vivre*.

Not chanting Om

Andres Serrano
He took photos of a crucifix suspended in a small tank of urine in the 80s.

Andres Serrano *Untitled XIV (Ejaculate in Trajectory)* 1989

It was called *Piss Christ*. Also, he suspended crucifixes in milk and blood. He took photos of his own ejaculating semen. He photographed terrifying sights in the morgue. He went to the Green Dragon's house in Tennessee – the Ku Klux Klan leader – and photographed him. He just phoned up and made an appointment with the secretary. And he photographed a lot of other Klansmen. Even though he's obviously not white. In fact, he's an amazing racial mix: Latino, Black, Chinese, it seems even. His photos are large and dignified, with strong colour.

He'd been in advertising for ten years, as an art director. Then he became an artist. When I saw him today in his flat in Brooklyn, he said he was trying to get into the movies. He thought he'd soon be finished with art. He'd been photographing some actors.

He was good at generating scandals and then coming through as the hero. In his apartment was a photo of clowns having sex. Another picture from this series, a woman pissing in a man's mouth, was used as the publicity poster for an exhibition in Rotterdam recently. It had to be withdrawn because of protests, but then the show got 90,000 visitors.

Andres Serrano

He said he'd seen the 'Sensation' show in London. He thought the controversy was all about one work there – the painting of the child murderer, Myra Hindley. He should know what gets people going, I thought.

Andres Serrano *Klansman (Imperial Wizard)* 1990

The devil

Serrano's apartment is all sombre colours. It's like a stage set only more classy. A stage set mixed with a museum. It's filled with macabre *objets*, which he's collected from all over the world and from junk shops in New York. But it's not a clutter. Everything is staged perfectly. A monkey's head, angels with bat wings, wooden tortured saints from the Middle Ages, heavy dark red fabrics, old church altars, human skulls, crucifixes. The bed is a vast monument in wood and velvet brocade, like a decadent Pope's bed. On the opposite wall is the sex clowns photo. From the bedroom you see through to another room, where the Dragon hangs: a four foot high green triangle contrasting with the general browns and purples and bone colour everywhere else. It's as if he got the devil to do the decorating. Serrano's face is another amazing sight. His whole head seems to stretch out longer than most, with sticking-out ears, smiling eyes and a mouth so protruding it looks almost deformed.

Serrano sits down, smiling and unblinking, in the one ray of light Ian MacMillan can find in the dark apartment, while his photos are being taken. A perfect scene from a vampire world, what with all the old church gear around. But he doesn't melt. A thoughtful glazed-eyed smiling beautiful gargoyle at home in the sacred shadows, a bit kinky and evil, but serene as well, more spiritual than any priest, even though he's sucked the blood of 10,000 humans.

After the snapping, he says he wants to do some big advertising jobs because he thinks he's just about done everything he can do in art now.

Andres Serrano's apartment

Karen Finley

I rang her sex line this morning. The messages got more and more complicated. The complication was how to pay for the call without your wife knowing you'd called. So that was the point. She's famous for obscenity and for inserting yams into her vagina on stage. The NEA rescinded her grant in 1990 then gave it back in 1992 after she sued them. Her performances were half stand-up, half art. She said she didn't know if it was art or not when Chris Burden shot himself but it definitely wasn't when her father did it. She wrote a good play called *The Theory of Total Blame*.

1-900-ALL-KAREN. Hello honey this call's absolutely free. Write these down baby. 1-900-HORNY. 1-900-GET YOURS. Ninety cents a minute. Stick your hands in your pants and pull out your credit card. Hi guys. Get ready to get off with horny housewives and students across the country. No record on your phone bill! 1-900 GET IT ON. Mmm hi baby. Welcome to the hottest phone sex line in America.

The sickos

Then this evening I tried to get into a live sex exhibition at the Jack Tilton Gallery, which had been promoted as having a scary prostitute or stripper as the main event. But the line for the exhibition ran for several blocks. What sickos! I thought.

In reverse

So instead of live sex, I went to a show of young American art across the road, where the paintings were all transparently derivative of young British artists like Chris Ofili and Gary Hume. It's strange to have transatlantic influence in reverse now, after all these years of it going in the other direction.

Not chanting Om at the Pentagon any more

Then I went to a screening of Jonas Mekas's film of Allen Ginsberg on his death bed. There have been many films by Mekas, documenting the Greenwich Village and SoHo art and poetry scenes since the early 60s. All in his wobbly unedited style, where there's nothing between you and the wobbly hand-held camera's view of the filmed event. No one knows why it has to be so wobbly. It's the integrity of the medium. You could say you soon get used to it. But you don't. It's really outrageous. It's Brechtian alienation. Only without laughs. He just won't do the conventional thing. Even when you'd quite like it and it might seem appropriate.

So instead of just filming Allen Ginsberg's body, once, steadily, the camera kept going in again and again, wobbling. But still it was very moving. It was a strange situation, sensitive and squalid at the same time. Ginsberg, author of *Howl*, peace activist, chanter of Om at the Pentagon, lay dead on his bed, a tiny corpse. But you couldn't tell how many people were also in the room and what they were doing there; if they were being quiet or respectful enough. It made you feel awkward. It was as if he was dead at the Gramercy Art Fair. You wanted to get in there and direct things. There were Tibetan monks conducting a sober Buddhist ceremony, with Peter Orlovsky, Ginsberg's lover. So that was good. But nobody else in the room seemed to be noticing.

Orlovsky told Mekas in the film that he'd been drinking and fixing up for all these years and hadn't written anything all that time but hoped he might write something again in the future. *Clean Asshole and Vegetable Poems*, that was his collection I remembered. I saw him reading from it once, in London in the 70s.

The funeral men came to take the body away. They folded it up and slid it on the trolley and they wheeled it out of the apartment and into the lift and out into the street and into van, with the wobbly camera following them, and Peter Orlovsky in view, waving like an old auntie at the van as it drove away. A sad sight. Patti Smith had been sitting in the apartment too.

Then it was later, in the film, and the memorial service for Ginsberg was going on. It was light-filled, with flowers. There was some singing of one of his hymns. The painter George Condo was at the memorial.

Nothing is important

Ian MacMillan went to photograph George Condo the other day without me, because I was working on something else, unfortunately. I met Condo in the 80s in Paris. He was in his early thirties. He painted cartoony expressionism in a beautiful and eloquent way. I went to interview him at the flat where he was living, which he used as a studio. There was mess

Jonas Mekas stills from *Scenes From Allen's Last 3 Days On Earth As A Spirit* 1997

George Condo
Figure with Crown 1988

everywhere, paints and boxes and paintings, some very small, some wall-sized. It was an enjoyably chaotic atmosphere. He would just pick up a tiny brush and start flicking calligraphic contours onto a canvas, to illustrate a point, and then go back to talking. There was a guitar and a piano. He was friendly with William Burroughs and Brion Gysin. He just wanted to talk about Beatniks and Keith Haring. He liked Haring, but there were a lot of artists he didn't like. He loved Schnabel. It was all a drunken druggy haze. He was very sensitive and old-fashioned. He seemed not to belong in the 80s. Except it was obvious he was an incredible success story. And soon after that he was taken up by Pace and became a blue chip star.

But his success is hard to understand exactly because there is no intellectual meaning to his art and no established critical constituency for it. It seems to be enjoyed by collectors, or untheorised sentimentalists like myself, rather than intellectuals or reviewers or other artists much. In fact, it's a type of absolutely free-flowing improvised Beatnik free-associational nutty Picasso-quoting and Arshile Gorky-quoting and Bugs Bunny-quoting expressionist painting that you might imagine would guarantee failure of some kind. But he manages to make it work. He churns out pastel drawings all the time and has an amazingly fluent painting and drawing style, and sticks his drawings on his paintings with lumps of white paint, and he seems to be able to put anything with anything. He said he was very interested in Nothingness and that Nothing was important.

I asked Ian what George had said, and who he liked nowadays. He said he didn't seem to like anyone else's art much any more. He didn't seem to like Schnabel any more. He said he liked Andres Serrano. His actual words were that he liked that guy who does those guys with the hoods. What are they called? he said. The Ku Klux Klan? said Ian. Yeah, those guys!

George Condo
Pink and Orange Abstraction 1997

Les Femmes Françoise Condo 92
NYC

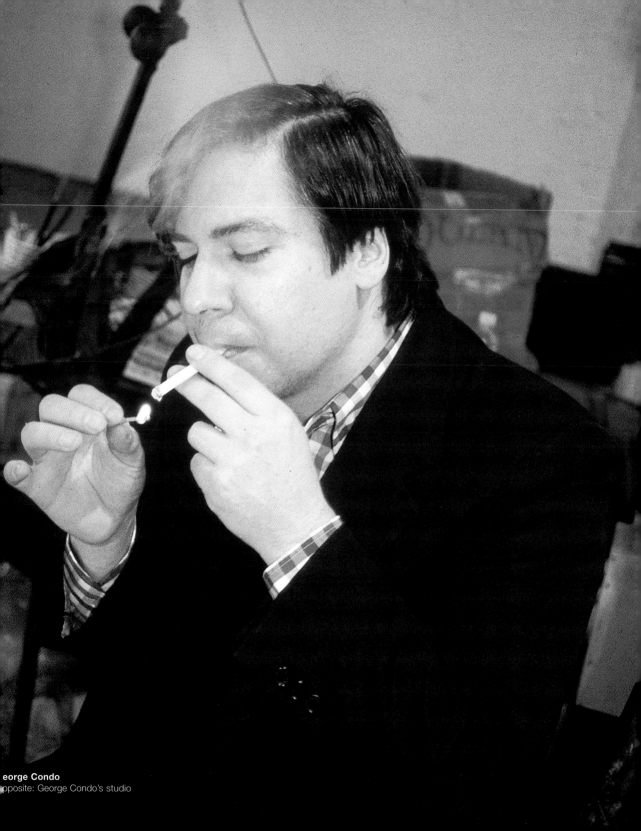

John Giorno

The star of *Sleep*, Warhol's first film. It just showed Giorno sleeping. Now it's 35 years later. He looks like the priest in *The Exorcist*, only jollier. Maybe his good disposition is from being a Buddhist. He has always lived at 222 Bowery, the former YMCA from 1910, now a protected building. There's some documentation about the building's history on the wall in one of his rooms. Ha ha, he laughs, as he points to the old 1912 photo of the young men, in couples, in their hats and suits, lined up outside the building. There used to be a swimming pool for the young men but that's gone now. The stand-up urinal is still here, though. In the stall next to it, the graffiti on the wall – a smiling face, a big cock – is by Keith Haring. He drew it one day when he was visiting William Burroughs, when Burroughs used to live here with Giorno. This is the head Beatnik's famous airless concrete bunker where he lived and died. Interestingly, his last word was 'love'. Now it's full of Tibetan prayer stuff. Brightly coloured fabrics and posters of mythological scenes and artless photos of Buddhist teachers smiling, and Giorno smiling next to them.

Why are you a Buddhist? I ask. He says it's about seeing the emptiness of the empty thoughts that plague us, so you don't have to be afraid of them. You don't have to lay off meat or sex, or not tread on ants. You have to get up early to meditate, though. I'm starting to feel quite dreamy but then I jump when he suddenly shouts out loud. Agh! That's the noise Allen Ginsberg made when Giorno was pestering him about the nature of meaning once, when they were both on LSD. It was Ginsberg giving him a sign that he should go to India and find out about Buddhism for himself.

Giorno is a poet and has published some writings about his life with Warhol. He gives public readings, declaiming theatrically. One is about the time Andy suddenly threw himself at Giorno's feet and began licking his shoes and then masturbated on them. Giorno never liked to have sex with him because he found him too plain. It was Warhol's mind he liked. But he would allow him an occasional blow job. Another reading is about drugs. Speed kills, Giorno says, but it's very good for art, and it was very good for Warhol's art because it gave him clarity. After he was shot he couldn't take it any more and his art went down, he says.

Sleep

In another room in Giorno's house is the original bed he slept on in *Sleep*. They used to go to underground films together all the time. They'd watch Jack Smith's *Flaming Creatures* and Kenneth Anger's *Scorpio Rising* again

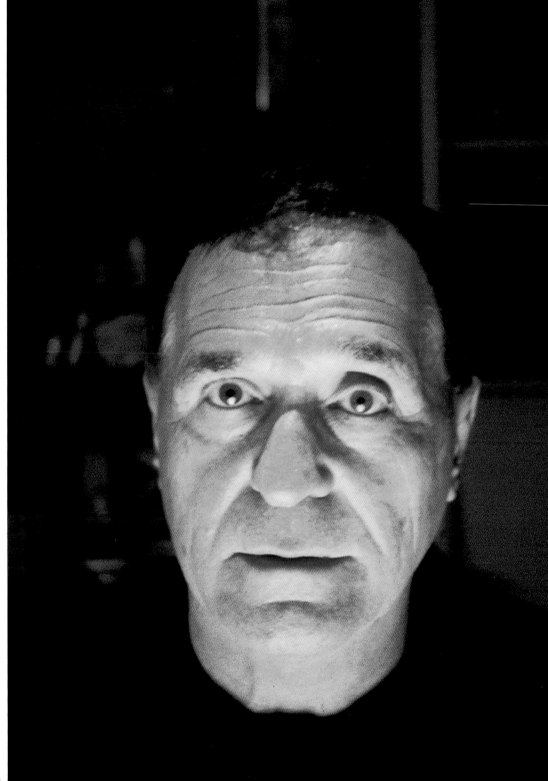

John Giorno

and again. And all the other underground films of the early 60s. They began to wonder why so many of them were so boring. Warhol thought he could do one just as well. So he bought a camera and filmed Giorno sleeping. He shot roll after roll, night after night, because they used to sleep together and it was easy to set the camera up. Giorno would pass out from being drunk, and Warhol would stay awake from being on his speed, which he got legally, from the chemist. Then he tried to edit the film, but he got into a mess with all the rolls and tried to get someone to edit them for him. And it all dragged on, going nowhere, and in the meantime the film already had a title and there were stills from it, circulating, and it had received a lot of publicity but it didn't really exist and eventually Warhol was getting really worried about it. Then finally he worked out a system of editing it himself, and he got an idea about the structure and the type of shots to use. He put together all the shots that showed good light and shade and abstract form, so it wouldn't look too gay. And he made it eight hours long, because that's about the normal sleeping time.

Different bodies

Nancy Spero *Goddess Nut & Torture Victim* 1991

Nancy Spero and Leon Golub
I go up to Nancy Spero and Leon Golub's loft. In the 80s Leon Golub painted torture scenes. Men in hoods and handcuffs being tortured and urinated on by horrible mercenaries. Laughing modern torturers leering at naked helpless female political prisoners. The paintings were mural-sized, in bright colours, with the colour scraped and burned-looking. He has a huge bald head, like Nosferatu. She has dramatic bleached blond hair. They both make art about power and who has it and its exploitation. Spero makes unique prints of goddesses and empowered women and tortured women. She puts a picture of a Chilean woman tortured by General Pinochet's secret police together with Artemis and maybe a quote or two from Artaud.

Golub's paintings of the horrible tortures and interrogations were partly horrible because they couldn't be exactly placed. They weren't very politically specific, and the grinning leering torture scenes were quite kinky, as if some of the source imagery was from S&M magazines. Which it was.

Nancy Spero and **Leon Golub**

They both go back years as artists, to the Existential 50s maybe. But they became big in the 80s. They were both probably considered a bit Agitprop before. That's a word we don't use any more. Her prints of goddesses are appropriated images. Ancient Celtic fertility goddesses mixed with Greek ones and other ancient empowered mythic females from books, and contemporary news images and sports figures.

They both always looked very striking. They still look that way now they're very old. They knock about the kitchen. It's like theatre. Their bodies are all angular and animated. The kitchen is small and cluttered, leading onto her studio and the sight of her long table, cluttered with empowered goddesses.

Leon Golub *The Blue Tattoo* (detail) 1998

Kiki Smith *Untitled (Cadaver Table II)* 1996

The kitchen table has all their different pills and little plastic containers of special food that won't make them clog up or gasp. They make black jokes about their infirmity. They were always Right On politically. They always supported causes. It was very good but a bit excruciating too. It's a mystery why that can sometimes be so. But now it seems all right.

I go in Golub's part of the studio and there's a huge painting of a heroic lion holding a sign. It's waiting for some lettering. What will it say? Support Chile? Down with mercenaries? He says it's going to say: *Getting Old Sucks*.

Yes Rod Stewart

Kiki Smith is the daughter of Tony Smith. Tony Smith was a proto-Minimal artist of the 50s and 60s. He made hollow black cubes. He went for a drive on the unfinished New Jersey Turnpike and in the darkness he had a revelation about what art meant now. It meant that all old art didn't mean anything any more. He thought big unsocialised spaces that no one thinks about were a bit like art. A big army training ground in Germany, for example. It's one of the main myths of Minimalism. It was anathema to Michael Fried, the famous critic. He said it was a wrong myth of art because it was only theatre. It wasn't presentness. Theatre is bad, he said. Presentness is grace. But no one wanted his presentness and eventually he gave up writing about contemporary art. He just couldn't stand it any more. He wrote about old art instead.

In the meantime, Kiki Smith was growing up. Then in the 90s she emerged as one of the main new artists of the body. She made extremely theatrical art. She showed sperm shapes made of blown glass. And bits of ears and mouths and nipples and other body parts, all integrated into a creepy weave pattern, like something from the movie *Hellraiser*. Her art became progressively more and more *grand guignol* and she was incredibly successful.

Ian MacMillan went round to her place to photograph her today. He said she had a cat called Cancer. When we contacted her earlier she didn't want to be photographed, but he reminded her he'd sent her a tape of a BBC film about

Kiki Smith

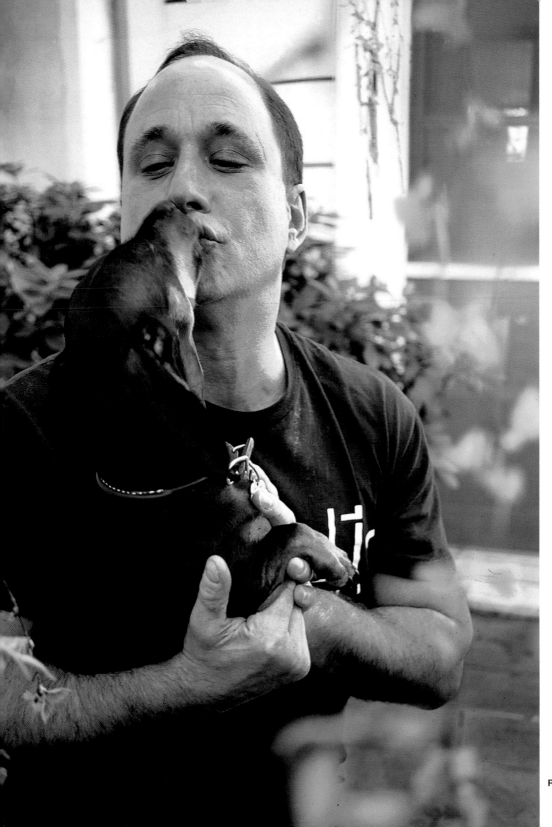

Ross Bleckner

Rod Stewart from the 70s about five years ago. So she said OK then because that was a film she'd really wanted to see. He'd met her at a dinner sometime, and she said she was a big Rod fan. He said he had that tape and he'd send it to her. Then he forgot and one day a fax came saying, Yes Rod Stewart. So that was a lucky break for this book. Cancer was ill apparently and on a macrobiotic diet.

Ross Bleckner

A painter. He produces a lot, much of it good. His house in Tribeca has his studio on one floor and living space on another. At the back of the living space is a gym. Everything is tidy. He has a little brown dog called Mimi, which he cuddles. The Mudd Club used to be in the bottom floor of his house, in the 70s. He's in his late forties or early fifties but he has a way of talking that makes him sound prematurely aged, like Billy Crystal impersonating an old man from Atlantic City or Miami. What? What? he shouts jovially. As if he was eighty. He has a conversation with Ian MacMillan about music. He's got Mazzie Star, Tindersticks, Stereolab. Junkie music, Bleckner calls it. You listen to that huh? he says to Ian. What? What?

In the 80s he was one of the innovators of Neo-Geo, with his strange invocations of Op art. He painted stripes in a waxy medium, obviously hand-brushed, but still optically shimmering enough to make you feel like you were looking at something from another age, the age of Op, which was the 60s. Op is considered a failed movement of late Modernism. It didn't last long, it was too gimmicky. Although actually its main stars, Bridget Riley and Victor Vasarely, are quite good. The feeling with Bleckner's reactivating of Op in the 80s was that it had something to do with death, because Op was a dead style and Bleckner painted it in a strange, deliberately lifeless way. It was the time of AIDS. He said young people at that time were thinking about death. Whereas before, that would have been an odd thing for them to think about.

Ross Bleckner *Wreath* 1986

After stripes he started painting more and more figuratively, but still in a deathly way. Glowing chandeliers or candelabra or chalices or humming birds, shimmering against backgrounds of infinite blackness. He moved back and forth between abstraction and figuration. He painted amazingly intricate circular patterns that described fantasy domes and ceilings, like

something from the Orient mixed with Aborigine dots. Or something from an opulently dressed science fiction set, post-*Alien*.

His main colour is black, and his surfaces are transparent and look like they've been made with a lot of strange mixtures of resins and glazes, following ancient recipes. Which they have been. In his studio, I saw the expensive heavy-bottomed iron cooking pots he cooks these mixtures up in.

Leonardo

Leonardo DiCaprio goes in the Guggenheim Museum uptown. It's April. There's a lot of fashion models in there. About five of them are naked. The rest are dressed by Tom Ford for Gucci. They have to stand around. If they feel faint they can sit down. They can't talk to the audience. It's called *Show*. It's a performance by Vanessa Beecroft. She's not in it. She just gets the models to stand around for an hour, or however long it is. It's a kind of Minimalism of fashion models. She's there taking photos. The photos are exhibited in galleries. Sometimes the models stand in front of the photos. You can't tell if she thinks fashion models are good or bad. It's spooky and sexy when they stand around, but a bit dead and unpleasant too. Hey, maybe that's the point! It's kind of a stupid point. But a lot of art now is quite stupid. We don't question it, though. Stupid is often the best.

Cindy Sherman

Film stills and fake body parts. That's what we think of when we think of her. She deconstructs the feminine. Everything she does is good. After

Cindy Sherman *Untitled* 1992

black and white film stills showing herself in non-existent films, she did colour photos using slide-projections and back-drops. She looked not quite right. That's how women feel. Because identity isn't natural, it's constructed. She just set up the set-ups and lit them, dressed herself up, made herself up, wigged herself up, squeezed the switch on the timer and took the pictures. She has an amazingly blank face that can look different again and again, without looking obviously in disguise, or as if something exaggerated has been done. Gradually the photos got darker in mood. Then disgusting. Out came the fake body parts. Plastic pimply butts and bulbous tits and comic wide vulvas. What kind of joke was it? A disturbing one. Out came the rotting vegetables and disgusting white furry mould. The condoms and bananas. The lurid lighting, green glows, steam and smoke machines. She was ushering in the general 90s taste for luridity and shock in art.

The only step off the perfect aesthetic taste track she took was a series of art history photos. It was herself dressed up to look like generalised women in pre-Modern art, in wimples and medieval shifts, with false noses and foreheads. And bustles and stays and *décolletage* with joke-shop plastic busts. But it was too broad and general compared to her other works.

Films and fashion shots and general pictures of women in magazines, not doing much but just being women, are absolutely bursting with signifiers. That's why her take-offs of them seem so good compared to her take-offs of art history. Because art history is actually a bit dead for us for the most part. Whereas with mass media imagery, we don't know how it works on us but we know it does in a million subtle ways.

Last year her movie *Office Killer* came out. It was funny and sick. The body as a series of discontinuous gestures in feminist theory was transformed into the body as a series of dismembered limbs in a psycho-killer's cellar. A plain Jane in an office murders her co-workers and a few children, and takes their electrified or stabbed corpses back to her cellar and plays with the rotting parts at night. Molly Ringwald, from *Pretty in Pink*, tries to stop her but she gets away.

Life of Riley

Peter Halley

He became famous in the 80s with paintings that were severely geometric. So severe, they were humorous. The squares and lines had the meaning of cells and conduits, sometimes prisons. The colours were flat, screaming day-glo. He wrote essays exploring the theories of Baudrillard and explaining post-60s art in terms of them.

Nothing is real, said Baudrillard. There is no original. Only the simulacrum. It was very exciting and everyone was convinced. Suddenly there was a massive fascination for Minimalism and Conceptualism and the whole look of 60s and 70s art. The 60s and 70s look returned in new 80s art, but with all the old meanings up in the air or vacuumed out altogether. It was a heady time of nihilism and braininess rubbing shoulders, as they so often have done in Modern art.

Cindy Sherman *Untitled* 1989

Peter Halley
Opposite: Peter
Halley's studio with
assistant and studio
door

index

MAGAZINE

HALLEY

I met Halley at the ICA in London in the late 80s. He was somewhat nerdy and wore glasses and had a droning way of talking. He didn't mind laughing at these things himself. That's why I feel free to mention them now. He said the former movement, Neo-Expressionism, was all guys you could imagine it might be fun to hang out with. Schnabel, Basquiat, Haring, Clemente, Baselitz. But his movement, Neo-Geo, wasn't. They were all mild guys. But actually he was nice to hang out with. After his first rise, his paintings got more and more complicated and the colours more decorative. He stopped being at the absolute whirring epicentre of the art world but went on selling anyway.

Peter Halley *Figuration* 1998

I met him again in the 90s a few times. He was very interested in the way the popular and the avant-garde sometimes intersect. He thought it didn't

always work. On the whole, popular was bad. But some avant-gardists could make them work together. Andy Warhol and John Lennon and Bob Dylan really had the gift to be funny in interviews, he said. But he never did. But of course, that was funny in itself. In the back of his studio were the portraits Andy Warhol had done of him, in triple focus, with triple glasses. Halley was always associated with the Koons world of glamorous intellectual high irony, but he went off Koons because he thought he strove too much to be popular.

He made a series of dramatic gallery changes. He was wooed by Larry Gagosian, the sun-tanned frightening new secondary market dealer. Secondary market art dealing is where you don't discover anybody. You just woo the artists who have already been discovered by honourable gentlemen dealers and then make a lot of money off them. In Halley's case it wasn't a biological gentleman but Ileana Sonnabend, the former wife of Leo Castelli. But the idea still works. In any case, he left Gagosian after a while, claiming he hadn't really been paid all the riches he was wooed with. And now he just deals his own art, farming it out to different galleries all over the world, when it suits him.

Once he gave me a gouache. I always kind of hoped he would give me another one. But instead he gave me a T-shirt with *Index* written on it.

Speed feels right
I arrive at Halley's studio today. A framed painting on paper on the wall by Rita Ackermann has the words Speed It Just Feels Right painted on it. Halley is tense because of a problem with his style and culture magazine *Index*, which is published from the studio. At the last moment before the deadline Wolfgang Tillmans might be suddenly unable to photograph Bianca Jagger at the airport.

Assistants are putting Halley's paintings together. The paintings are in the same Neo-Geo style as ever, the style he started out with in the 80s. But the colours are more metallic and day-glo and artificial and poisonous now, and the handling of the paint is much more standardised. Before, it had been semi-standardised. He used to say he didn't use assistants to do the actual painting, only to help with all the other things. Because they were either too good or too bad at the brushing. But now he doesn't seem to mind.

The whole atmosphere here, with the telephones going and the busy offices to the side of the main painting space, and the assistants and the

stacked-up half-finished and finished paintings, and the piles of *Index* – not to mention the set of Warhol *Electric Chair* silk-screeens on the wall – is like a conscious re-staging of the Warhol Factory myth, only with no one sexy or glamorous or obviously drug-addicted hanging or lying around. The studio is in a former light industrial building in Chelsea. He moved here because Tribeca, where he used to be, was too arty, he says. He likes it better with views of business and industry outside the window. His space here is $4,000 a month. Tim Rollins and K.O.S. are on one of the floors. (Shouldn't they be in the Bronx with the burned-out cars?) Bob Nickas, the art writer and curator, is the editor of *Index*. He works here in the studio. *Index* prints 10,000. The interviews are enjoyably bland. In the current issue there's one with Joe Dallasandro, Warhol's sexiest superstar, star of *Flesh* and *Trash*, now in his fifties, an occasional model for Gap. I'm impressed, but Mark, the recently graduated art history student who has been helping with these photo-shoots, hasn't heard of him. He's twenty-four.

Feeling

Halley says his paintings are not about numbness, they are about feelings. He thinks when people nowadays talk about feeling in art they are often unconsciously thinking about a nineteenth-century idea of feeling – huge emotions like grief and joy and ecstatic love. But he thinks there are lots of new feelings now, like feeling a bit spacey, or feeling freaked out, which his paintings express. He thinks the feelings in Pop and rock music are more realistic feelings, that modern people actually feel, more than the ones in, say, Steven Spielberg's films.

He says over the last few years he has felt a bit out in the cold because of what he recognises as a general art world aversion to painting. But also because maybe collectors and critics find his colours too working-class. They think muted colours are more tasteful.

Philip Taaffe

In the 80s Halley was associated with Philip Taaffe, another painter. They were both ironists. Like Halley, over the years Taaffe has become less and less ironic, more and more like a painter. He first became famous for re-doing Bridget Riley and Barnett Newman and other abstract geometric or semi-geometric painters. He seemed to give them a new meaning, but the meaning was strange and modern, or strange and decadent, and hard to get hold of. But it felt amazingly right. He painted a Barnett Newman with an elaborate patterned column, like a piece of Victorian ironwork, replacing Newman's stark stripe. Newman is about the sublime. The sublime is now,

Newman famously wrote. Actually not that famously because no one remembers it. We want the sublime but it's like fairies: it just goes away if not enough people are clapping. Maybe that's one of the meanings Taaffe's decorative sublime Newman might have had.

When you saw them in magazines, Taaffe's paintings looked all image. Then in real life, you could see they were very physical and wrought. His Bridget Rileys were complicated collages, with every visually oscillating Op art band actually made from a separate strip of paper. He said he felt like a surgeon when he was making these Rileys. Surgically reconstituting them. That's a good association, because his Rileys tended to have faint blotches of colour showing through the black and white stripes, like bruises. We were looking at one of them from ten or twelve years ago in a dark room in his studio the other day. There were other paintings knocking around. A new one that looked like bits of a Riley, floating in a void, like musical riffs. There was a painting leaning against the wall, featuring repeated cobras, disposed asymmetrically across the canvas like Jackson Pollock gestures. But silk-screened, instead of poured or splashed. He said Riley came round to his studio once in the old days and was very friendly and positive. But then he heard from other people that she was saying she found his re-makings of her paintings disturbing and she was upset by them and didn't like them.

Over the last ten years he has got more and more interested in outright decoration and also in natural forms. There are sea shells and plants around the studio, and books of hieroglyphs and books of early nineteenth-century scientific illustrations of natural forms,

Philip Taaffe *Queen of the Night* 1995

Philip Taaffe *Yellow Painting* 1984

and a live bird in a cage. The paintings have shapes from flowers and plants and animals. There are lots of prints and materials for making prints. There are lots of sheets of paper with drawings on them. One has a lot of spirals, which he drew from a ventilator in a window. Then over the years he used the spirals again and again as patterns in paintings. He says he's doing a lot of sea forms and plant forms and lizard and snake forms now, and maybe one day he'll evolve to the stage of doing a human form. He knows it's a bit strange to be painting in this way, obsessing about shapes and compositions and colours and textures and space. Most art now doesn't care about these things because of the influence of TV and the media. But he doesn't care about the media, and in fact he never watches TV.

Fascination

The fascination for original 1960s and 70s Minimalism that came in with the Neo-Geo or Neo-Minimal or Neo-Conceptual period of the late 80s is still powerfully with us. Hardly anyone doesn't think Minimalism is fantastically stylish nowadays. Photos from the 60s of bushy-sideburned people standing around staring at metal or Plexiglas cubes just seem right, somehow. Whereas in the Neo-Expressionist period of the early 80s, such photos didn't have any resonance at all, or else made you shudder.

But in fact the memory of that blank feeling and the feeling of shuddering are both in the feeling of fascination and rightness that we now have for these photos of 60s and 70s works. It's the same feeling we have when we see the works themselves.

We think, how did the world ever think this stuff up? What a birth it must have been. What agonies. No wonder we are glad to forget it for a while. But it's only natural we should now think back on it with a feeling of fascination and awe, because it was such a monster. Not just Minimalism but everything that went with it, including the things that came after it, like Conceptual art and the original Body art.

Original Body art

Body art, like Vito Acconci's *Seedbed*, or his films where he's biting himself or offering his naked body for sex, or dressing his penis, was about the private self and the public self. Nobody thought it was shocking because they couldn't be shocked. It was art that made sense in 1972, the time of encounter groups.

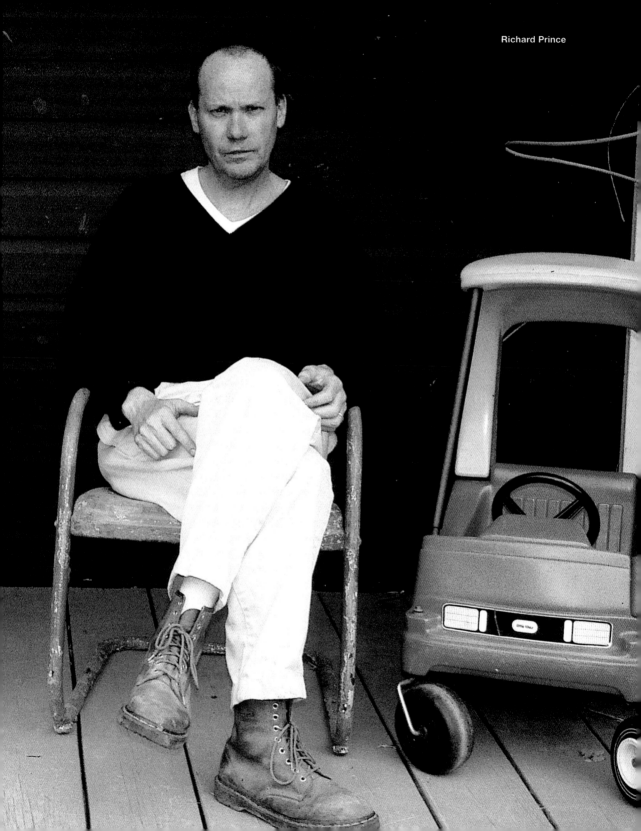

Acconci thinking up *Seedbed*
This morning I went round to Acconci's architectural studio to do some filming with him. He said he loved Minimalism when it came out. You had to look really hard to see where the art was, to make sure you weren't fooled by a light fixture or some pipes. And that was one of the impressive things about it. It was like a father art movement. And then he had to work out how to kill the father.

He said when it came to *Seedbed*, it was the abstract structure that was the first thing he thought of. Then the title. Then the masturbating. He got the title from Roget's Thesaurus. In those days everyone revered the Thesaurus and it was always being mentioned in articles, and artists were always getting their titles from it. The structure idea was that Acconci's body should somehow become part of the gallery structure. Maybe part of the ceiling or the walls or the floor. He decided against the ceiling because it would be too godlike. So he decided on the floor. But he couldn't go underneath the floor because there was another gallery on the level below. So he had a ramp built at the end of the gallery and he was going to put himself under the ramp for the duration of the show. But what should he do under there? He thought about spitting, but that didn't seem enough. So he looked up words for floor, and *seedbed* came up, so masturbating naturally followed. And that was it. Except for deciding to verbalise his fantasies so everyone in the gallery would know it was them he was thinking of as they walked over the platform.

Then after the interview he was filmed doing some readings from some of his old 70s performance scripts. There was a lot of grunting. He talked into the microphone of his old 70s tape recorder. I thought it was good that a copy of *Krapp's Last Tape* lay on the floor, by chance. But I haven't got any important ideas about it just now.

Rock Lobster

Ideas out
Richard Prince deconstructed advertising imagery by re-photographing ads in magazines, and then presenting the re-photographs as art. I saw some of them in a SoHo gallery today. It was in a mixed show of 80s deconstructionists and ironists, including Christopher Wool, Cady Noland, Martin Kippenberger and Prince. The review in the *New York Times* said these artists made art that was full of sneers and they acted like their audience

was their worst enemy. Good act, artists! Prince had a job working in the *Time-Life* library, clipping stories for the writers. He clipped the stories and kept the ads. He re-photographed all sorts of media imagery, including Marlboro ads and images from biker magazines. Bikers and bikers' girlfriends. A lot of them aren't really bikers' girlfriends but just girls the biker magazine photographers could get to pose. Once the sister of one of the girlfriends, whose photo Prince had re-photographed and exhibited, came into the exhibition and complained and threatened to sue. So he withdrew the picture. He knew you could never go to court with something like that because you'd always lose. The judges don't want to hear about aesthetics. Then later he was in a bar and the actual girlfriend, the original sister of the sister, came up to him and introduced herself. So that must have been a laugh. And spooky, when you think about the levels of meaning, and the question of what is an original, and the reflecting and doubling and so on that goes on in his re-photo works.

Then he started writing down common jokes on pieces of paper and selling them. Gradually he built up an enormous body of more and more visually elaborate works based on the initial joke idea. After writing the jokes he started painting them, and the paintings got more and more painterly and sophisticated, with ambiguous pictorial space, until he pretty much became a painter.

When I met him this afternoon, in Albany, where he lives, he said he wanted to put idea art behind him, he was fed up with it. Nowadays he only liked art where you could imagine someone making it, maybe even yourself. Spending an afternoon making something. That was the idea now.

Why did the Nazi cross the road?
He lives in a good house in the sunny leafy suburban countryside, like a *Blue Velvet* setting, with a lot of art on the walls and children's toys knocking around, and a stuffed moose head, and his library of interesting first editions, like a first edition of Bob Dylan's *Tarantula*, and a studio a few yards from the house. In the studio is a basketball net and a lot of cassettes including tapes of Woody Allen and Lenny Bruce. He said stand-ups were incredible artists. He was amazed by one gag of Woody Allen's. I forget which one. But he'd made up a joke inspired by it.

Richard Prince *Untitled (Girlfriend)* 1993

It was the first joke he'd made up himself, rather than appropriating. It went, Why did the Nazi cross the road? That was it. The first joke he wrote down has become quite famous now. *I went to a psychiatrist. He said tell me everything. I did, and now he's doing my act.*

He didn't make it up. It's quite funny in itself. But also it's funny when you think of Appropriation, which he pretty much invented. Doing someone else's act. He said Appropriation was just a way of saying stealing.

Reality in
Another thing Prince said was that everything he had done in art had an autobiographical and personal meaning and he thought that was the same for any artist. In fact, his father had been a biker. Not a Hell's Angel, but he did drive around on a big Harley. Prince lost touch with his parents early on but then they tracked him down when he was famous. They called him up and said, Are you this guy? And then they came to his retrospective at the Whitney.

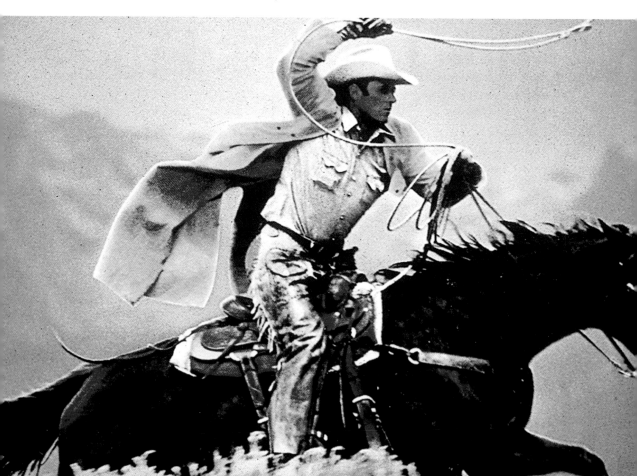

I went to see a psychiatrist. He said, "Tell me everything." I did, and now he's doing my act.

~ ~ 86

Richard Prince
Untitled 1986

Why did you think that first joke was funny? I asked him. He said he thought the idea of telling somebody everything was kind of funny. I've never told anyone anything, he said, a bit inexplicably.

Not just brown
Prince asked if I really thought Lucian Freud's paintings were only brown. It was something I'd written. He read about it in a review. I read that, he said, and I thought I'm not going to get along with this guy. I was just trying to say something normal about him, I said. They are pretty brown, aren't they? He said he was a big fan, especially of the fat people.

Good Neo-Expressionist
We always think of Prince as part of a movement in art that was antithetical to Neo-Expressionism. Didn't he like any of those artists? Yes, he liked Basquiat. He was stylish and painted an image that really meant something to him, because of being black, instead of just picking images out of the air, which was the thing for painters then, on the whole. He said he thought Basquiat lived a short happy life and that Schnabel made his film about him because he wanted to be like him as an artist.

ard Prince *Untitled (Cowboy)* 1984

The New
Prince always knew Jeff Koons and was always impressed by him, and could have bought his basketball tank for very little when it was first shown, because he worked at the gallery. But he didn't get round to it and now he regrets it because it would be worth a fortune. He liked him calling his first vacuum cleaners *The New*, and he was always amazed by his inept come-ons to women in bars.

Placed
When Prince was young he ran a gallery for a few months outside of New York and he once showed Carl Andre there. He spent all the budget on materials, which Andre then rejected. Andre went out and found his own materials and then did the show and went home. Then Prince saw him in New York a few days later and Andre wouldn't give him the time of day, even though a few days earlier he had really been giving him the time of day a lot. But Prince respected him anyway, and thought of him as a mentor. Andre didn't do anything to the materials, he said. Just placed them.

All the best
The reason I was meeting Prince was that I was interviewing him for a film, and there were seven other people with me. He gave us all photos of Pamela Anderson, each with a felt-penned inscription over the image reading, *To Richard Prince, All the Best, Pamela Anderson*, which he'd written himself.

Kids of success
Richard Prince was always in ZG magazine, which was published by Rosetta Brooks. She was a contributing editor for *Artscribe* for a while and she introduced me to a lot of artists. She said she never slept. Her skin was strangely dark, as if sleeplessness was causing melanism. She sent me off to meet Tim Rollins, who taught a special class of learning-disabled Hispanic male and female teenagers in the Bronx, and made a kind of art with them, which he was having a lot of success with. I went to the public school in the Bronx where he taught. He called his project with the teenagers, Tim Rollins and K.O.S., meaning Kids of Survival. He taught the teenagers, who were largely illiterate, to read or somehow absorb books by Kafka and other great writers, and to talk about them and make art based on them. He had to battle against some of the officials of the school, and he had to battle the art world to make it accept the art of K.O.S., and give him millions of dollars for it.

Tim Rollins and K.O.S.
Amerika I 1985

The art world loved it, but after a while they forgot about it. Before they forgot about it there was a period of sourness. It was sourness following a honeymoon.

It wasn't just K.O.S., it was said, it was Tim Rollins and K.O.S. There was something not entirely selfless about the whole thing. After it seemed heroic, it seemed a bit egotistical. The Kids label was infantilising and cutesifying. The art they did was too transparently gallery-friendly and not real enough.

It was pages from the books he'd taught them, glued onto huge canvases, with painted-on imagery floating across the pages. The imagery fitted with the text. Golden horns for Kafka's *Amerika*. Wounds for Stephen Crane's *The Red Badge of Courage*. Letter As for Hawthorne's *The Scarlet Letter*. The use of texts invoked the supposed worthy intellectualism of Conceptual art. The floating imagery was more recent-trendy, invoking Sigmar Polke or David Salle. You only had to think about it for two seconds, it was thought, to imagine that these heroically survived Kids might not naturally identify with the mind set and experiences of a Salle or a Polke, or with the Salle/Polke audience.

But the money he made filtered through to the individuals in the group, after his cut and the cut to his gallery, and expenses. He worked incredibly hard and never gave up the project, or the teenagers, even though some of them gave up on him. So although the whole project gradually became less and less a talking point, nobody really felt he was a terrible man.

Another interesting thing about him was that he was married to one of the B52s. *Rock Lobster*. That was their big hit.

Handy guide to all ideas

Study art for years

It's hard to understand art if you haven't been studying it for years. Here's a handy guide to the main ideas. The big movements of art since Warhol are Pop, Conceptual art and Minimalism. They all happened roughly at the same time, in the 60s. Pop came first, but by about 1968 they were all up and running. And everything that came after relates to them.

Both Pop and Minimalism don't have feelings, or hardly any. Conceptual art doesn't have feelings either, but it has many ideas. Minimalism doesn't have any narrative or ideas or subjects. Just objects. It can seem a savagely absurd and anarchic movement with a satirical humour. Or a dull academic one. The first is best. But both apply.

Down to nothing

Pop and Minimalism are often thought of as endpoints of Modernism. But Minimalism is the main endpoint. That's the point at which the succession of Modernist styles, from Cubism onwards, or maybe back from Impressionism onwards, starts to be thought of as a refinement down to nothing of everything that art could be. Obviously that's an absurd idea, but that was certainly the amazing power of Minimalism. It really got hold of that idea and made a look for it. At the same time it was outrageous the way it seemed to accept that you didn't need any meaning. You could just have something that was more or less designed to go in a space and look all right in there. A box, a line of bricks, a neon tube.

Post-Modernism

Post-Modernism is when Modernism is no longer seen as a movement toward a refinement down to nothing, which is what it had seemed by the time it got to Minimalism. With Post-Modernism, Modernism is seen as just a lot of styles. None of them more important than any other. Not even Cubism. So you could use any one you like, or mix them up. That's the visual level. The philosophy level is that Post-Modernism is an opening up of art to different narratives, not just a mindless following of one master narrative. The reason not to follow the master narrative is that the master narrative is bad.

That's a simple scheme of the way ideas work in Modernism and Post-Modernism. In reality it's all more blurred. But that's generally the

difference between philosophy and life. Unless it's the other way round. Philosophy can seem very blurred because of the complexity of all the ideas, and the need to keep up when reading. Whereas reality just comes blasting out at you whether you like it or not. Even if you haven't got an idea ready for what's happening.

Conceptual art, dual role

Conceptual art is nowadays sometimes thought of as the absolute total end-point of Modernism. But sometimes it's the beginning of Post-Modernism. When it started, it was just more Modernism, because Post-Modernism was hardly a notion then. It got going as a widely acknowledged notion at the end of the 70s. David Bowie, Laurie Anderson, Cindy Sherman. They all seemed to stand for it in their different ways. And it was gradually thought that maybe Conceptual art stood for it too, instead of standing for the endpoint of Modernism.

Conceptual art started becoming well known in about 1968. It was the Modern art ship drifting totally out to sea. That's it for me with art, most ordinary people said. But within art, where everything still made sense, the idea was that Conceptual art was even more refined than Minimalism. Or it was very similar to Minimalism. The two overlapped a lot. As well as being antagonistic, or a critique of each other.

Minimalism was a critique of everything. Because it was so minimal. It made everything else seem too much. And Conceptualism was the same. It was so open, it made all other art seem too closed.

Everything I know but which I am not at the moment thinking. That was a work by Robert Barry, a main Conceptual artist, now forgotten.

No one forgotten

No one is ever really forgotten, it turns out. And there's always a basement or stockroom full of the supposedly forgotten artist's works, waiting to be entered and pillaged and the works all sent to Sotheby's. Container-loads of Robert Barry's 1960s thoughts will probably soon be on their way to the new Guggenheim in Bilbao.

Movements welcomed back

At the moment, there is a big fascination with the art of the 60s and 70s. The three main movements and all their offshoots. We want to know what really happened then. It's an obsession.

A surprising offshoot of this drive to remember the past is the way art with no meanings at all, not even the non-meanings of Minimalism, is welcomed back too. That's the non-anarchic, unhip, formalistic targets and colour-fields and spray paintings and metal-beam sculptures of Ken Noland and Olitski and Caro and others.

Is Pop popular?
Pop is confusing because we're not sure if it's meant to be popular, or just about things that are popular. And frankly there's no easy answer. One guide, though, is that Warhol was the only one who systematically set out to make himself popular and to make his art be seen as essentially popular. But he did it in such an extreme, transparent, absurdly self-conscious way that it's hard to imagine how it ever succeeded. And yet it did, because Warhol is one of the most popular artists in history. But he didn't succeed in popularising his meanings, otherwise everyone would know what they are.

Conceptual art
Get the art out altogether. Frame up life raw.

Wittgenstein and Beckett
Big figures for Conceptual art and Minimalism. Not Pop so much.

Wittgenstein's *The Tractatu*s has arguments between characters who have letters of the alphabet instead of names, suggesting mathematical logic, even though the arguments are philosophical. An incredibly heady mix to artists of the 60s looking for meaning. Not for ones doing only colour and form, of course.

In Beckett's *Watt*, the character Watt moves pebbles back and forth between the large pockets of his old overcoat, making obsessive nutty logical or pseudo-logical systems in his head from all the possible mathematical combinations and variables, like a mad person. Which is what Watt is. Because it's Existentialism and it would be bourgeois not to be mad. That's the idea anyway. Another big hit as a concept for artists in the 60s, even though it comes from the 1940s or 50s, or whenever *Watt* was published.

For example, Sol LeWitt's idea in his *Statements about Art* of 1969 was that Conceptual art wasn't rational. It was irrational. Because it was art. He said the irrational thoughts had to be followed up systematically, though.

Conceptual art

Joseph Kosuth

Who first gave up painting? is a question that sometimes seems to be raised. Then a lot of grizzled 60s survivors kind of lurch forward with their hands up, and in these scrums it's always somehow Kosuth who gets the prize. There was a certain look his art of the 60s had. Dry, grey, sparse, ungiving, undecorative. The text was the plainest traditional serif text. The photos, the plainest straightest photos. The source for the texts, the plainest sources. Like the dictionary or the Thesaurus. This was the terrifying bottom line. Nothing in art would ever be the same again. Then you never heard anything about him and then suddenly in the 80s he was hugely back and in Europe all the time. And his art suddenly had a very pleasing visual look, almost like theatre sets, even though it was still text-based. It was fragments of texts from Wittgenstein and Freud, printed directly on the gallery or museum walls, or the walls of places outside an art context. The texts were enlarged and crossed out. Sometimes they were on glass, with photos or negating X marks. It was as if there'd been a subtle change in the terrifying bottom line, from the dryest of the dry to a more visually engaging look.

Joseph Kosuth
Titled (Art as Idea as Idea) 1967

Very young

I saw Kosuth in his house in Ghent the other day, just before he moved to live in Rome. He's always cracking jokes and talking fast. He said he was incredibly young when he was first successful. It was his dictionary definitions that made him successful. The definitions of words like Nothing or Meaning. He cut them out of dictionaries in the library and then had them blown up into photostats, white on black, 48 inches square. Later, in case the negative photostats seemed too much like painting, he started taking ad space in newspapers to show works. He was embarrassed about his young age and never gave his date of birth in interviews or on his CV until he was twenty-eight. During the year he reached twenty-five he made so much money he bought a farm in Tuscany, and he still has it.

This farm was a sore point because I was at his house now, in Ghent, which he was just about to leave, with a film crew to film Marcel Duchamp's first unassisted readymade – his snow shovel inscribed with the words *In*

advance of the broken arm. Kosuth acquired it in the 80s. It was a re-make from the 60s. It cost $50,000. He swapped one of his early *Definitions* – the definition of a stool – for it. But now it turned out he'd just sent it on to the farm in Tuscany by mistake.

Kosuth on Greenberg
Kosuth was once introduced to Clement Greenberg at a party. It was just after Kosuth's essay 'Art After Philosophy' had been published and everyone was talking about it. It was an attack on Clement Greenberg's cult of the eye, in favour of Duchamp's cult of the mind. The followers of Greenberg were there at the party and Kosuth was interrogating them about meaning. When he asked them anything, they would all turn to Greenberg and say, Clem, how was it you put that, in that article? And when he talked to Greenberg, Greenberg only said, Hmm, Kosuth, Kosuth – where have I heard that name? He wasn't ready to be killed by the son just yet.

Duchamp smoking
Duchamp was filmed by Warhol once, in 1966, shortly before Duchamp's death, for a screen test. The old wry, dry Duchamp smokes a cigar and stares sardonically into the camera for a few minutes, and then the film's over. Jasper Johns was always putting references to Duchamp in his paintings. And John Cage is always mentioning him in his books. Ad Reinhardt, Jasper Johns, Marcel Duchamp – the big moments leading up to Conceptual art.

Ad Reinhardt
Ad Reinhardt, an artist of the Abstract Expressionist period who died in 1966, questioned everything everyone believed in about art, and ridiculed the pretentious statements of the Abstract Expressionists and the writers who took their statements seriously. He painted all-black paintings for the last six years of his life. He liked ancient art and Eastern art and Zen, and he was a committed socialist and political activist and a good cartoonist.

Duchamp generally
Generally, the idea with Duchamp is that he was an artist and then an anti-artist and then he went underground between about 1920 and the 1960s. In 1920 he declared he wasn't an anti-artist any more, but an engineer, and he was just going to play chess. And in the early 60s he was the hero of John Cage, Rauschenberg and Johns, and then of the Conceptual artists.

In the 60s, the myth of Duchamp we now know – incredibly refined, intellectual, urbane, witty, mysterious, sardonic, ironic, laconic, wry, dry, a bit erotic, alchemic, *Cabala*-influenced, contemptuous of commerce, despising of brush-strokes – started up. His was felt to be the spirit behind everything in art that wasn't purely sensual or beautiful. Which was everything that happened in the 60s except Greenbergian formalism, which he wasn't interested in. He said Conceptual art was quite interesting and Warhol's soup cans were quite interesting. Not the cans themselves, but the mentality of someone who could think of painting 32 of them in the same way. He was ambiguous about Pop Art generally. He thought it was a bit too visual.

We imagine hardly anyone was ambiguous about him, though, and that everyone thought he was a god. But in fact not all the cult artists of the 60s and 70s supported his myth. After Duchamp's death, Robert Smithson, the artist of Site and Non-site art, complained that the art world had Duchampitis, and that in the end ideas weren't art, objects were.

Interestingly, in the 90s hardly anyone mentions Duchamp any more. Without Readymades, both Richard Prince's jokes and Sean Landers's texts, for example, would be impossible. But both artists don't think about him at all, they said, when I asked them about him. Prince said if he could have seven famous works for himself, a Duchamp wouldn't be one of them. Whereas a de Kooning might be.

Lawrence Weiner
He looks like a Hell's Angel or an old lag from prison, with tattoos and black leathers and a white T-shirt. He is always talking. An unguarded free discloser of intimate facts about himself and his personal life. Quite disarming and charming. His art is only words on the wall. It was radical in the 60s when it came out and it's still good. It's never obvious but it's not obscure either. The words describe actions that have been done already – even though they haven't and don't ever have to be – and the conditions of their doing. For example: *Within the context of a double standard*. It's poetic even though it's not poetry, it's art. Some other good sentences from different early installations include: *A field created by structured simultaneous TNT explosions. Common steel nails driven into the floor at points designated at time of installation. A removal to the lathing or support wall of plaster or wall board from a wall. One standard dye marker thrown into the sea.*

Lawrence Weiner

Another thing to enjoy about him is the films he has been directing since the 1970s, which are rarely screened, and which often show his swinger lifestyle. Sexy stoned people are seen smoking joints on his barge in Amsterdam and reciting his paradoxically impossible to remember sentences – paradoxically unmemorable because they seem to be so unconcrete and yet are always returning to the world of things.

That's why he says his art is about materials and not about language, even though history thinks of him as one of the main innovators of Conceptual art, and basically an artist of words.

He has made some records too. I got one recently. He makes them with a band. *Circles, circles, circles of remorse*, they sing, surprisingly passionately and melodiously. And, *There is no light at the end of the tunnel*. Also, *Row, row, row your boat, shit flows down the stream*. That's the kind of thing we want to hear. If we are from the passionate but sceptical generation.

Lawrence Weiner
More or Less, That As It Is 1997

I went round with him in Prague for a few days. He was having some sentences put up by sign painters on the façades of various buildings. *Things capable of combustion collected*. And *Things made to be seen forcefully obscured*. And other sentences. He was glum because it was so boring there and the food was bad. I felt he didn't like me and thought I was just a weak guy, not a strong guy. But it might have been the cabin fever of having to go around with each other all the time. And the novelty of absinthe, which you can just buy in bars in Prague, like in Paris in the nineteenth century. So I was sorry about that but I liked his disclosings.

Jagged edge

Weiner said he was an autodidact. He'd been in a juvenile detention centre when young, for some reason. It was the practice there, he said, to stick a broken Coca-Cola bottle up the ass at night, with the jagged bits facing out, to deter rapists. But I don't know if he did it himself or if it was even true that anyone else did it much. I felt he sometimes just said these things for the effect, or to fill the long East European days. It was fine because he was a born actor and would have made a good Warholian superstar if he didn't have a big beard.

Dan Graham

School teachers wrong and war bad

Weiner says he was always put down by the Conceptual artists for being too materialist. But he doesn't care about the Conceptualists because they were just school teachers who were only interested in their wonderful new academic movement, he says. They murmured that he was a danger to them because of his sensuality. But, he says, the only danger he represented to them was he was an artist, whereas they had no intention of making art. Their only intention was to find some kind of new subject that only they would be equipped to teach, so they'd have a job. Now it's a bitch making a living, he says – rising to his theme, but kind of acting it at the same time – so he couldn't complain about that. But it's got nothing whatsoever to do with art! In fact, it fucking well goes against the aspirations and hopes of each succeeding generation! he exclaims, with an absinthe-fuelled triumphant actorly flourish.

Also, he says he's against Expressionism because it is a type of art that looks to the past. The past is bad because of all the wars.

Dan Graham

A great artist and writer of the 60s. For an early Conceptual artwork, he attempted to get a medical expert to describe in purely factual terms the stages of a penis's detumescence after sex. You can see how it makes sense in relation to a critical notion of the hidden male power of Minimalism. But he couldn't get any replies for his ads in magazines. I think he must have done the description himself in the end, because I saw it framed up in the Lisson Gallery in London recently. And he made a film called *Roll* where he filmed himself rolling on the floor. Then his later writings analysed Punk Rock as a gender and class revolt.

Rock My Religion. That was his film about rock music, including Patti Smith and the Doors, and the Shaker movement. Then it was the title of his collection of writings. He has a monotone voice. He looks unkempt and shabby in a sympathetic way. He talks like his writing, which is very intelligent. There are witticisms and intelligent observations but not much conventional sense of beginning, middle and end. I think it's good, but it's not surprising that his early pieces were always intended for magazines but were never published, or else crassly cut, or carelessly illustrated. Not taken care of. In conversation he makes jokes, and lectures at the same time. All in the same tone. So you're never sure exactly what you just heard. If that was an important bit or just an aside. He's very interested in the relationship between mass culture and art.

Dan Graham
The Roof Top Urban
Park Project
Two-Way Mirror
Cylinder Inside Cube
1981–91

Rock My Religion – fantastic! I said, on the stairs at the DIA Centre, near the Dan Flavin neon tubes. Have you seen the film? he asked. Of course, I said. Douglas Gordon ripped it off, he said, referring to the Scottish artist who recently won the Turner Prize and then the Hugo Boss award. Oh right, I said. Yeah, he said. They're trying to make him into a Scottish football hero.

Homes for America

Dan Graham's main work that should always be mentioned is his spread of photos of façades of cheap homes, published in the art magazine, *Arts*, in 1966, the year Minimalism first took off as an established movement, but two years before Conceptualism took off. It was a description of the homes, and analysis of how they were structured and what social types they appealed to. All in a deadpan style and presentation. The colours preferred by males and females were indicated. Females disliked Patio White

Dan Graham *Homes for America, Arts Magazine*, 1967

but liked Moonshine Grey. Males liked Colonial Red but disliked Nickel. But a lot of the males' and females' preferred colours overlap. Both dislike Patio White. You can't tell why this information was presented by Graham in an art magazine as art of some kind. But gradually the idea took hold that it was an extension of Minimal art into the social world, and this became the main idea connected to Dan Graham. It was an extension but also a critique. He made performances and films and text-works, and then in the 80s and 90s his art became more and more architectural.

Architectural art
Always link it to social world.

Mass culture
Not bad but must be deconstructed. But dominant culture always bad and must be subverted. In fact, dominant culture is like master narrative.

Helpfully
A well-known work of Dan Graham's is his permanent roof garden at the DIA Centre. It's a transparent glass structure. A spherical structure within a square structure. You go up in the lift and out onto the roof and then walk into the structure through a heavy door and close it behind you, and once inside you look out over the Manhattan skyline in a 360 degree circle. From one point you can see a cooling tower. The shape of the glass structure you're in consciously echoes the tower. Graham says the architect and writer Aldo Rossi once said the cooling tower was the symbol of New York, rather than the skyscraper. But Rossi was gay, he points out helpfully.

Dan, talk to me
That's what I was saying on the DIA Centre roof this morning, during filming, because he was facing the other way and talking to the cameraman instead of me, as we were all awkwardly exiting the heavy glass door of the roof-garden structure. It was TV, but we had to pretend it was real. At first neither of us could find the door, because it was the same glass as the walls. And then neither of us could open it because it was heavy, and both of us were trying to look natural and relaxed as we discoursed. Then we got it open and tried to exit it in a natural way, as if we weren't being followed by a film crew. All around us, through the glass, we could see people the film director had brought along specially, walking in circles around the glass structure, in a rather zombie-like way, I now noticed, imitating real people. Because this was a day when the DIA was closed to real people. And while we were struggling with the door, Dan was talking in his genial, idea-packed

monotone about the role of the spectator in his art since the 60s, and how he prioritises it. As opposed to the art object. Which he began to see, even at the time of Minimalism, was becoming just an expensive commodity.

Nixon

This architectural roof-garden art at the DIA is connected to a café on the top floor where video art is shown. It's an integral part of the work. The whole thing is an attempt to re-radicalise free space. In the 70s or 60s or sometime, there wasn't any architectural free space in New York because Nixon was letting the city deteriorate. He wanted to get the power out of the city centres to the suburbs and the country because the cities were subversive. So the free spaces were deteriorating and the artists were colonising them for dance or avant-garde events or art, like Happenings at the Judson Memorial Church. Then in the 80s the only free space was corporate space, like roof gardens in shopping malls. That's bad. Somehow the roof-garden art-work subverts that.

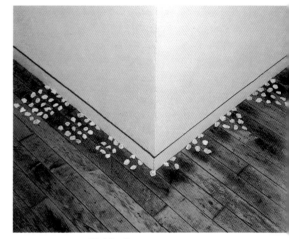

Mel Bochner
Triangular and Square Numbers 1971

Dan on Dan

In his youth, in 1965, Dan Graham ran a gallery for a year, but of course it didn't quite take off, like his writings never took off at first. But also like them, it was the beginning of who he later became and it shaped his aesthetic and his ideas. One of the main influences on him was Dan Flavin and his sculptures that were just neon tubes. Absolutely top, Dan had thought of Dan and Dan's attitude to art and life, as Dan sent his tubes back to the shop after the show came down. It was with reference to Flavin that Graham said Minimalism was hilarious whereas art today is only witty.

Mel Bochner

Huge name in explosion of Conceptualism. Forgotten now. Arranged pebbles. Wrote articles about Minimalism. Praised it because it denied art mysticism, art existentialism and humanistic stammering. Then tried to deny these things even more, himself. Put on installations of different types of documentation, like Xeroxed diagrams and articles from *Scientific American* and Don Judd's bills from the factory that made his sculptures. Said it was art. Or not art. It was good that it was not art. Not bad. 'Working drawings and other visible things on paper not necessarily meant to be viewed as art' was his historic breakthrough exhibition in 1966. Went back to painting in the 80s.

Interesting new Anti-Form

Scatter art

In the 60s there was a vogue for scatter art. It was part of Post-Minimalism. The idea was not to be so Minimalist, without being wholly un-Minimalist. The Post-Minimalists didn't hate Minimalism, they revered it.

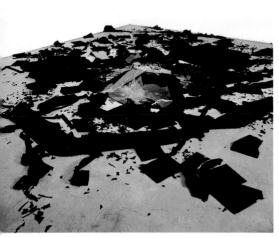

In the case of scatter art, materials were scattered around on the floor. The first famous scatterer was Barry Le Va. He scattered tough things from hardware shops. He scattered tins of paint with their lids off so it was a scatter paint-piece. Or a spill. Or a dispersal. And he scattered pieces of cut felt and panes and shards of glass.

With Minimalism, there was an excitement about the idea of elementary forms, like cubes or spheres or triangles. But especially cubes. Even though it wasn't Cubism. So one of the next things after cubes – but still very much in the spirit of the elemental that went with the cube fascination – was something that seemed opposite. Like scatterings.

Barry Le Va *By the Act of Dropping* 1967

Robert Morris

Robert Morris was an important scatter artist too, as well as many other things. He made felt works, earth works and Neo-Dada enigmatic works. He did practically every style from Pop to now. He was attacked for doing that, but also considered to be very wise for doing it.

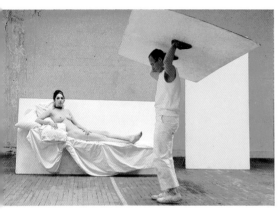

No one knows what to do with him, though. He had an enormous retrospective at the Guggenheim, but no one liked it. He tried everything before everyone else. He is an intellectual and a good writer, as well as an artist, and obviously that makes people suspicious. Sometimes you can't tell what he's for or against because his writing is so dry. He had some good photos taken of himself. One posing in Nazi homo gear in the 70s, critiquing the male power of Minimalism. And one wearing a mask of his own features, in the 60s. With Carolee Schneemann in the background, posing nude as Manet's *Olympia*. It was part of a Happening critiquing flatness. Or perhaps extolling the virtues of it. He was one of the main Minimalists, but his grey boxes were against everything and

Robert Morris *Site* 1966

had no meaning. Whereas Donald Judd's boxes weren't grey and they were only against European art, and they probably did have a meaning, only nobody knows what it was.

To scatter now

Nowadays, Post-Minimal scattering and Minimal cubes seem very close, because they're both ideas about form. Whereas we hardly ever think about form in the 90s. We think about death and illness and the Millennium and war and cultural identity and child abuse and daytime confessional TV.

In the early 1990s scatter art came back. In the old days it was an anti-form idea. Even though it was also a form idea. But in the 90s it was an abjection idea. It was to express impotence and a sense of the pathetic and not being convinced by anything. You could scatter anything in the 90s. But it was better if it was limp or lame or idiotic or funny or camp things. Not tough things from a hardware shop.

The big 90s scatterers

Karen Kilimnik was one of the big 90s scatterers. She scattered bits and pieces of nonsense paintings and graphics, with imagery copied from fashion magazines, and electrical wiring and lights and silver foil. One of these installations was about *The Avengers*, called *Mrs Peel... We're needed*.

And the other day I saw another *faux*-idiotic good scatterpiece by her, with scattered samovars and naïve paintings of Princess Anastasia and other romantic snowy Russian scenes, and a scattering of fake snow.

I first met her some years ago. It was in the back of a van in New York, which was being driven by the artist duo Pruitt Early. She was their friend. Everyone seemed about thirteen, although in reality they must have been in their late twenties. We were on our way to an AIDS benefit drag show. She seemed very far away and childish. She couldn't answer a question directly, or even at all sometimes, as if she had a kind of dyslexia of hearing, and meaning connections were a problem for her. But she was witty at the same time.

Karen Kilimnik
Mrs Peel... We're Needed 1992

Pruitt and Early
*Big Portraits of
the Artists in their
Studio Hung, Black
Denim Border*
Early 90s

Pruitt Early

Rob Pruitt and Jack Early were scatterers too. Exhibiting under the name Pruitt Early, and breathlessly dating their works Early 90s, they exhibited clusters of six-packs of beer, scattered around a red sports car with a *Playboy* bunny logo. In another show they scattered gay porn mags around bales of hay. And in another, they scattered some cushions with lurid early 90s pop culture slogans and images on them, making up an installation called *Artworks for Teenage Girls*. The slogans were things like *Wine Me Dine Me 69 Me*, *I Will Always Love Him* and *100 Per Cent Bitch*. This was the sister exhibition to the beers and sports car scatter show, which was called *Artworks for Teenage Boys*. They really did have sisters, who looked just like them. The hay and porn mags show was a Country and Western scatter-piece.

What happened to Pruitt and Early? They disappeared. They were intro-duced to Leo Castelli and they put on a black show in his space. It was an installation of posters bought from shops of black popular culture heroes from the 60s to now, like basketball players and Shaft and Niggas With Attitude and Public Enemy. The posters were spattered with paint in Rastafarian colours, red, yellow, green. The walls were black and there was a soundtrack of immortal black music from Jimi Hendrix to Ce Ce Peniston, with a DJ intro dubbed over one of the immortal tracks, by Pruitt Early, saying things like, We're cool, we're hot, we're Pruitt Early. But the reviews were vicious. It was 1993 and they had to be killed because it was the wrong climate for that kind of thing. It was after that they disappeared.

Karen on Pruitt Early

Me: When did they stop working together?
Karen: Maybe like a few years ago.
Me: Why did they stop?
Karen: Well, I don't know. Uh, they were so much fun.

The biggest scatterer

But the biggest 90s scatterer was Cady Noland, the daughter of Ken Noland, the Greenbergian formalist. Greenberg was disappointed she just turned out to be a fashion phenomenon. But the fact is, her art just couldn't be registered by the Greenberg eye. The look of her art was macho chrome and metal, quintessential American, like trucks and diners and lobbies and elevators, but with the macho matter spread out in anarchic heaps and accidental spillings. Metal railings with macho things hanging from them, like plastic US flags or handcuffs or police batons. Metal supermarket baskets

with used Bud cans in them. Boxing gear – red punch bags, an entire boxing ring. A reception desk caged behind metal railings, called *Reception Cage*. And silkscreened news photos from old tabloids printed on sheets of aluminium, just standing around, or with arbitrary holes cut in them. Or actual tabloids lying around in baskets. The headlines screamed America. But a dark America, not a Pop one. *Abbie Hoffman Dead*.

For a few years she was huge. But then she wavered and her light dimmed and went out in about the mid 90s.

Top Minimalists

Judd in Marfa

One of the main figures of Minimalism is Donald Judd, who died of cancer in 1994. He owned the box form. It influenced everything that came after, more or less, in some way. He invented it in the 60s and after that he never wavered and he got more and more convinced of the need never to waver. And also to make millions of dollars in order to have spectacular showings of his non-wavering work, displayed how he wanted it. He couldn't stand his art to be seen in group shows or in museums with other art because that was just Disneyland, he was convinced.

Above and following pages: Marfa scenes, including (middle row, left) some of Judd's collection of Indian objects, blankets and tartans; and (middle row, centre) one of the army sheds Judd owned outside Marfa

By the early 90s he had bought up most of a small town in Texas near the Mexican border called Marfa. It was famous for its mystery lights – faint dots of light that seemed to bounce on the horizon at night, just out of town. He started buying it up in the 70s. He arrived there in jeans, with a beard and a hippie ponytail. Eventually he owned the bank and supermarket and various other large buildings and a whole army base near the town, and a couple of ranches with thousands of acres of land, and all these buildings were now all filled with his art and the art of other artists he admired. At first he got money from the De Menil family, who started the DIA Foundation. Millions of dollars. Then he fell out with them and got more money during the 80s by selling many art objects and prints to Japanese museums and collectors. He made a lot of editions of sculptures. Some days he would just order up dozens or hundreds of works from the fabricators in one go. During this period there wasn't anything that spectacular about his stuff, it really was being churned out. But still,

you can catch yourself being impressed by it. Unfortunately you can't see any in this book because the Judd Estate wouldn't give permission for the photo rights. So you'll just have to imagine it. It's decorative. It looks handsome and stylish. The colours are so high sometimes, the objects spin from handsome to rococo, almost to outright kitsch, though never quite. The ones in the army base at Marfa make a spectacular sight. Uniform but different. All shining. One hundred glinting metal geometric forms in endless rows, with high windows all around and the Texas fields beyond, with deer walking about out there. But it's obviously not ecological art. It could be anywhere and still look the same. In the city. On the moon.

Judd became more and more lordly. He liked bagpipe music and he drank whiskey. He collected obsessively, like Warhol. American Indian artefacts, old china and pottery, old furniture, old weapons. I went round his houses and buildings in Marfa and saw it all, the year of his death. I went to his ranch and saw his grave. The grave wasn't marked except by a black tartan cloth, which was now ragged, from the wind and dust. The ranch was on the edge of a range of blue mountains. The Chinati mountains. The air was dry, the sky clear and the mountains blue, and there were cowboys rounding up horses. You could feel the myth power gathering. Then the other day I happened to be back in Marfa. It was a privilege to once again be allowed to look at his sculptures in the best way possible, as he wanted them shown. On the other hand, the Judd operation had got more and more smoothly corporate, fulfilling what had been inevitable about his whole operation in his last years. There was *Judd Foundation* inscribed on the windows of all the buildings in the town, virtually. And inside them, Judd furniture and Judd representatives, and postcards of Judd works to buy, for a dollar, and catalogues of his exhibitions in Germany.

Bitter Judd
In 1982 Judd published an article in the *New York Review of Books* called 'Not About Masterpieces But Why There Are So Few Of Them'. This was the period of Neo-Expressionism. He complained bitterly about Post-Modernism in art and architecture and the use by Post-Modernists of history as a bag of toys. He said it was a mystery why there were so few good artists coming up any more – the last time there were a lot of good ones coming through was the late 50s and early 60s. He didn't say this was the period when he started being an artist. He said the fault was with education, that it was so bad. And business, that it was allowed to call the shots in too many areas. About this time, he was awarded an honorary professorship of some university or other. It was as if there was a new Judd. The bitter honorary professor.

The old Judd of myth had his own intelligence. He studied art history, philosophy and painting at university. But his ideas about art always seemed beyond the conventional. His cleverness seemed aggressive, almost punky. He was a punky anti-bullshit clear-headed intellectual aesthete, not standing for snobbery, hypocrisy or dullness. It was a new exciting way of being rebellious, being rebellious the Modern art way. The new professorial Judd of the 80s was egotistical, which is always right for a star. But also boorishly self-aggrandising and oblivious. Which the old one hadn't been so much. The old one advocated artists' rights to better pay and better showing conditions and more control generally. All this was part of his clear-headedness and willingness to call a spade a spade. But the new angry professor only wanted the bad artists got rid of.

Dan Flavin

Another of the main Minimal artists. His neon tubes were just standard light fixtures. A straight one, or two making an X, or a diagonal one. And so on. The first one was a diagonal one, titled after the day he did it, *Diagonal of May 25, 1963*. Sometimes they were white, sometimes other colours. But always standard industrial fixtures and colours. Industrial was the thing at the time. Carl Andre was from this time too.

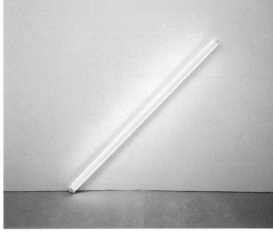

Dan Flavin
*The Diagonal of May 25, 1963
(to Constantin Brancusi) 1963*

Industrial

The 1960s. Industrial, factory-fabricated, factual, not romantic, not expressionistic, not sentimental: these were all good things. Elaborately composed, done with a palette and brushes, copying Picasso, copying Matisse, going to France: these were all bad.

Carl Andre

A very good artist and an interesting character. He just does what he feels like. He places things. He likes Neolithic art and the Pyramids. He gets some materials and puts them in a row and it's a sculpture. It's not Conceptual. He's a poet and he knows what language is, but he doesn't want any of it in his art. He only wants materials, mass and pleasure. He worked on the railways as a freightman and conductor, and lived outside of New York. Then he became well known. He wears overalls and has an old-fashioned beard under the chin. He looks like he might belong to a separatist farming sect, like the Amish. Why don't you ever allow yourself to be filmed? I asked

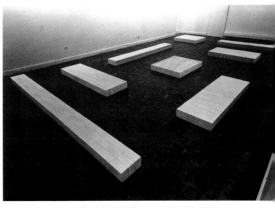

Carl Andre *Equivalent I–VIII* 1966

him. He said he wanted to be invisible. But it was a strange look to adopt for invisibility purposes. In 1974 the Tate Gallery in London bought one of his brick sculptures for £800 and the British press went wild. Ever since, his sculpture has been a by-word for obscurantism for the press. The bricks sculpture – Ha ha. Or: The bricks sculpture – Grr. That's about the level of it.

Dan Flavin later on

In the 80s Dan Flavin's neon light artworks got more and more elaborate and grandiose. A not uncommon trajectory for the stars of the 60s. From hard, tough, factual; a Zen-like absence of ego. To enormous, decorative, elaborate, corporate; ego absolutely the main thing.

Falling

Carl Andre sometimes drank too much and so did his wife, Anna Mendieta, the feminist artist whose photos of herself in weird facial feature-altering make-up and wigs anticipate Cindy Sherman. They rowed and rowed. Once they were drunk and rowing and the next thing Andre knew, he said later, his wife was out the window. She died from the fall and he was arrested by the police. But then it was decided he hadn't done anything wrong and he was freed.

Ana Mendieta
Facial Hair Transplant 1972

Dan Flavin later still

Before Flavin died, I went to his house on Long Island. He had an Irish nurse who it was obvious didn't know him well, and didn't know who he was, and was just from an agency. There were two big dogs there too. It was nearly Christmas, and upstairs, where the bedroom was, it was all decked out with decorations. In the bedroom, the decorations were really wild. They were everywhere. It was like a child's fantasy. There was a huge Christmas tree. With a trainset round it. He was lying in bed. His illness was something to do with diabetes. He had turned completely anarchic. He would ask the nurse to turn on the train, like a child, and then sigh with ecstasy when it made its train sound and chuffed round the tree. He called out to the popular baseball star on the enormous TV screen – Bubby Brewster! Bubby Brewster! And then when I asked if the set could be turned down, because I was going to interview him, he went Wah! like a baby. But he was clear when he wanted to be. He was very sincere about his former friend Judd, for example, who had named his son after him, but had eventually fallen out with him, as he seemed to fall out with more or less everybody. He said Judd was the greatest American artist of the twentieth century. But he said the set-up at Marfa was egomania, and a punishment for the art audience, to make them trek out there to see his genius.

Robert Ryman

Ryman is the Minimal painter famous for all-white paintings that are always square. Unlike the earlier all-white paintings of Rauschenberg, which were flat, Ryman's are all about surface incident, and differences, and details of the way the paint meets the edge of the canvas, or just edges up to the edge. And the way it's not always canvas, but board, brown paper, metal, fibre or other surfaces. And the way these materials or canvases are screwed or fixed or masking-taped, or otherwise fastened, to the wall. He is a fantastic artist even though his paintings deliberately don't mean anything. Maybe it's because of that, we could say. But that would bring up a whole complicated idea about meaning.

I went to his studio. He is a pleasant guy, very ordinary in appearance, except with a slight resemblance to Peter Lorre. He just talks in a normal way. There were books about billiards and pool technique on the shelves. And a real pool table in the back of the studio with antique brass lamps over it. There was a lot of white oil paint. Tubes and tubes. And piles of it on the glass surfaces of his paint trolleys, kept wet under cellophane sheets. And small unfinished white paintings on the walls, showing long hours of white labour. The dates were dramatic incidents, so were his initials, or just a trailing stroke, or an abruptly curtailed one, or a

Robert Ryman *Term* 1996

date inscribed twice instead of only once. He said he never thought about Minimalism or thought he was a Minimalist. His favourite artist at the Museum of Modern Art, when he worked as a guard there in the 1950s, was Matisse.

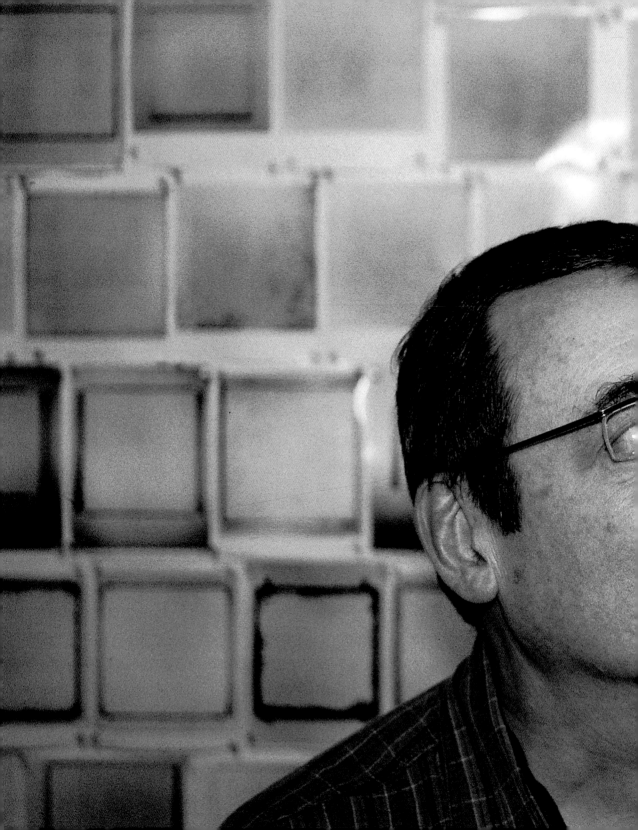

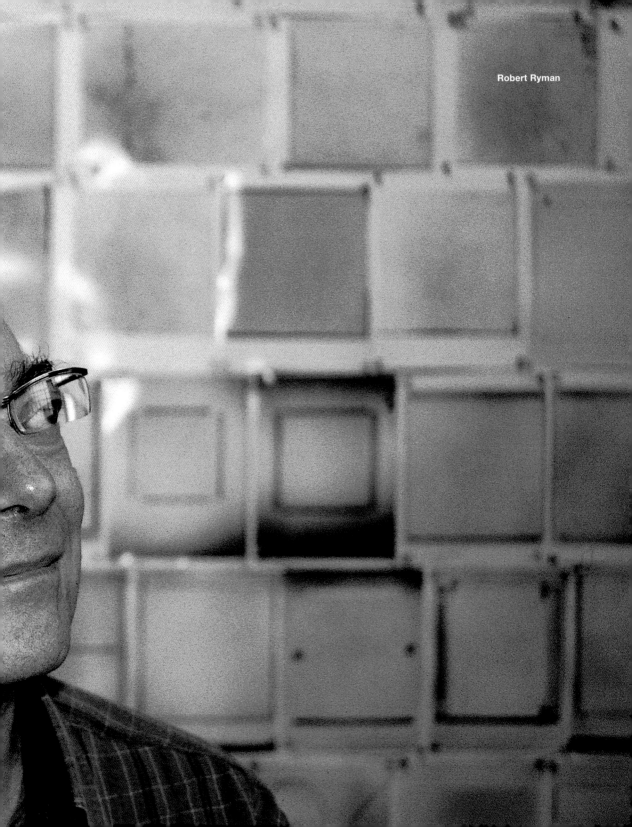

Robert Ryman

Robert Ryman's studio

Minimal guards
Robert Ryman had been a museum guard and Dan Flavin had been one too. Sol LeWitt worked at the Museum of Modern Art.

Names for Minimalism that didn't catch on
Cool Art, The Third Stream, Specific Objects, ABC Art, Primary Structures, The Art of The Real.

Show that put Minimalism on the map
'Primary Structures: Younger American and British Artists' in 1966 at the Jewish Museum. There were about 40 artists in it. Judd, the main one, complained most of them only went geometric in the year leading up to it, when it was known that the show was going to be put on.

Sol LeWitt confusing
Sol LeWitt stands for open white cubes in systemic structures. Structures that elaborate visual systems. They're not Minimal but Conceptual. But it's confusing. Also, he stands for line drawings on the walls. Anyone can execute them. Diagonals, straight lines, curved lines, whatever. A thousand, ten thousand, etc. He just sets up the instructions and assistants execute them. He started them in the 60s. He thought up something irrational then had it systematically followed through by assistants to the bitter end. Then it usually turned out not to be all that bitter at all, but elegant. Then in the 80s his coloured ink wall drawings, which are basically paintings executed in coloured ink, looked incredibly decorative in a straightforward way, neither Conceptual nor Minimal. So that was confusing.

Sol LeWitt *Four part variation, Serial Project I (A, B, C, D)* 1966

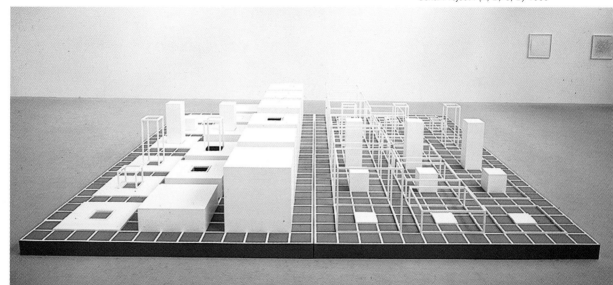

Always say entropy

Cult artists of the 70s
Today, Gordon Matta-Clark is one of the main cult artists of the 70s. We are fascinated by him. Also, Robert Smithson and Chris Burden. We like them, too. Matta-Clark studied architecture and then gave it up because it was just policing the body. He started to do Cuts and Splittings. He cut sections out of buildings with a chainsaw, and then began to cut them in two, and then photographed the results and documented them. The address and date and so on. He was the son of Matta, the Chilean Abstract Expressionist painter, who wasn't very good. Even though, curiously, Marcel Duchamp really took to him, perhaps just to be kind. Or perverse. But obviously Matta-Clark was a much better artist because nobody takes Matta seriously, whereas Matta-Clark is a cult figure. He died in 1978 from cancer when he was still only in his late twenties.

Gordon Matta-Clark *Exterior of Food restaurant* 1971

Food

Matta-Clark was a free spirit. He shot the window panes out of the windows of the Architecture Institute in New York, instead of giving a talk about architecture there. And he offered oxygen to straights on the street in New York's financial district, because they were stuffy. Also, he opened a restaurant in SoHo called Food. It sounds like an ironically plain name for a fashionable place of now, but in reality the atmosphere was very different. It was the time when artists were against the Vietnam war and the art system. Therefore it was an artists-run restaurant. That's just the way the logic worked in those days.

Entropy

There were different buzzwords in the 70s from the ones we know now. Entropy was one of the notions then. It had a feeling of decay about it. And decay seemed right after the thrusting forward progress of the 60s, especially thrusting Minimalism. Even though Minimalism's thrusting was nihilistic as well as optimistic. No one cares about entropy now or even knows what it means. It was the thrilling sense of the seething broken-down formless *phlogiston* that everything is made up of and will return to, including all the systems and formalisms and ideas and highways and airports and art galleries.

SoHo just begun

At Food the artists got cheap wholesome food, cooked by other artists, with music coming from the kitchen. Also, some sections of the building got the Cuts treatment. It was 1971. SoHo had just begun.

First in SoHo

Don't forget. First gallery in SoHo. Paula Cooper. She bought her building in 1968. It's not particularly interesting, I know, but we must always say it.

His last object

It was George Maciunas who really started SoHo as an artists' area. He came from Germany and was the founder of Fluxus, the international art movement that lasted a surprisingly long time, from 1962 to 1978, and overlapped at first with Neo-Dada. It ran alongside the other movements in a kind of corridor on its own, and it was more tolerant than them of chancers and strays. It was all about jokes and ephemeral events and pointless objects and films, and a very expanded notion of musicality. It was made up of musicians, poets and artists. They had Sonatas for everything, and Events for everything. The main figures were George Brecht, Robert Watts,

George Maciunas performing *Carpenter's Piece* at Fluxhall concert in New York 1964

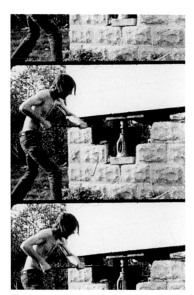

Gordon Matta-Clark
stills from *Splitting* 1974

Dick Higgins, Joseph Beuys, Nam June Paik, John Cage and Yoko Ono. George Brecht was the main one for Events. A dripping tap Event, for example.

There was a lot of silliness. Maciunas was a kind of Stalin of silliness. Everything had to be done exactly as he said, to a point almost of fanatical control. However giddy or flaky the personality of the Fluxus artist was that he was controlling at the time. For that reason a lot of the artists fell out with him. Also, he would often excommunicate artists, like André Breton did with the Surrealists, or Guy Debord with the Situationists.

He tried to control an exhibition Yoko Ono was putting on with John Lennon in 1970, and when Yoko complained he exploded with anger and ran out into the street and they never spoke again. And after that Yoko gave up being an artist until she made her return in the 80s, with George now forgotten.

Gordon Matta-Clark stills from *Office Baroque* 1977

Maciunas started SoHo by finding empty lofts and organising artists' collectives. He would do all the arranging and get loans from the bank. Some of these collectives are still running today, exactly as he started them, with the original inhabitants still living there. One of these is the film-maker Jonas Mekas, a Czech immigrant, who moved into his loft in 1971, the year of Food. I was up there the other day. It was a fantastic jumble of old books and stuff, with a kind of pathway down the middle. A long space. You walked through the jumble, from the house plants at one end, getting the sun, to the kitchen at the other, with the boxes of cereals and tea bags. There was a white wooden cube about three and a half feet square, with rounded corners, and holes cut into the sides. It was a big dice. The rounded corners were so you could be rolled in it. It was the last object George Maciunas made, Mekas said. He got in it and closed the lid over himself, to demonstrate how it worked. Then he got out and gave a charming bow. He said George Maciunas wouldn't pay some builders for some work they'd done badly. So because they were Mafia builders they beat him up with iron bars, to the point of death. He recovered but then he developed cancer and died. Interestingly, Maciunas was a transvestite. He bought a whip and asked his wife to lash him with it. When they were married, they exchanged their clothes, item by item, as an Event, with Mekas filming it.

George Brecht, Bertolt Brecht
Not connected.

Blurring but not eradicating the boundaries
Matta-Clark documented Food. He photographed and filmed the place. In those days everything was documented. It just seemed right. It was the end of formalism. Art should come from somewhere other than art, it was thought. Because art from art was élitist and arid or only decorative or entropic or not entropic enough. A good place for art to come from was from social and everyday things. Social and everyday things could actually be art. You could just section them off as art events. A good way of pinning them down once you'd sectioned them was to document them.

That would be mad
There was still a boundary between everyday things and art, of course, otherwise it would be schizophrenia and that would be horrible. It would be like a perpetual panic attack. The idea must have been to radically blur the boundaries between art and everyday life but not to eradicate them altogether because that would be mad.

Looking back at Food

In the photos and films that document Food, the young artists of the early 70s eat their food at Food and chat and smoke their cigarettes, wearing their jeans and jumpers. I saw them the other day at White Columns, the non-profit gallery that somehow connects historically with Food, or with some other gallery that was connected to Food at the time, down the road from it. And also to the Conceptual art magazine Avalanche, which was a communication lifeline between the radical artists in the old days. Also, a bit of the Food building that Matta-Clark cut out was on display. A square of wall. Maybe the space left became a hatchway to pass the food through. That was the last utilitarian Cut by Matta-Clark, he said in an interview once. The more art overlapped with utility the better, it was thought.

Smoked Swiss cheese

Another film was on at White Columns, as part of the Food exhibition. It was by Robert Kushner, who was briefly famous as a Pattern and Decoration artist in the late 70s. Pattern and Decoration was a short-lived movement that didn't make any impact. There's an acronym for it now, P&D, although in fact it's hardly ever mentioned. There were a number of practitioners. At the time of Food, the early 70s, Kushner put on a food performance, and that's what this film was documenting. It was a food fashion show filmed at Food, called 'Wear What You Eat'. It was him and some other young artists, naked except for avocados and other healthy eatables. They paraded on a catwalk in different skimpy food creations while he introduced each creation to the audience. My fall line, he would say. Pitta bread and smoked Swiss cheese epaulettes.

Swirling

Matta-Clark first cut a building in two in 1974. He went on doing that and photographing the results and exhibiting the photos until he died in 1978. It was a type of art where you didn't have to see the real thing, and in fact hardly anyone did.

The swirling meanings of Minimalism and Post-Minimalism and Fluxus and Performance art and Body art and Earth art and Conceptualism. It's hard to remember it all, especially if you weren't even there. The meanings were all in the air and everyone was contributing to them and responding to them. Not like now, where they all seem to go on without you.

Further top cult artists

The other 70s cult artists

Chris Burden, the West Coast artist, and Robert Smithson are other cult figures of the 70s, besides Gordon Matta-Clark. You would have expected Chris Burden to be dead because of all the shooting and violence in his mythology. Gordon Matta-Clark only had that one shooting incident, with the window panes. But Chris Burden famously had himself shot with a rifle as art and he used to do other shooting events, like firing guns at passing aeroplanes, which would also be art. And he had himself crucified on a Volkswagen. And he rolled on cut glass. But in fact it's Gordon Matta-Clark and Robert Smithson who are dead. They both died young in the 70s.

Robert Smithson cult

Robert Smithson currently has a cult even stronger than Matta-Clark's. Its present strength dates back to the late 80s, to the Neo-Geo period of Jeff Koons. In the previous period, Neo-Expressionism, the memory of Smithson was only a faint beep on the art world radar.

When Neo-Geo was in, there was a sudden rush to rehabilitate the old Conceptual and Minimal artists who'd been forgotten during Neo-Expressionism. There were round-up shows of their work in commercial galleries. Professors of art were hired to write catalogue essays about them, in a recycled style, as if nothing had happened since the first time around. The work was shown alongside the new wave of Neo-Conceptual and Neo-Minimal art. It helped to sell the new art, and the rage for the new art helped to sell the old art.

Fantastic, said the market! Grr, said the Neo-Expressionists, and also their enemies, the Walter Benjamin theorists. The Neo-Expressionist painters were dismayed because they'd been ruling the roost. But the theorists were dismayed because they'd had their cleverness stolen from them by artists. And now they only had their moral high ground, which of course nobody wanted anyway, because it was the greedy 80s.

An example of 60s Minimalism that everyone liked in the 80s

A taste started up, for example, in the late 80s, for Donald Judd's early work, the art he made before he really became Judd. Before, his early work – which he made himself, by old-fashioned sawing and hammering, instead of sending out plans to a factory, which is what he did with his famous

works – was just thought of by everybody as the work he had to go through to get to his famous works, his streamlined boxes and Plexiglas shelves and rounded wall-pieces made of anodised aluminium in space-age colours. And he certainly didn't sell much of the early work when he made it. In fact, it's mostly all there in his Judd Foundation in Marfa, Texas, because he always owned it. But, in about 1986, it was thought of as fantastically interesting, not just as precursor or prototype art, but as an art achievement in itself. And it was.

Judd before Judd

Cadmium red light. That was the colour of the paint he used a lot when he was first working out what might be a good way of making something that was new and interesting and un-European and without any composition or hierarchical relationships. And neither painting nor sculpture, because both were dead, he thought.

He made elementary shapes like squares or rectangles or triangles, which were complicated in some way. A section was cut off, say. Or the rectangle had another rectangle on top of it, going upwards, where the main rectangle went along. And he would paint the forms, which were made of plywood, with red. Or maybe the red was mixed with some thick textured matter to make a surface that was rough but evenly modulated at the same time. A nod to interesting paint texture and colour relationships in Modern art, and a negation of them at the same time.

There would be a square of red on the wall and, in the middle, a circle of metal. Or a box with a triangle cut out might be all red, except for a sudden interruption of purple Plexiglas. Or green. Or a grey metal section.

Suddenly he found out how to do something good, but he didn't know what it was yet. He thought Specific Objects was a good name for it. Geometric forms were useful because they weren't organic, he said – but a form that was neither would be a good discovery. Part of the interest of these early Judds for us today is that we still don't know what they are, whereas when we see his boxes and shelves of later years, we just see trademark Judds.

So it was good, the new wave of new-meaning or non-meaning art in the late 80s bringing out the old art from the early 60s. And a fashionable thought isn't necessarily a wrong thought.

Robert Smithson *Sixth Mirror Displacement* 1969

Smithson's writings

When Minimalism came back in, in the 80s, everyone started reading Robert Smithson's old writings. Some of them are about Minimalism. A lot of them just go on about obscure mining companies. It's baffling at first but then you get the idea it was part of accepting ugliness and the spaces and places and processes we don't normally notice in life. Or don't normally think of as anything to do with art. Like piles of earth and roadworks and old tunnels.

In a lot of his writings poetic visionary streaming thoughts are intertwined with would-be rationalistic 1960s art terms. For example, at the end of one particularly crazy trawl of imagery, which comes up full of smoking ruins and slime and monsters and death beasts, and includes a hymn-like four-line poem by Smithson, he suddenly launches an inspired attack on Greenbergian formalistic target paintings, which he describes as zeros within zeros for zeros by zeros. We don't have to agree that all these Ken Noland zeros necessarily add up to zero. But we can appreciate the unhinged fiery savage poetic intelligence of Smithson when he was on a writing roll, and understand why he's a cult figure. Even if Donald Judd said he was only mediocre.

Spiral Jetty

A canonical work. Smithson got a contractor to tip rocks into the Great Salt Lake, bit by bit, with the truck going out further and further into the lake, over the tipped rocks, until a spiral of rocks had been made. He filmed this process and took photographs. And that was the work. The spiral itself. Which hardly anyone has seen. And the documentation. Which hardly anyone hasn't seen. The jetty is still there. It was submerged at one time, but I think it came up again recently. It's Land art. The most famous example. Another example is Michael Heizer's Land art in the desert. It's a big geometric structure. He didn't do zany writings, though.

Other Smithson works

A truck tipping asphalt down a hill. That's another icon of 60s art. *Asphalt Rundown* by Robert Smithson. As well as Land art he produced a kind of combination Pop/ Minimalism with

Robert Smithson *Asphalt Rundown* 1969

geometric abstract forms, with artificial metallic paint finishes, looking like strange new alloys, as if the forms had been sent to a factory to be finished and the factory was on Mars. He made Minimal objects with serial progressions, and Minimal objects with mirrors. He went out into the deserts and sub-urbs and mining areas and put mirrors in the ground and photographed them and then took the mirrors away. He brought rocks and earth back to the gallery and put them in geometric containers. On the walls, he showed maps and photos and written texts that documented the stuff he'd been doing outside the gallery. His Land artworks were Sites. And the rocks and dirt he brought into the gallery and showed in geometric containers, with map drawings on the wall, were Non-Sites. Soon maps and written-over photos became a mannerism and everyone was doing them. Then everyone hated maps. But now they're back.

Robert Smithson 1971
Polaroid portrait by Brigid Polk

Hip gallery finds old plan
Recently, the directors of a new hip gallery in Brooklyn dug up an old plan of Smithson's, to sail a kind of raft round the East River with some trees growing out of it. And now everyone's excited about the idea of that old plan being realised. But actually it's good enough as an old plan.

Rice dinner, spider dinner

From Food to food
An exemplary cult Globalist artist of now is Rirkrit Tiravanija who is half Thai. He shows at Gavin Brown's Enterprise in Chelsea. I went to a an opening there of forgettable international interchangeable photoworks by a new young artist. In the back was a tree by Rirkrit. I asked Ian MacMillan what he thought it was about. He went away to ask the assistant. She says it's bamboo, he said when he came back. Yeah? She said maybe it's something to do with his background. Oh.

But actually he's a very good artist, of course. He cooks rice and the gallery-goers eat it and it's art. It fits with Gordon Matta-Clark's Food, which is good because everything fits with that now. It's about overlaying an art structure on the everyday. Or the reverse.

Rirkrit Tiravanija 1995

Rirkrit Tiravanija *Untitled (D)* 1995

Then I was at the Philadelphia Museum to film the Duchamp collection there, and in another part of the museum was an installation by Rirkrit with maps. In fact, he was there himself later on, in the cafeteria, appropriately enough. He said the installation was an ongoing one, about his trip across America with some Thai students. They were going to make the journey in a silver mobile home, and then he was going to include the home as an exhibit in the installation, together with all the documentation of the trip that had already been building up. But the home was hit by a hit-and-run driver on the first day, so it was out as a possible exhibit. Also, it meant the rest of the trip had to be done in an old van he just bought cheaply in a hurry, which didn't go and had to be pushed up hills by the students.

While the trip was on, visitors to the installation could receive phone calls from the trippers. Which were quite inane if they were anything like the exhibited messages on the postcards the trippers had sent. Also, they could browse through books about taking trips, by authors like Jack Kerouac and Robert Smithson.

PS1

PS1 is a former public school in Queens, turned into a big contemporary art space. Artists from all over the world come there on residencies and emerge as Globalists. You can't be a Globalist just by being from a different country. You have to come to New York and merge your vision with the cosmopolitanism that's already here. Then it's really interesting that you come from Pakistan or Beijing and a fascination builds up around you and your work. Of course, it doesn't work for everyone. If you can't speak English, stay the fuck away! New Yorkers say to cab drivers and deli owners.

There are different shows at PS1 all the time, shows of the residential artists' art and shows of the art of major historical figures. A big Jack Smith retrospective is on there today. The cult underground film-maker died of AIDS in the 80s, after never quite succeeding in rising above the underground. His early masterpiece *Flaming Creatures* is showing, only it's so pale it can't really be seen. Maybe the projector's broken. The show is enormous and rambling, room after room filled with old posters and old costumes – big, crazy, camp, elaborate, insect or lobster-like – and photos and scribbled notes and sheets of typing. All the writing is witty and angry, all very un-centred, as if everything is the spun-off rhetoric from some main central point that has been lost. There are bitter jibes at Warhol, who Smith considered to have exploited the Smith vision and commercialised it. Jonas Mekas is put down too. His name appears in a poster with dollar signs instead of Ss.

When I asked John Giorno about Smith, he said it's true Smith was very angry all the time because he couldn't get any support. But also, he couldn't get support because he was so angry. On the other hand, his anger was all internalised when he was round at Warhol's Factory, because on the surface he was very quiet and just used to sit there not saying a word and not hurting a fly.

In another part of PS1, there is a little hole in the floorboards. You look down it and there's a tiny video work by the Globalist, Pipilotti Rist, from Switzerland. It's a tiny Pipilotti looking up, calling out in a tiny voice: Look at me!

Dinner
Then it's later and I'm at the Hugo Boss award exhibition at the Guggenheim downtown, walking through a darkened room with some string bags hanging down from the ceiling. There are live tarantulas in there. It's horrible. It's an installation by a Globalist from China. My friend who works in the office at the Guggenheim says the tarantulas were in there for a while waiting to be installed, eating their dinner, which was mouse embryos. I stagger into another darkened room, and it's a film projected on the floor by Pipilotti Rist, the camera roaming repeatedly over and almost in and out of her naked body. And in another room Douglas Gordon's prize-winning work replays an old film of early psycho doctors holding down a woman who might be psycho, unless the doctors are psycho and the woman is resisting patriarchy.

Feminists against master narrative

Lucy Lippard
She wrote *Six Years: The dematerialisation of the art object*. It is a thorough record of Conceptual art events from 1966 to 1972. It is an invaluable record in a way, but in some ways it is a book of comedy. It would be a treat for conservatives if they ever read it. Someone's photo of a segment of a staple on graph paper. Or Hans Haacke exploring systems of condensation. Somebody else's painting of the words *Note: Make a painting of a note as a painting*. And no one bothering to say what anything means.

Feminism
Lucy Lippard was active in the Art Workers' Coalition, which was a collective of 60s artists who advocated artists' rights and were against the war. Carl Andre was in it. Everyone was in it. It gradually deteriorated as outside groups got involved, and those inside got less involved. Some Black Power activists got involved at one point. What Lucy Lippard mainly stands for now is that she was a big part of the rise of Feminism in New York art. It was an important rise. It happened in the 70s. Art now is Post-Feminist. The lessons are taken for granted. That's a relief in a way. Judy Chicago was a big feminist artist in the 70s. Obviously she came from Chicago. She exhibited a triangular table with place settings that commemorated top women of history. The Post-Minimalist sculptor Eva Hesse wasn't part of Feminism because she died in 1970 before it got going, but her brand of Post-Minimalism is considered to be a big influence on it. She used basic forms from Minimalism but inflected them with quirky individuality and absurdity. The absurdity was in the hand-made look, coupled with industrial forms. It was industrial and organic, simultaneously. In the 80s the main feminist art was by Barbara Kruger, Jenny Holzer, Sherrie Levine and Cindy Sherman. It was a photo- and text-led type of feminism. In the 90s there was a brief movement of Riot Grrls, so-called to emphasise a growling sound, because they were growling at patriarchy. Their art was in many forms, including painting. One of the painters was Nicole Eisenmann, who painted cartoonish but also realistic paintings of vaguely art-historical scenes, repopulated with sexy lesbian girls with big busts, like *Tank Girl*.

Guerilla Girls
An early 90s Feminist movement within the art world, which is still going on, is the Guerilla Girls. They were established artists who got together and wore gorilla masks and went around town in a posse posting up statistical

information. What proportion of shows at the main galleries were of women artists, or how many articles in the main magazines were about women artists, and so on. Also, they sprayed graffiti on urban surfaces, using stencils. The graffiti were ironic slogans and statements that drew attention to inequality and entrenched or unconscious sexist attitudes in the art system.

Everyone likes them. Even though they can often seem a bit tedious. I went to a bake-in they organised at a gallery in SoHo once. The cakes were all baked by male artists, who were showing their solidarity.

Then in Paris the other day I saw some sprayed Guerilla Girl graffiti in French. One went, *Regarde mon art. Je te dévoilerai mon sexe*. Which means, See my art. I divulge my sex. And another one went *Mon âme d'artiste a le même sexe*. Which means something like, My artistic soul is the same sex. Let's hope the French can work it out. They have a lot further to go in the war against sexism, as we know. Like the war against smoking. Both slogans had the phrase *Guerilla Girls MA & PA Conscience du Monde et de l'art* in small type under the main text.

MA & PA is good. Maybe it was unconsciously influenced by Lawrence Weiner's rubber stamp slogan from the 80s. *Muti & Fati Kultur*.

Bourgeois myth
We can't help seeing Louise Bourgeois's art through a filter of decades. Her art was always slightly off the mainstream, so, as if to compensate, it was always presented in books and articles in terms of whatever the mainstream of the time was. In the 60s, she seemed to be part of Eccentric Abstraction. In the 70s, she did some performances and events, like wearing art. She wore a latex outfit with myriad pairs of latex breasts, like an Assyrian or Greek goddess. In the 80s there was sexual aggression, in the form of the famous Robert Mapplethorpe photo of her smiling and carrying a latex sculpture, a huge gnarly phallus, under her arm. In the 90s, she put on mysterious installations using cast fibreglass human bodies and found bits of bric a brac.

When she was young her mother tolerated her father having an affair with her English governess, who was called Sadie. She became an artist because she couldn't accept her past. Before, we might not have cared, but now, in the 90s, her life story just seems naturally very interesting, and her myth is a good myth and we don't mind hearing about it. Also, nowadays we naturally

Louise Bourgeois with **Jerry Gorovoy**

warm to the element of craft in art generally, but in her art in particular. It seems more and more a good thing, as long as the forms aren't too corny. With her, they're quite eccentric and interesting. Bulbous, bodily, animal, human, spidery, made of cloth or rubber or sculpted marble or steel or glass.

She was married to the art historian Robert Goldwater, now dead, who wrote about Modern art and its relationship to Primitive art. She has an intensely eccentric interview style, punctuated with entertaining urgent mad pronouncements. And she has a tendency to change her clothing in mid-talk. Or to drag an old heater round on a piece of string like a pet, or an ego substitute. Come along ego. Down ego.

So of course she's a favourite of feature writers and British TV crews, though no less good for all that. Her assistant Jerry Gorovoy looks like a handsome Rasputin, with long Jesus hair and high cheekbones and deep-set brown eyes. He takes care of everything and gets her to her studio and makes sure the materials are ordered and the catalogues written and the deadlines for shows all over the world met.

Her tall narrow old brownstone house in Chelsea is ramshackle and atmospheric, with a notice board in the back room covered in a history of posters and documents and photos, yellowing and fading. There is old bric a brac all over the place, which looks familiar from her drawings and gouaches through the ages. An old wooden stool – it could be from any decade, maybe the 60s – stands in a corner with a pencilled graffiti message on it: *I love you*.

Louise Bourgeois *Harmless Woman* 1969

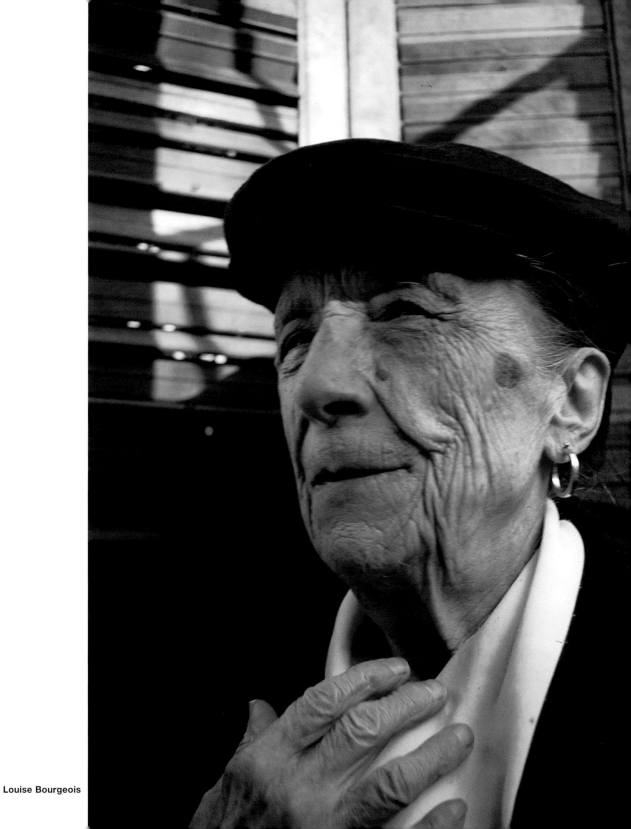

Louise Bourgeois

Oh please let it all mean something

May 68 – May 98

That's the name of the exhibition in Cologne I'm at today, in May. From Situationism and the Paris revolts to now. The weather is hot. It's a hot, pre-private view reception at the *Kunsthalle*. In the centre, on the ground floor, is an old scatter-piece by Barry Le Va. Snips, swathes and rolls of purple and black felt, with shards of clear glass.

Where's Al II, 1998, is an installation by Allen Ruppersberg, a West Coast Conceptual artist of the 70s. It's got a lot of stills from movies and a few film scripts and some lines of dialogue on index cards. For example: Would you introduce me to Guy? I've always admired his music. Plus there's some screen-writers' how-to books. *How to write a movie in 21 days* by Vikki King. And the script for *Scream*. Apparently originally titled *Scary Movie*. Then I see *Where's Al I*, which is from 1972. This one, the original *Where's Al*, is a take on the notion of the death of the author, which was only just beginning to become popular with artists in those days. It has more index cards with dialogue. Each one starts with an enquiry about where Al is. For example: Where's Al today? Why isn't Al here? Wasn't Al coming with you? Who knows? No, I think he went to Texas. He's working.

This art opening is sponsored by Kolsch beer, with the logo: *Die Revolution der Frische*. Which means something like, the revolution of the fresh. On the stairs, there's a 60s Claes Oldenburg soft plug and socket. There are some Lynda Benglis anti-form sculptures from the same decade, made of poured lead blobs. Upstairs on the floor, there's an anti-form spill by her called *Contraband*. Maybe it's smuggling ideas through. Something by Richard Artschwager is here. No one really knows what's great about him but he's always there, making more formica Minimalism. Here's a sculpture by Eva Hesse. She looked up titles in the thesaurus. And Mel Bochner once made a drawing for her, showing all the words in the thesaurus that might describe her, in a pile. Her work here is a Post-Minimal, hollow, clear perspex box, with lengths of three and a half inch clear plastic tubes set into the inside walls of the box, in a thick carpeting, like plastic fur or hairs. Inside there's a black void.

On the wall are exciting big anarchy quotes from Proudhon through to Jefferson and Thoreau, through to Tony Blair. One from the Unabomber goes: *Some anarchists have used bombs, but would rather remain unheard*

than kill people to gain attention. The vast majority of murderous fanatics are authoritarians. And one from someone called Olaf goes: *I will not kiss your fucking flag – there is some shit I will not eat.*

I look for the 90s artist Gregory Greene's bombs, but there's none here. He makes them himself and exhibits them as art. They were at the Saatchi Gallery. There was a long queue to see them. Also, he recently exhibited all the ingredients that make LSD, so whichever collector bought a batch could make some if they wanted and be deeply moved. Ian MacMillan went round to his place to photograph him the other day in New York, and he was surprised how friendly he was. Because he expected him to be angry or revolutionary, perhaps.

The quote from Rabelais is: *Do what you will.*

Do what thou wilt shall be the whole of the law. That's a quote from Aleister Crowley but it's not on the wall here, because he was a Satanist, not an anarchist or a Situationist. My mind is wandering, obviously.

Kolsch beer. Sponsorship. Tablecloths laid out. Blond servers smiling and slaving. No knowledge of the revolution they missed and that never happened anyway. In the courtyard, a child plays by a Conceptual art fountain. German collectors saunter across the square in their linen suits, to look at their radical Le Vas and Hesses and Ruppersbergs, out for their airing from the old store cupboards. Maybe they don't mean anything now. Harold Rosenberg said you should never see art as an object but as a product of etiquette. If you saw it as an object it was just barbarism. But what did he know? Greenberg would have said.

Silence

Small circle

Do artists really mean it? is an anxiety we're all familiar with, since Warhol. Are they just playing or acting or parodying or mimicking, for some reason that only they, or their small circle of friends, know?

Johns and Rauschenberg

The bridge between Warhol and Abstract Expressionism is Rauschenberg and Johns. They were enigmatic and Zen, in an urban ironic context, a bit like Beatniks. For example, a quarter of a real New York phone book, in a

box, like a saintly relic, as part of a Rauschenberg Combine painting, from the 1950s.

Beatniks are more passionate, you might say, but Johns and Rauschenberg are passionate too. Only it's in their surfaces and brush-strokes. But on the other hand, it's true there's something cold about these things with them. Maybe they're the beginning of going off the path.

But what about their predecessors, the Abstract Expressionists, being so macho? Come out and fight! the Abstract Expressionists would growl at each other when they met at the famous Cedar Bar. Obviously that was wrong. And that might have been the beginning of going off the path. What was the path anyway? No one remembers.

Swish

Neither Rauschenberg nor Johns liked the idea of Pop art and they didn't want to be connected to it. And they didn't like Warhol, even though Warhol had bought some of their work. He could afford it because he was very well off before he was an artist, earning $60,000 a year at one point from his commercial drawings. An amazing income for those days, the late 50s. They didn't like him because he was so outrageously gay they thought it was uncool. He was swish, they are famously supposed to have said. They thought it was better if you were gay to be more suave about it.

Clock

Rauschenberg mainly stands for Combine paintings. They are free, gestural abstract paintings from the 50s, done fast, with objects stuck on them, or attached to them in some way. For example, a clock, or a stuffed eagle, or a tie, or a cushion, or a flashing light bulb, or a bit of wire. In a Combine painting featuring two real clocks, one is stopped at the time Rauschenberg began the painting, and the other is stopped at the time he finished. That was a whole new idea about meaning.

Another painting Rauschenberg did in the 50s was called *Factum*. It had a partner called *Factum II*. Both *Factums* had the same materials, colours and gestures and the same collage elements. They were each free and

Jasper Johns

gestural and spontaneous, with arbitrary collage imagery. But they were both repetitions of each other. So that was a whole new idea about spontaneity and originality, which set the tone for the future, through Warhol to now.

Rauschenberg crying
Rauschenberg was crying. Nothing means anything! he moaned. Gilbert & George were there. They told me. It was the early 70s. They befriended him when they first went to New York and he cooked a meal for them. He was always crying, they said. He was very emotional, even neurotic, about nothing meaning anything.

No dinner
Another time, it was Rauschenberg's retrospective at the Tate Gallery in London, and afterwards it was raining on the steps of the Tate, and there was a little disconsolate cluster of Rauschenberg and his entourage, plus Gilbert & George, plus the director of the Tate at the time, Alan Bowness, who was in his raincoat and holding his briefcase, with the strap broken. I'm afraid I can't offer you dinner, he said to Rauschenberg. Because my wife's poorly. So the living sculptures had to buy him dinner instead.

Star
Another thing about Jasper Johns is that he set the mould for being a young art star. He had his paintings bought by the Museum of Modern Art when he was only twenty-eight, in 1958. Which must have been horrible for someone like de Kooning, who wouldn't have thought flags and targets were much good, and who didn't get a show until he was forty-four, in 1948.

And in fact it was de Kooning's famous comment about the dealer Leo Castelli – the discoverer of Johns – that Castelli could sell anything, even a couple of beer cans, that inspired Johns to cast two in bronze and get Castelli to sell it. And now it's a dazzling enigma.

From left to right:
William Goldston, **Tatyana Grosman** and **Robert Rauschenberg**

Bob, how long did it take you to erase that de Kooning drawing?
Rauschenberg was always being interviewed about his erased de Kooning drawing. It is one of the main killing-the-father myths in American art. He

did it in the early 50s, after he started to become known. It had to be a drawing that was really hard to erase. It took fifteen erasers or 30 or 20, and five months or one or three or two weeks. First, he drank a bottle of Bourbon or gin, or three bottles, or Tequila. He did the drinking with de Kooning himself, in de Kooning's studio, after he knocked on the door and introduced himself and de Kooning let him in, and he told de Kooning what he wanted from him.

Interviews

In Rauschenberg's early TV interviews, charming and old-fashioned, in black and white, he is nervous and formal, in a suit, even a tie, thinking hard about his replies to the questions. Gradually over the years he gets more and more blasé and a kind of blasé affectedness sets in. There is a 1977 interview shot in colour, in his studio. He has long hair and a big white shirt like the cheesecloth shirts from India that were cool in the 70s, only maybe more the very early 70s than 1977, and he looks like a swami. His replies seem to be coming through a haze. Through this haze he refers to the time he made the White Paintings. It's just a little thing but it's so much at the heart of why contemporary art sets otherwise sympathetic people's teeth on edge. Why not *some* white paintings?

Neo-Dada Zen and Beatnik Zen

Rauschenberg's White Paintings of the early 50s were all executed with a roller, and each have the same matt flatness. They were sets of several tall separate all-white flat canvases, making single horizontal all-white shapes, with the separate edges making vertical lines. It became part of art mythology that he thought of them as airports for incidents, like falling dust or shadows. Or maybe it was John Cage who thought of them as that first. In any case, it was through John Cage that this thought first entered mythology, because the thought was in *Silence*, Cage's most famous book. The others are *M* and *A Year from Monday*. *Silence* is the one most remembered, because of Cage's piece of music by the same name. It was seven minutes of silence, to allow street noises and rustlings in the room to be music, instead of violins. It was the random field of meaning.

Cage's books have recipes for mushrooms, and thoughts about art and music and time and space and chess and the *I Ching*, which are strangely

John Cage and D T Suzuki

structured on the page. For example, structured as acrostics. Or else normally structured, like the essay on Rauschenberg. They are precious but good, a not impossible combination.

Another essay in one of the books is about Jasper Johns. It is amazingly romantic about the notion of genius. The special gnomic things Jasper said. The special coincidences that punctuated his life. But like the one about Rauschenberg – and others about Miró and Duchamp – there are a lot of good insights about Johns's art. But also a lot of affectation. Zen and affectation, in art they went together in a precious way. In Beatnik circles they went together in a more rough and tough way. Neo-Dada and Beatniks. They overlapped a lot but they were different as well.

Just say Neo
Neo-Dada was saying No to classical structures and eternal values and Beethoven, and saying Yes to chance and the everyday and the random poetry of the street. It overlapped with Fluxus. John Cage is Fluxus and Neo-Dada. But Rauschenberg and Johns were Neo-Dada and not Fluxus. It wasn't really Neo-Dada anyway, and the label soon stopped being used.

In early interviews Johns would say he'd never seen any Dada art when he started painting, only Marcel Duchamp, and through an interest in Duchamp he read a book about Dada, but he wasn't originally influenced by it. We never know what's true and what is a conscious construction of an artist's myth, and after a while the artist can't remember either. All new myths eventually say Yes to eternal values anyway, and museums and classicism and violins.

The role of chance
If Flaubert was writing the dictionary of received ideas at the back of *Bouvard et Pécuchet* today, and it was about New York art, his entry under the heading 'Chance' would be: Always say The Role of Chance, or Aleatory, or With a Chance Roll of a Dice. And frown and nod wisely. Rauschenberg and Johns were thought to be masters of Chance, under the main master, Duchamp. But also Chance is massive in Jackson Pollock and in Post-Minimalism, especially in scatters and spills and works obeying gravity.

Electricity run out
After it disappeared as a lively idea, Chance still went on being referred to but nobody could remember what was good about it. It became academic.

After all, if it's meaningless, or only chance, what's the point of it? That was the feeling when Chance's connection to the real word and the random field of meaning was gradually forgotten, and it just became an academic term.

This is the kind of Chance we find ourselves reading about now, in enormous Johns and Rauschenberg catalogues, when they're getting the violins treatment. As if Chance is an eternal value. That's why it's never all that interesting to read these catalogues and hardly anyone does. It's quite interesting to read the old ones by Lawrence Alloway, or whoever, though. Because in those days Chance still had some electricity.

Magritte

Last year, I was introduced to Johns. It was a cold day and he arrived at the Museum of Modern Art on the last day of his retrospective there, wearing a woolly hat and a padded jacket and jeans. He was sixty-six. The museum was closed and there were just a few people in for a last look at the show, by invitation only. Including Leo Castelli and some women with him, and David Sylvester, the great British critic.

I walked in behind everyone else and because there were too few people for any one of us not to stand out, I felt incredibly self-conscious, as if I was imitating someone in a gallery looking at paintings, which in fact I have very often done, for TV. Then Sylvester, Johns and I were, by Chance, within the same few cubic yards of air and space. Sylvester said, Oh Jasper this is Matthew Collings, Matthew Collings, this is Jasper Johns. And Johns's hand came out and I shook it. It was an incredible moment. I always revered him. Maybe he would embrace me as a son and say, Welcome, my boy, to the dignified world of the enigma. Come join me on my Caribbean island and help squeeze out tubes of expensive purple!

Matthew has interviewed me many times for the BBC, Sylvester was saying, on subjects like Magritte…

For the News

I felt David's voice fading out and lists of titles and visions of artworks and a memory of all my old art-school fanship of Johns fading in. *According To What, False Start, Target With Plaster Casts, Drawer, Coat Hanger, Painting With Two Balls*. The random everyday field of Zen meanings. The rulers and thermometers and misleadingly straightforward stencilled labels, and the idea of measuring things that couldn't be measured. The school desk equipment, the maps and dusty timelessness. The nutty factuality.

The hot iron imprint with the word Iron in it. The words Top Right painted at the top right of a painting and Bottom Left at the bottom left. Brr at the North Pole in his *Map* after Buckminster Fuller, in a collaged *Nancy* cartoon. The jokes on Abstract Expressionism, cutting it to measure, or down to size, or labelling it wrongly. As if the confusion of art that we can't understand as students, but somehow we go along with its myths and laws anyway, until we just accept that's what art probably is after all, was being acknowledged and undone both at once, in an unexpected but – it turns out – longed-for way. Abstract Expressionism, Cubism, Naum Gabo, Orphism, André Breton; the chart of isms; the slightly boring reality of it all, all now suspended in a Johnsian enigma, where jokes are in a non-hierarchical relationship to feelings. Grey instead of colour. Numbers instead of angst.

Four horizontal canvases hinged together, to make a tall vertical. Each canvas covered with expressive, expert, elegant, all-grey brush-strokes, which don't have any meaning at all. A real early 60s newspaper, yellowing and ancient, wedged between two of the panels. Three big capital letters painted on one of them. T, H and E. *4 The News*.

Warning
… and it was always a nightmare! David Sylvester's sentence ended with a dry laugh.Jasper Johns laughed back with his jolly laugh. Thanks for the warning! he laughed. And off he went to check if *Toy Piano with Collage or Green Target* was hung the right way up still. Or *Device Circle*'s device hadn't fallen off.

Index

All page numbers in *italics* refer to pictures.

Photographic credits

The publishers have made every effort to contact all holders of copyright works. All copyright holders who we have been unable to reach are invited to write to the publishers so that a full acknowledgement may be given in subsequent editions.

We are very grateful to the artists for their permission to reproduce the works and for agreeing to have their photos taken.

The publishers also wish to thank the owners and photographers of works reproduced in this book for kindly granting permission for their use. Photographs have been provided by owners and those listed below:

© ARS, NY and DACS, London 1998 pp. 14, 18, 19, 68, 177
© 1997 Matthew Barney p. 31
Courtesy Mary Boone Gallery, New York pp. 92, 151, 169
Courtesy Marianne Boesky Gallery, New York p. 118
Courtesy Gavin Brown Enterprises p. 210
Courtesy Leo Castelli Gallery, New York p. 177
Courtesy Cheim & Read, New York p. 42
Photo Ken Collins © KATZ Pictures p. 110
Courtesy Paula Cooper Gallery, New York pp. 134, 136, 193
Courtesy Jane Crawford and the Gordon Matta-Clark Trust p. 200
Courtesy DIA Centre for the Arts, New York pp. 18, 56, 193
Courtesy Deitch Projects, New York pp. 46, 67, 121
Courtesy Anthony d'Offay Gallery, London p. 84, 148
Courtesy Andre Emmerich Galley, New York pp. 98, 99
Courtesy Gagosian Gallery, New York pp. 159, 160
Photo Allen Glatter p. 56
Courtesy Barbara Gladstone Gallery, New York pp. 31, 33, 165, 166, 167
Installation Jay Gorney Modern Art, New York p. 93
Courtesy Peter Halley Office, New York p. 156
Photo Lisa Kahane p. 90
Courtesy Jeff Koons pp. 51, 52, 75
Photo Tseng Kwong-Chi p. 80
Courtesy XL Xavier LaBoulbenne, New York p. 29

Courtesy Lisson Gallery, London pp. 181, 199
Courtesy Luhring Augustine, New York pp. 27, 38
Photo Sara Lukinson courtesy Jules Olitski p. 96
© Ian MacMillan Part Two title page, pp. 17, 25, 26, 30, 34-35, 40, 41, 43, 44, 45, 65, 72, 73, 76, 77, 83, 87, 116, 117, 119, 120, 123, 124, 126, 127, 129, 131, 135, 137, 142, 143, 145, 147, 149, 150, 154, 155, 162–163, 176, 178, 180, 189, 190–191, 196–197, 198, 215
Courtesy Jonas Mekas p. 139
Courtesy Metro Pictures, New York pp. 24, 152, 153
Courtesy Metropolitan Museum of Art, gift of the artist, 1995 p. 91
Photo © Billy Name – frontispiece, Part One title page
© 1991 Hans Namuth Estate Courtesy of the Centre for Creative Photography, University of Arizona, Tucson p.184
© Ken Noland/VAGA, New York/DACS, London 1998 pp. 98, 99
© Jules Olitski/VAGA, New York/DACS, London 1998 pp. 102, 104, 106
Courtesy PaceWildenstein, New York pp. 49, 71, 140, 141, 195
Photograph by Brigid Polk p. 209
Courtesy Andrea Rosen Gallery pp. 114, 115, 122
Courtesy The Saatchi Collection London pp. 118, 125, 128, 199
© David Salle/VAGA, New York/DACS, London 1988 p. 130
Courtesy Sonnabend Gallery, New York p. 184
Courtesy 303 Gallery, New York, pp. 66, 185, 186 –187
Installation at Tibor de Nagy Gallery, New York p. 193
© Caroline Tisdall p. 68
Collection Walker Art Centre, Minneapolis T.B. Walker Acquisition Fund, 1994 p.19
© The Andy Warhol Foundation for the Visual Arts, Inc. pp. 14, 18
© 1967 The Andy Warhol Museum, Pittsburgh, PA, a museum of Carnegie Institute p. 14
Courtesy John Weber Gallery p. 208
Photo Laura Wilson © British Vogue/The Conde Nast Publications Ltd pp. 20, 21

Many people made working on this book even more enjoyable and rewarding than I expected so here come their namechecks. Thank you to all the artists for being so patient with their time and letting me snoop and snap around wherever I wanted, and a special thanks to Jack Pierson for finally giving in and to Maureen Paley for convincing him. A big hug to Anthony Viti for the use of his apartment and for being such a good friend over the years, and to Jeremy Pollard for his enthusiasm and support. Thank you Karen Wright for allowing it all to happen. Finally, three cheers to Matt for always being nothing less than entertaining and often a lot more, and to David Richards for anything and everything. I'd like to dedicate my contribution to this book to my mother, the wonderful Betty. I'm sorry she's not around to see the finished result.

Ian MacMillan

Also published by 21

BLIMEY!

From Bohemia to Britpop: The London art world from Francis Bacon to Damien Hirst

by Matthew Collings

A driven man's journey from the 1950s to Britpop. A hip, postmodern, beat anthropologist, Collings takes us from his life in children's homes to the incredulous world-weary critic... Hilarious and horrible, intelligent and frightening, *Blimey!* is the book the art world deserves.

Adrian Searle, *The Guardian*

One of his great strengths is his insistence that in art things are not either/or but both/and. He is constantly aware that something can be basically flawed, can be pretentious, even a bit phoney, but can still have artistic power. Another of his strengths is his total fearlessness about giving offence: he writes as if he doesn't give a damn whether he ever finds another day's work in the art world. It is tempting to quote from his better anecdotes, but the intervening passages of criticism are equally funny while being exceedingly serious... In its laconic way *Blimey!* has the moral weight of great criticism.

David Sylvester, *The Independent*

Collings has the pecking order off pat, ranking the stars and starfuckers, the galleries, critics and magazines with needle-sharp precision... Accepting the fiction of it all, he is free to roam relatively unhindered. He knows the tricks of the trade, the fashions, the recycling that goes on, but has the nous and sensibility to know when it is done well or badly, and sometimes even why.

Martin Coomer, *Time Out*

Well written and eminently readable. His powers of description are fearlessly precise. He comes across as believable, relevant and insightful.

Vicky Rimell, *London Magazine*

Published worldwide by **21**

21 Publishing
2nd Floor
3-4 Bartholomew Place
London EC1A 7NJ

First published 1998
Reprinted 1999
© Matthew Collings 1998

Editors: Karen Wright and Linda Saunders
Picture research: Sophie Mackley

Designed by Herman Lelie

Typeset by Stefania Bonelli
Production coordinated by Uwe Kraus GmbH
Printed in Italy

British Library Cataloguing and Publication Data
A catalogue record for this book is available from the British Library

ISBN 1-901785-03-3

Front cover: Matthew Collings with Andy Warhol's *Silver Pillows* 1966 and *Cow Wallpaper* 1966. Photo © Ian MacMillan 1998. Courtesy The Andy Warhol Foundation for the Visual Arts, Inc. ARS, New York and DACS, London 1998

Inside front cover: Andy Warhol, still from *Lonesome Cowboys* © 1968 The Andy Warhol Museum, Pittsburgh, PA, a museum of Carnegie Institute

Back cover: Jeff Koons. Photo © Ian MacMillan 1998

Inside back cover: Vanessa Beecroft, photograph of *VB36, SHOW* performance, R Solomon Guggenheim Museum, New York, 1998. Photo Mario Sorrenti. © Vanessa Beecroft. Courtesy Yvonne Force Inc